Hal
Camdeborde
Henderson
Chartier
Bras
Jonsson
greco
Avillez
Orlando
rchand
Féolde
Aduriz
Muñoz
Elverfeld
Ekstedt
Gréba
Desramaults
Henry
Steiner
Nilsson
Herman
Levha
Grattard
De

INSIDE
CHEFS'
FRIDGES,
EUROPE

Top chefs open their home refrigerators

CARRIE SOLOMON *&* ADRIAN MOORE

INSIDE CHEFS' FRIDGES, EUROPE

Top chefs open their home refrigerators

foreword by
NATHAN MYHRVOLD

illustrations by
AURORE D'ESTAING

TASCHEN

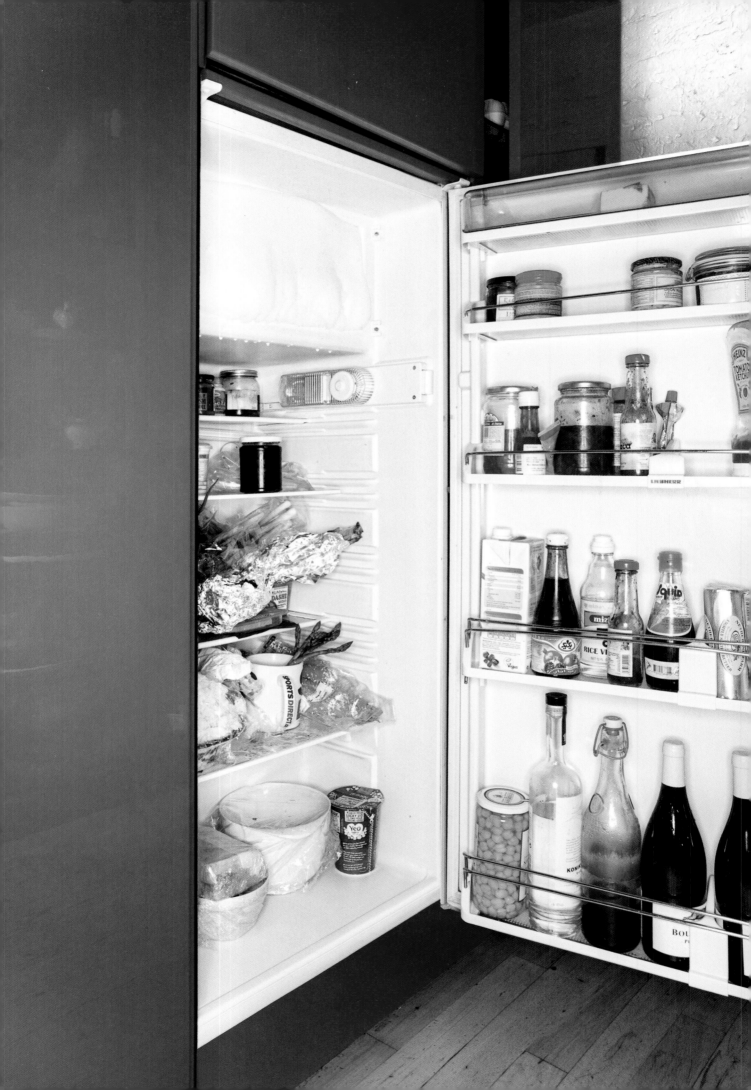

CONTENTS
Inside Chefs' Fridges

• • • • • • • • • • • • • • • • • • • •

FOREWORD

• ⋯⋯⋯⋯⋯⋯⋯⋯⋯⋯⋯⋯⋯ •

Over thousands of years we developed techniques to make perishable foods last longer. We began turning milk into yogurt and cheese, pickling vegetables, and curing meats and seafood. Ice cream was a fleeting luxury for the exceedingly wealthy and leftovers were really "rest overs" that had to be eaten almost immediately. Refrigerators democratized cold food, changing how we eat, shop, and, thanks to refrigerated boxcars, even where we live. We store ice cream by the gallon and look forward to eating yesterday's takeout. And the great irony is that today we refrigerate our yogurts, cheeses, pickles, and cured meats and seafood—our refrigerators are full of jars and tubs of items that could traditionally sit out for months.

Maintaining temperature is the key to managing your refrigerator. Each time you linger indecisively with the door open, cold air spills out, and the temperature inside rises. Hot foods have the same effect and place thermal stress on neighboring items. If you must, place hot items on an empty upper shelf—the heat will not reach the bottom, which is the coldest region. Lower shelves and bins are well suited for raw items, though fresh produce and meat should be stored separately. You can prevent smaller items from getting lost by storing them in the door. The shallow shelves keep condiments and spreads visible. Don't combat an increase in temperature by adjusting the thermostat of your refrigerator so low that it turns into a freezer: large ice crystals form on food that is frozen slowly, causing cell walls to rupture. The cycle of thawing and refreezing actually causes food to spoil more rapidly.

Refrigeration can slow microbial growth by a factor of about 1,000. But, after a certain amount of time, microorganisms move in and food spoils. In principle, we should be organized enough to monitor our food and use it before it goes bad, but, inevitably, holiday leftovers and odd condiments get pushed to the back of the refrigerator and are forgotten. If food safety inspectors visited our homes, many of us would have failing grades slapped to our refrigerators.

In a sense, refrigerators preserve more than food. Archeologists analyze unearthed food containers to learn more about ancient cultures. Now, the single fastest way to tell what continent you are on is to step into a kitchen and look at the refrigerator. In the United States, refrigerators are gigantic—some are chilled closets, more or less—because Americans put everything in them: large volumes of beer and soft drinks, eggs, butter, and even bread. Reclining chairs are made with refrigerated beer coolers in the armrests and we can purchase cars that hide compact refrigerators in center consoles. Travel to parts of Europe or Asia and you'll find that refrigerator sizes are greatly reduced. Portions are smaller, so there are fewer leftovers, and trips to the market are more frequent. Eggs and butter are kept on the counter or in pantries without incident.

If you really want to learn about a person, look in their refrigerator instead of their medicine cabinet. Those chilly time capsules are windows into where and how we live, and, ultimately, who we are.

NATHAN MYHRVOLD

INTRODUCTION

• •

It all started with a bloody steak on a kitchen counter at Inaki Aizpitarte's influential restaurant Le Chateaubriand.

I was perusing a freebie indie magazine I was writing for, one of my first food-reporting missions in Paris, my adoptive hometown, when I spotted the picture, which has stayed with me. The composition was surprisingly simple: a big piece of meat, slapped down on a bloody cutting board, a glistening piece of primal protein, taken from above, contrasting with the wooden grain. The photographer was Carrie Solomon. It was the first food picture that moved me.

Now, years later, I've come to believe that that one image burned into the retina of my mind might have been the seed of this book, my first, and our first collaboration. Over the years we've discussed various projects, but it was not until an event organized by *Le Fooding*, surrounded by chef friends, that we solidified our idea for this book and decided to go for it.

We thought: How can we penetrate the inner sanctum of these culinary artisans and artists? What one thing do these chefs, from every corner of Europe, share with the common man? The idea seemed so simple and overlooked: the fridge. We started enlisting our chef friends from that very night.

Choosing the participants, then convincing them to allow us into their homes and share what little precious time they have away from work was one thing, then traveling all over Europe, meeting them, and exploring and dissecting their kitchens quite another.

From the north and south of France, to Belgium, Denmark, Germany, Italy, Spain, Sweden, and the United Kingdom, some of the world's greatest culinary minds opened their refrigerators to us.

Fridges are an invention that changed people's lives. They enabled those without gardens to eat chilled produce out of season. Large families could buy food in bulk without spoiling as it did in days gone by. Easy to prepare meals could be stored for later consumption. The refrigerator became the most popular home appliance in the developed world and has since come to occupy a place of psychic comfort, a safe haven, which beckons after a long day at work, and soothes with a promising light when plagued by thirst or hunger in the middle of the night.

Even for the world's most prestigious chefs, the fridge remains resolutely personal, and however sloppy or manicured theirs might be, give key insight into the very core of these extraordinary personalities and show what they themselves eat when freed from the restraints of their chosen profession, what they buy for their mates or families, where they store ingredients for meals that will be prepared for loved ones.

Their fridges hold culinary experiments, the germ of future great dishes, and hide away in their dimly lit corners sinful junk foods, gifts from producer friends, and forgotten, mysterious, and sometimes indefinable matter. There is low end and high end, and every nuance in between. Even fridge doors are zones replete with reminders, keepsakes, mementos, a repository of the highly personal.

Our food safari allowed us a direct and privileged connection with some of the world's most interesting chefs, an opportunity to peek into their refrigerators and lives. Over many months we spent time with over forty culinary innovators, sharing nearly sixty Michelin stars between them. We have some amazing original images of the insides of these intimate appliances, visual gold struck in a sort of Sub-Zero Holy Grail. And deep within these chill, hermetic environments, we hope we've found where they've buried a little bit of themselves.

We thank them all for sharing.

ADRIAN AND CARRIE

A SHORT HISTORY OF THE REFRIGERATOR

●.................................●

The invention of the refrigerator created a sea change in our relationship with food. Once upon a time, people would eat only what they would see butchered in a public square, consume creatures they raised and saw living. This life-changing appliance made it possible for food to be stored for longer, transported further, and gave consumers a world of choices unmatched before refrigeration.

Refrigerators have existed throughout the years, however. The Chinese, for example, used snow for cooling food millennia ago, while ancient Egyptians created ice by placing boiled water in jars on the roofs of the houses to allow the cold night air to turn it to ice. The Greeks and Romans saved snow in pits they dug in the ground and insulated containers to cool wine and make ice cream. Various cultures cooled food in streams and caves over the years—all of this in an effort to refrigerate food.

In 1748, a Scottish professor named William Cullen designed the first artificial refrigerator with a chemical vacuum machine which sucked the heat from the air and produced ice, but had no practical use; and in the 1800s others, such as German engineer Karl von Linde, American Oliver Evans, British scientist Michael Faraday, and Americans Jacob Perkins and John Gorrie constructed various contraptions that soon faded into the history books.

A refrigerator is, in its most basic form, an insulated box with a heat pump whose purpose is to transfer the heat from the inside of the box to the outside, bringing the temperature to just above the freezing point, and therefore perfect for preserving all sorts of food and other perishable materials.

In the late 1800s and early 1900s, the harvesting of natural ice had become such a huge business that public demand quickly outweighed the supply, depleted resources, and this, coupled with pollution from the ongoing Industrial Revolution, and warmer winters, all but destroyed the industry. Refrigeration technology was rapidly evolving thanks to newly discovered and safer compressed gasses, translating into economically attractive home appliances. The refrigerator quickly became the most widespread, and arguably, the most loved home appliance.

ICE STORAGE

TALLER: THIS LABEL IS TO BE REMOVED BY THE CUSTOMER)

WO FULL BUCKETS OF ICE PRODUCED MUST BE DISCARDED. ALLOW 24 HOURS BEFORE DISCARDING THE FIRST BUCKET OF ICE.

MAY CLUMP TOGETHER DUE TO INFREQUENT USAGE. THIS CONDITION IS NORMAL.

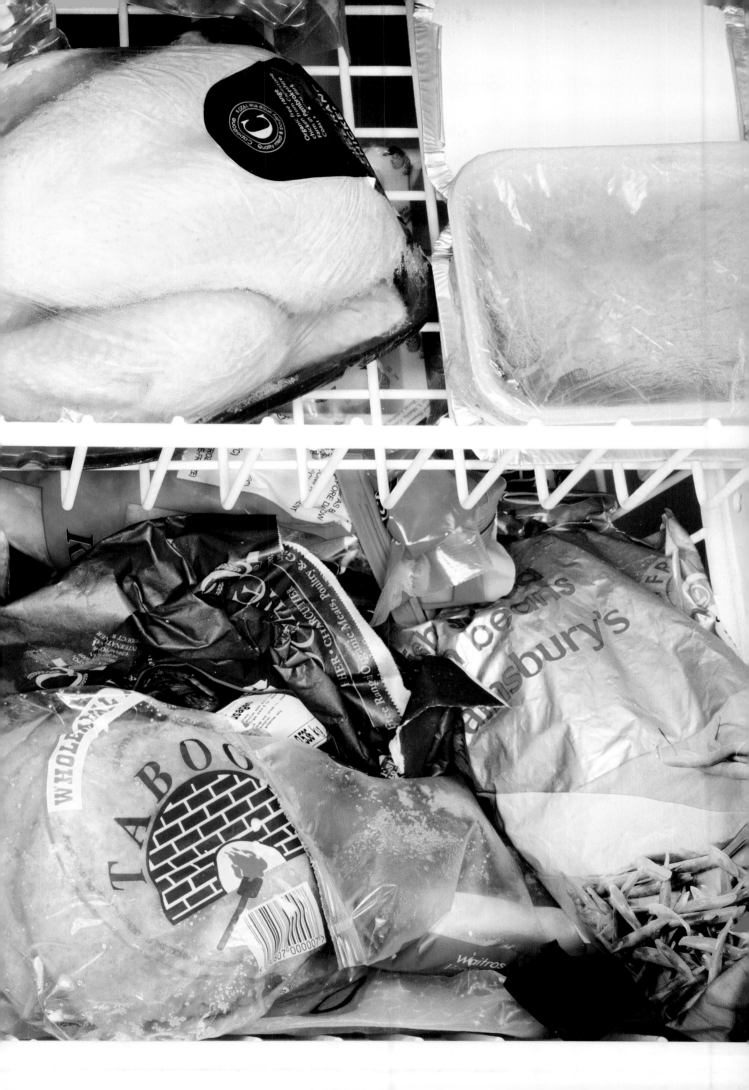

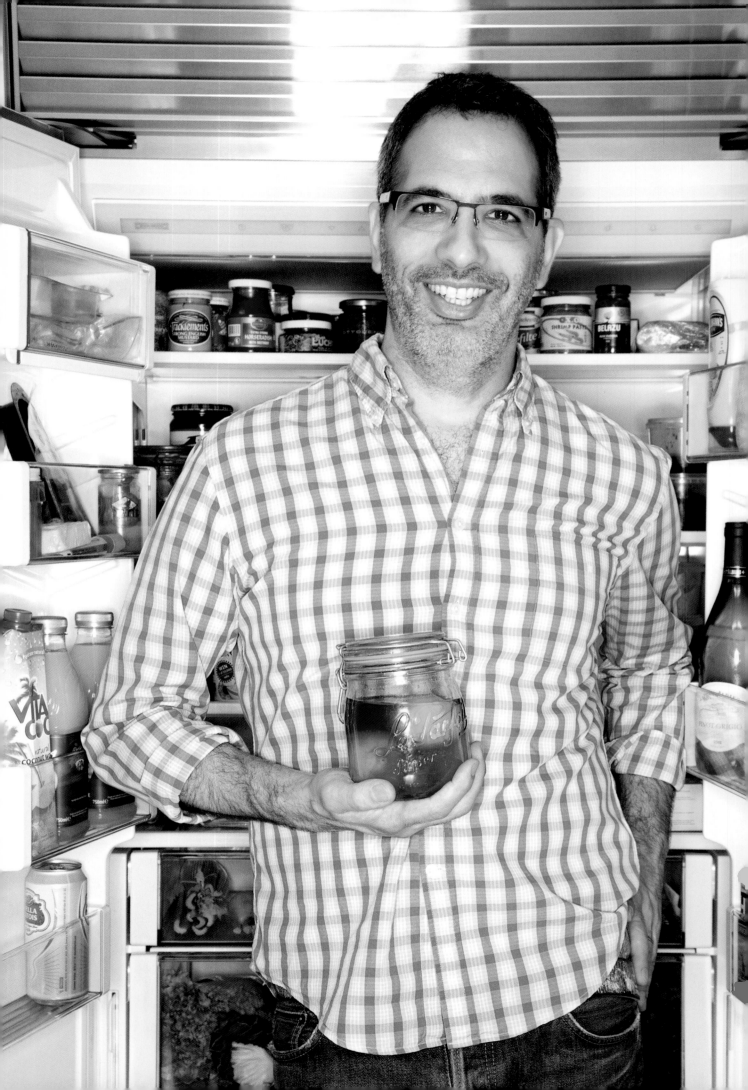

SO
TELL ME
CHEF
WHAT IS
IN YOUR
FRIDGE
?

In their professional workspaces, chefs have everything they need: an organized environment, high tech equipment, and a well-prepared team to ensure the job gets done. At home, it's often quite another story. For even the most demanding chefs, personal life seeps into every corner of the home kitchen, casual preferences take rein and the hermetic environment of the daily workspace give way to a certain casual chaos, to nostalgic noshing, and learning to play nice and share refrigerated space with family members and friends. In the work kitchen, it's real. At home, it's another reality.

We've been to the bistro chef's sparsely decorated bachelor pad, chaotic family spaces, palatial residences of famous chefs, and art-filled weekend retreats. We've met up-and-coming bistro chefs finding their stride and making their way, and venerated masters who have forged culinary history, cutting edge mad scientist types, and self-taught talents who've never seen the inside of a cooking school.

Chef, what's in your fridge?

Is it full of daily necessities, basics for human survival? Is it overstocked, out of fear of not being a good provider for your partner or family? Is it full of leftovers or takeout in unmarked plastic containers or the fruits of your restaurant walk-in. Is your fridge pristine in its clinical cleanliness, full of name dropped niche producers, or haphazardly strewn with supermarket industrial fare?

Chef, what's in your fridge, and more importantly *who are you?*

APPLES

MALT / WHEAT

sprouted/dried gr...

Mushroom

DRIED ZEST.

QUINOA

BEANS

DRY
CUCUMBER

DRY QUINO...

SHELLS

Candied Corn

Kamut

DRY
CORN

BARLEY

A POWDER

DRIED BEETS

DURUM SEED

SESAME

ALMONDS

BLACK SESAME

ALMOND

ALT (BARLEY)

SUNFLOWERSEED

Emmer

PUMPKIN
SEEDS

MALT
BUCKWHEAT

SMOKED
HAZELNUTS

DANIEL
ACHILLES

REINSTOFF

•·····················•

Berlin, Germany

An unassuming, discreet force for gastronomy in a city known more for its currywurst than for fine dining, Daniel Achilles has been whiling away at his craft in a hidden lofty space in the former Edison works yards, in Berlin's trendy Mitte district. The site that was once famous as the birthplace of the creation of Germany's first light bulbs is now illuminating the way forward with cutting edge cuisine and awarded two Michelin stars in a short span of time.

Achilles, who trained with two of Germany's great three-star master chefs, Juan Amador and Christian Bau, creates a resolutely modern cuisine, working with locally sourced products and two different types of menus: "*ganznah*," with a more classical bent, and "*weiterdraußen*," a much more avant-garde dining experience.

Achilles's cooking is, in his words light, local, and seasonal and inspired by the people of Berlin. He says: "A very colorful mixture, and that, combined with my local farmers, producers, and hunters, is what drives me. Also, the most important thing to have as a chef is your personality, a signature, and for people to recognize your own style."

At home, where he always does the cooking, Achilles has his work cut out for him, having to please both his vegetarian wife and a three-year-old son who eats practically only sausages and mini bananas. In the family-sized fridge, easy food sourced from the local organic market shares space with supermarket fare: cream cheese and smoked salmon, German style Dijon mustard, and Krombacher pilsner. There is also a bottle of Kikkoman that has followed them over the years from apartment to apartment, never to be consumed: "It's like an extra member of the family," he says laughing.

Home meals are simple, often starting with bread and cheese, fish of any sort with potatoes or pasta and soups ("turnips, carrots, whatever the seasons bring"), with herbs and spices holding a special importance to elevate the taste of these everyday dishes (especially for his meat-free wife). Achilles's favorite treat is especially nostalgic: his grandmother's potato pancakes with quark cheese.

And although Berliners are, in his opinion, "a bit cheap" where food and restaurants are concerned, he thinks that what the German capital needs to be taken seriously on the world stage is a three-star Michelin restaurant, a benchmark to inspire others to move forward. One he seems all too happy to provide.

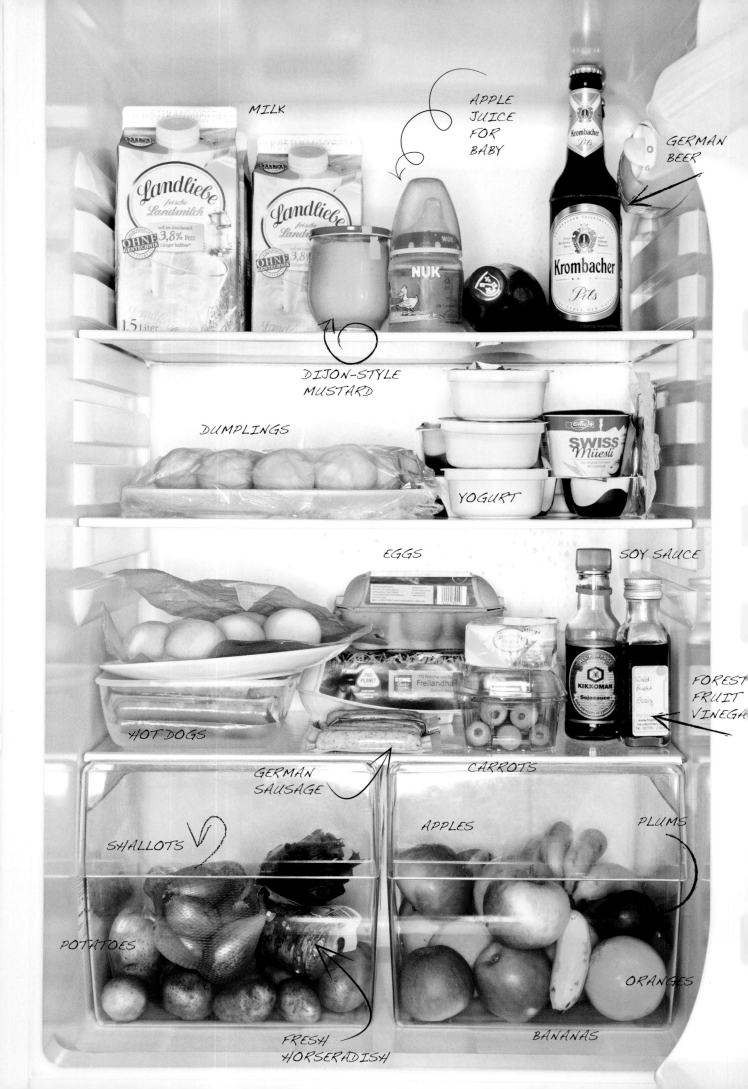

QUARK FRITTERS (*QUARKKEULCHEN*)
WITH SPICED PLUMS AND SOUR-CREAM ICE CREAM

Serves 4

Sour-Cream Ice Cream
500ml (2 cups plus 2 Tbsp.) sour cream
125g (⅔ cup) sugar
100ml (⅓ cup plus 1½ Tbsp.) heavy cream
40ml (2 Tbsp. plus 2 tsp.) Grand Marnier

Spiced Plums
7–15g (1–2 Tbsp.) mixed ground spices, such as cloves, cinnamon, nutmeg, and freshly ground black pepper
20ml (1 Tbsp. plus 1 tsp.) mineral water
200g (1 cup) sugar
½ lemon, preferably organic
1 kg (2.2 lbs.) plums, halved, pitted

Quark Fritters
400g (14 oz.) potatoes, peeled
40g (¼ cup) raisins
40ml (2 Tbsp. plus 2 tsp.) rum
200g (7 oz.) quark, curd or cottage cheese
1 egg
1 egg yolk
60g (¼ cup plus 2½ tsp.) sugar
½ lemon, preferably organic, zested and juiced
Seeds from ½ vanilla bean
50–80g (about ½ cup) flour
Vegetable oil for frying

Sour-Cream Ice Cream:
Combine all ingredients in the bowl of an ice-cream maker, and freeze according to manufacturer's instructions.

Spiced Plums:
In a medium saucepan, combine spices (in a spice bag or tea ball), water, sugar, and lemon, and bring to a boil. Add plums and gently simmer until soft. Chill sauce, discarding lemon and spice bundle.

Quark Fritters and Assembly:
Bring a large pot of water to a boil. Add potatoes and cook until tender. Meanwhile, soak the raisins in the rum. Mash the potatoes, and stir in the soaked raisins, curd, egg, egg yolk, sugar, lemon zest, lemon juice, and vanilla bean. Slowly add the flour until the mixture can be kneaded by hand and is no longer sticky. Fit a large, heavy saucepan with a thermometer. Pour in oil to measure 7 cm (3 inches), and heat over medium-high until thermometer registers 175°C (350°F). Form 12–16 small fritters. Working in batches, fry dough until golden brown. Transfer to a paper towel. Serve with sour-cream ice cream and spiced plums.

ZANUSSI ZBB3244

Quark, a simple, soft white cheese is popular throughout Germany and known in other cultures variously as cottage cheese, fromage frais, paneer and labneh. Made by straining sour, fermented milk, its fat free content has led some to call it an up and coming "super food."

GERMAN DUMPLINGS (*MEERRETTICHKLÖSSE*)
WITH PORK AND HORSERADISH

Serves 4

Pork

1 pork knuckle
2 small onions, quartered
1 small leek, cut into large pieces
2 carrots, cut into large pieces
½ celery stalk, cut into large pieces
3 bay leaves
4 allspice berries
6 peppercorns
1 thyme sprig
1 lovage sprig
35g (3 Tbsp.) sugar

Dumplings

1½ kg (3⅓ lbs.) potatoes, peeled, divided
5ml (1 tsp.) white vinegar
50g (3½ Tbsp.) butter
2 slices bread, crusts removed,
cut into ½-cm (¼-inch) cubes
Salt
Handful flat-leaf parsley leaves, chopped
Freshly grated nutmeg (for serving)
Freshly grated horseradish (for serving)

Pork:

Rinse the pork knuckle thoroughly under cold water. Transfer to a large stockpot, cover with water, and bring to boil. Skim surface foam and add remaining ingredients. Cook at 80–85°C (175°F) for about 70 minutes. Once the meat is tender, remove carefully with a meat fork, and set aside. Strain, reserving vegetables.

Dumplings:

Set aside ⅓ of the potatoes. Grate remaining ⅔, then, working over a bowl and wrapping the grated potatoes in a dish towel, squeeze out as much liquid as possible. Reserve the starchy potato water. Add vinegar to the grated potatoes, and mix well: This will keep them from turning brown. Bring a large pot of water to a boil and add the reserved uncooked ⅓ of the potatoes. Cook until tender. Drain the potatoes, mash, and set aside.

Heat butter in a skillet, and fry bread until golden brown. In a large bowl, season the grated potatoes with salt, and stir in the reserved starchy water. Add the mashed potatoes, and stir until the mixture comes together and becomes homogenous. Form the dumplings by hand: They should be about 4–5cm (1½–2 in.) in diameter. Place a few toast cubes in the middle of each dumpling. Heat a large pot of water until very hot but not boiling. Transfer the dumplings into the hot water. When the dumplings rise to the surface, use a slotted spoon to remove them from the water.

Assembly:

Remove the bone from the cooked pork knuckle, and slice the pork. Divide the pork, cooked vegetables, and dumplings among 4 deep plates or soup bowls. Top with parsley, freshly grated nutmeg, and freshly grated horseradish to taste.

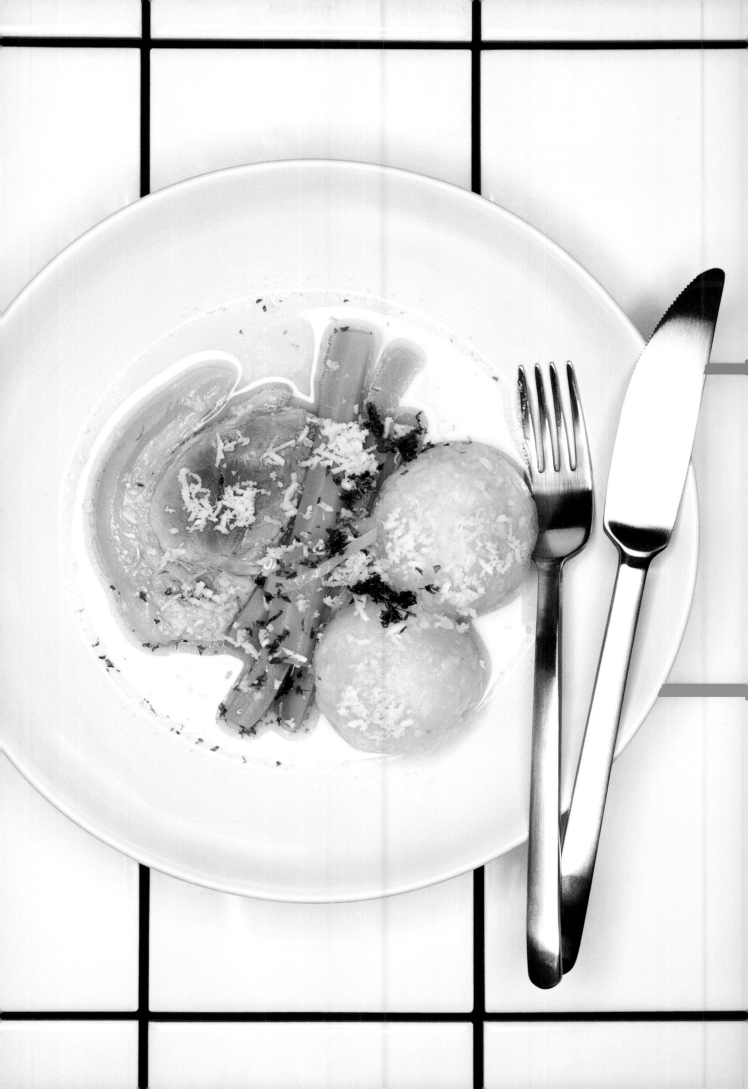

ANDONI LUIS
ADURIZ

MUGARITZ

•⋯⋯⋯⋯⋯⋯⋯⋯⋯•

Errenteria, Spain

One of Spain's most well-known, iconoclastic, and cutting edge chefs, Mugaritz master chef, Andoni Luis Aduriz's culinary education took a turn when he discovered he was unable to follow a recipe to bake a cake during cooking school. "This was the beginning of my frustration," he says. "I couldn't even follow the most simple instructions and made what was probably the worst cake in history."

Andoni had been attracted to cooking from a young age, with memories of watching his mother in the kitchen and listening to radio shows about cooking, although he realizes that nostalgia is a fickle mistress: "Like has been scientifically proven recently, every time you access a memory, it changes a little bit. I used to watch my mother in the kitchen, listen to radio shows about cooking. It's funny that even though I may cook exactly the same dish as my mother made, it's never the same. It could be the weather, the shape and size of the room, but it never tastes the same."

It was his mother, a survivor of starvation in the Spanish Civil War, who pragmatically chose cooking school for him, so that he would never go hungry. And although he was still unmotivated, and flunked the first part of his studies, he discovered the revelation of French cookbooks and glossy culinary magazines and decided to learn the secrets behind the scenes of the world's great restaurants, visiting as many of them as he could and absorbing everything, before taking the plunge and forging his own unique culinary destiny.

His first professional cooking experience was doing part-time stints in a humble pizzeria owned by a famous Spanish chef, who he tried to impress. As his skills and confidence grew, he went from kitchen to kitchen, eventually ending up at El Bulli, a relatively unknown destination at the time, and his biggest single influence. "Ferran knew what he wanted to do, and he was passionate about everything."

Andoni cooks almost every day at home for his wife and son ("he gets nervous and anxious when he's hungry"), shopping either at the local market or in his restaurant's fridges. "Sometimes we get a supplier bringing us exceptional products that we don't need, so I'll take it home and cook it for my family." He tries to feed them as much fish as possible, and the home fridge is often full of seafood such as hake, bonito, squid, and anchovies as well as anything else in season: local peppers and tomatoes, figs and Itxassou cherries.

Andoni's life philosophy is as intense as his kitchen persona: "You've got to be on all the time. If you choose to live your life in a specific way or by certain values, it has to be all the time, not just from 9 to 5. Not knowing exactly where I've been going all this time was a big advantage. If you know what's important to you, your life is already going in the right direction, and you're open to change."

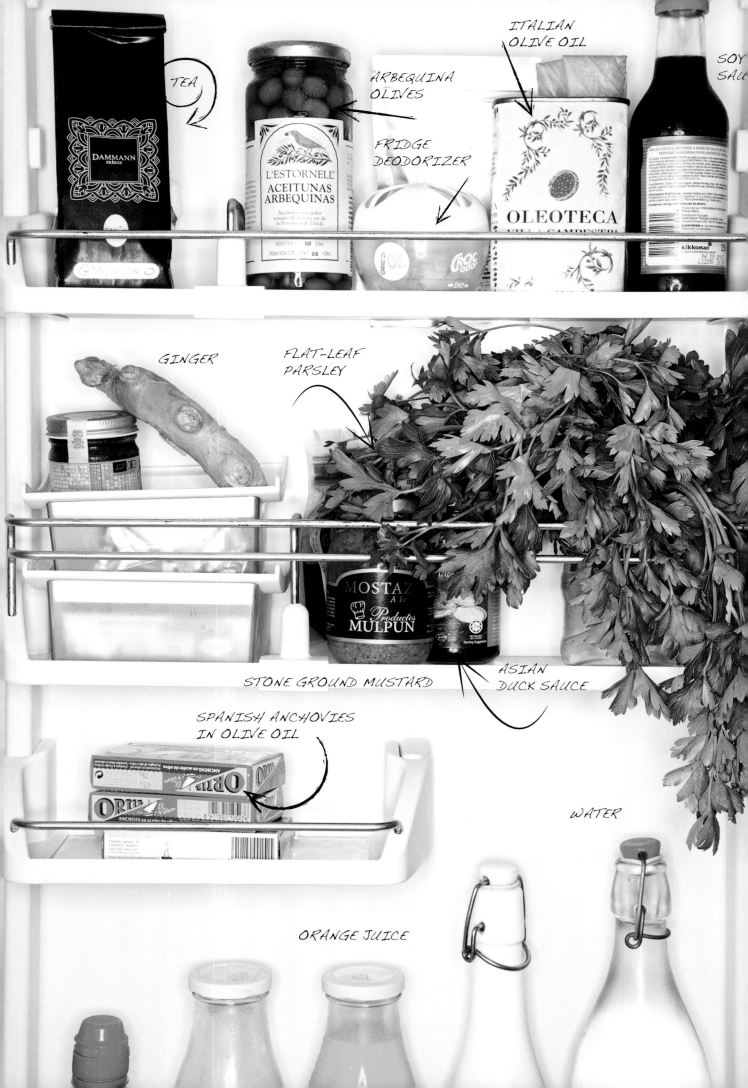

Sake, Japan's most iconic alcoholic beverage has
a history as ancient as their society. The drink,
made from a special rice, is polished to leave only
the starch, steeped in water, steamed, and fermented
multiple times with special molds and yeasts, which
are then extracted, carbon-filtered, pasteurized, and
left to mature. Sake may be served chilled, at ambient
temperature, or warmed, depending on the drinker's
preference or the occasion.

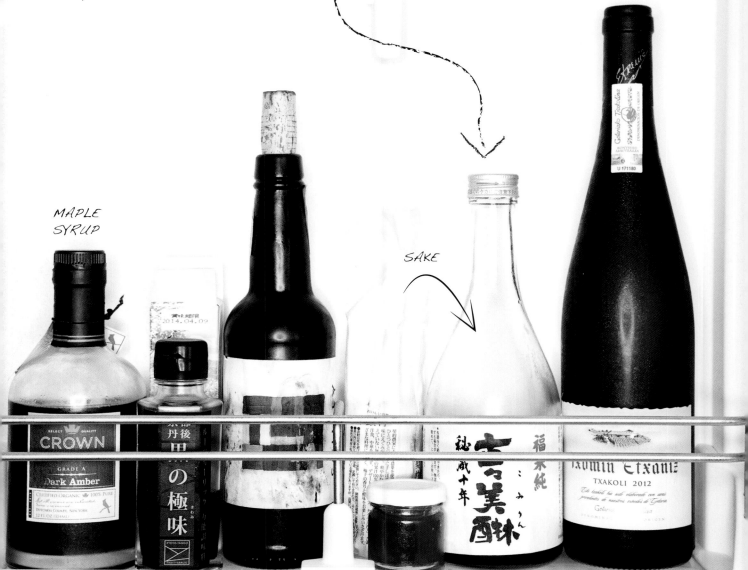

MAPLE
SYRUP

SAKE

BASQUE
WHITE WINE

CONCENTRATED
GARLIC-YUZU
SAUCE

GRILLED STEAK
WITH RADISHES AND HERBS

Serves 4

1.25kg (2¾ lbs) T-bone steak, bone-in
44ml (3 Tbsp.) olive oil, divided
4 radishes, thinly sliced
1 spring onion or scallion,
white parts only, thinly sliced
Handful basil, chopped
Handful flat-leaf parsley, chopped
Handful chives, chopped
7ml (½ Tbsp.) kosher salt or salt

Preheat oven to 130°C (275°F). Separate the bone from the steak. Heat a large, oven-safe skillet over medium-high heat. Add 30ml (2 Tbsp.) olive oil to the skillet, followed by the bone. Cook, turning occasionally, until browned. Remove the bone from the oil, and discard.

Divide the steak into 4 even portions. Sear the steak in the bone-infused oil until both sides are golden brown. Transfer to the oven and roast 10 minutes for rare or longer if preferred.

Meanwhile, toss the radishes and onion with remaining olive oil in a small bowl. In a separate bowl, combine the herbs and salt. Spread chopped herbs and salt on the cooked steaks, and serve with radish condiment.

White tuna is also called bonito. It is a common bluefish from the Cantabrian Sea and is line-caught from July through September.

LIEBHERR CS-2062

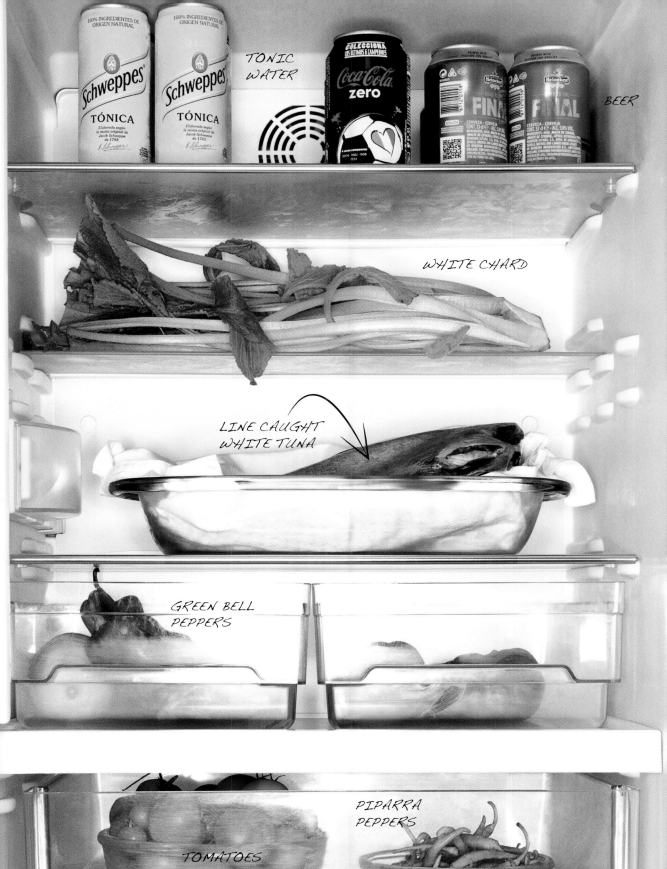
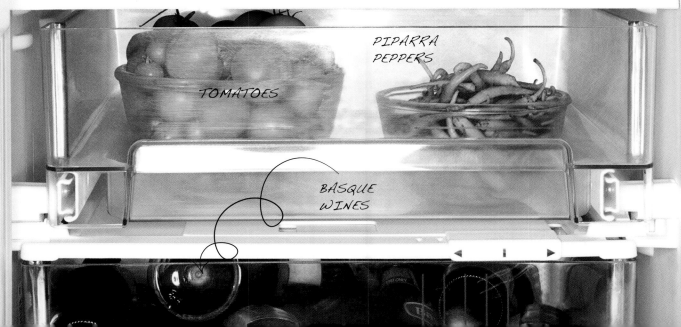

nombre: BONITO COM TOMATE
cantidad: 1 1/2 Ración
fecha elaboración: JULIO 2014
fecha caducidad:

WHITE TUNA
IN TOMATO SAUCE

SQUID INK

BROAD BEANS

BREAD

EDAMAME BEANS

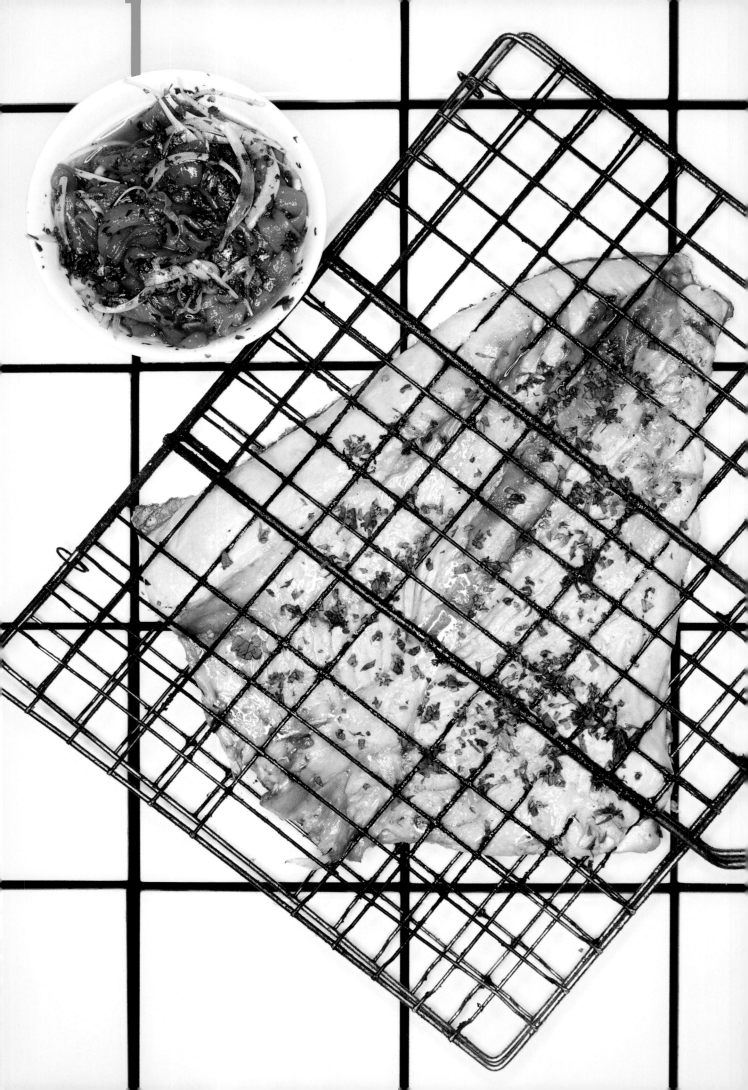

ANDONI LUIS **ADURIZ**

● ●

Errenteria, Spain

GRILLED WHITE TUNA BELLY
(*BONITO*) WITH CRISTAL PEPPERS

Serves 4

220g (8 oz.) jarred cristal peppers

150ml (⅔ cup) olive oil

2 garlic cloves, sliced

1 spring onion or scallion, white parts only, thinly sliced

Handful flat-leaf parsley, chopped

1 whole white tuna belly

5ml (1 tsp.) fine salt, plus more

25ml (1½ Tbsp.) olive oil

Drain the peppers, and use two forks to shred them into thin strips. Heat olive oil over low in a skillet. Add garlic, and cook until it begins to brown, then add shredded peppers, and continue cooking over low heat, about 5 minutes. Strain, reserving oil for another use. Combine spring onion, parsley, peppers, and a pinch of salt in a small bowl. Set aside pepper condiment while you prepare the fish.

Clean the belly by removing the connective tissue; leave the skin intact. Sprinkle 5ml (1 tsp.) fine salt on the non-skin side of the fish, then rub both sides with olive oil.

Build a medium-hot fire in a charcoal grill. Clean and oil the grill grate. Grill fish, skin-side down, until it reaches desired temperature. Serve with pepper condiment alongside.

CRISTAL PEPPERS

Cristal peppers are a very sweet variety of red peppers, which are grilled then preserved without their skins in jars with olive oil.

INAKI
AIZPITARTE

LE CHATEAUBRIAND

• •

Paris, France

Before food became the new rock n' roll for the Instagramming masses, Inaki was doing what no one else was in a forgotten corner of not-yet-gentrified eastern Paris. The Bordeaux-raised, Basque-blooded chef, who had traveled the world, from the Middle East to South America, was shaking up preconceived notions of what fine dining was. From a timeworn old bistro in the 11th arrondissement, Inaki Aizpitarte was rocking the polite foundations of the restaurant world.

Inaki's eclectic learning curve made him what he is today, a hugely influential chef and darling of the ever-pervasive food media.Before cooking professionally, Inaki went from being a stonecutter, landscape gardener, and a short stint at oenological school to a globetrotting odd jobber. It was when he landed a job as a dishwasher at a Tel Aviv restaurant to make some extra cash that his destiny changed forever. Little by little he helped out in the kitchen and eagerly learned the rudimentary basics of classic cooking. He knew what he wanted to do and returned to France, eventually to open Le Chateaubriand.

A consummate risk taker, Inaki has a talent for mixing up disparate products from France and further afield. His cooking style driven by his sensibility and personality (and sometimes by how much he partied the night before), and he is universally known as being one of the most inspired and ballsy chefs on the contemporary food circuit, the *enfant terrible* of French cuisine.

His fridge takes the bachelor pad icebox to another level. There are literally science experiments in there (and he cleans his fridge only when things start to rot); an international selection of condiments (he loves his piri piri hot sauce), frozen bread for guests (he never eats it), and lots of food gifts from international chef friends (any one of which might stumble out of the guest room at any moment). He almost never goes shopping, unless it's at the nearby Place des Fêtes farmer's market, and most of his pack rat fridge is filled with edible offerings from fawning kitchen trainees and visiting cooks.

"I've been cooking since I was young, so it has always been very immediate for me and I always wanted to go to cooking school, but it just didn't turn out that way."

Legend has it that piri piri came from Portuguese explorers who discovered the African birds eye chili pepper in the 16th century in Mozambique. Others say that Christopher Columbus brought them back from the Americas, where it made its way somehow to the African colonies. Whatever the exact origin, the small red pepper, which grows wild in a handful of African countries, was instrumental in creating perhaps the world's first hot sauce. The settlers made the fiery sauce by crushing it and combining it with citrus peel, onion, garlic, pepper, salt, lemon juice, bay leaves, paprika, pimiento, basil, oregano, and tarragon, although the recipe has myriad different versions. Piri Piri means "pepper, pepper" in Swahili.

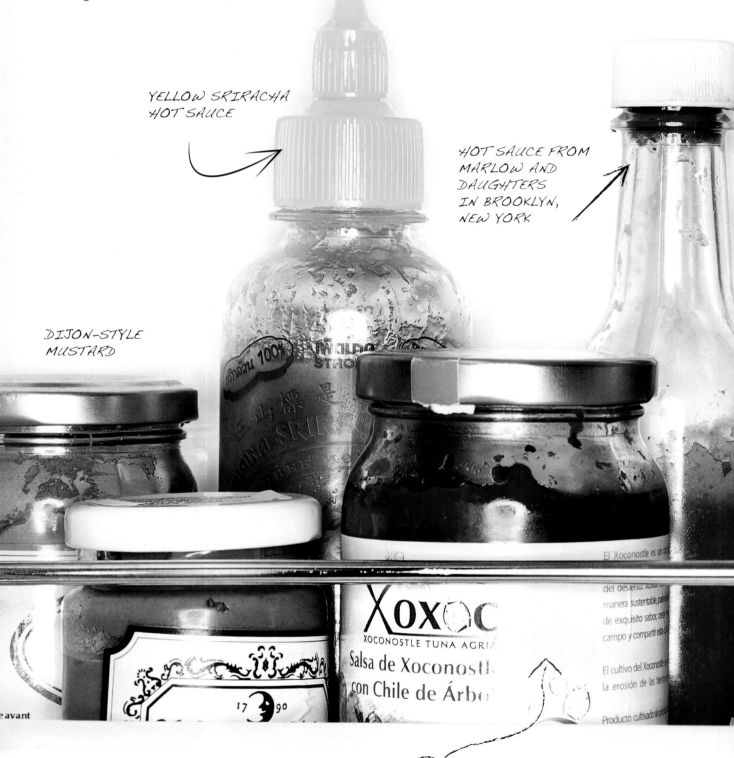

YELLOW SRIRACHA
HOT SAUCE

HOT SAUCE FROM
MARLOW AND
DAUGHTERS
IN BROOKLYN,
NEW YORK

DIJON-STYLE
MUSTARD

"XOCONOSTLE"
TOMATILLO
HOT SAUCE

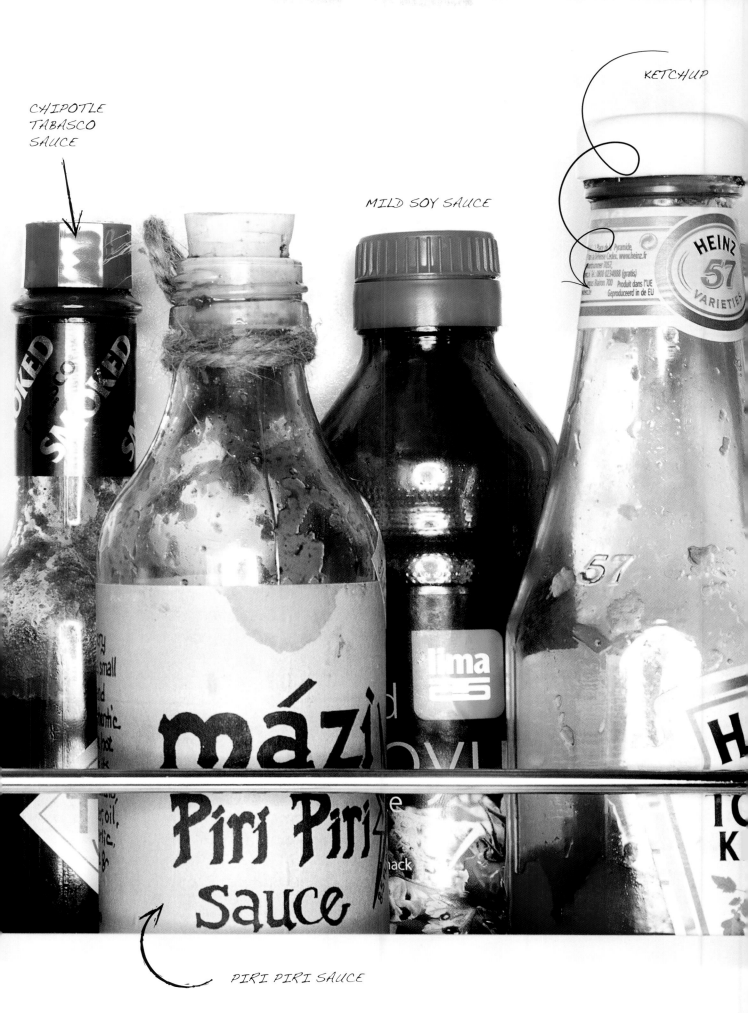

CHIPOTLE
TABASCO
SAUCE

MILD SOY SAUCE

KETCHUP

PIRI PIRI SAUCE

Always the conscientious host, Aizpitarte keeps bread on hand in his freezer, ready for a quick defrost when late night dinner guests come by.

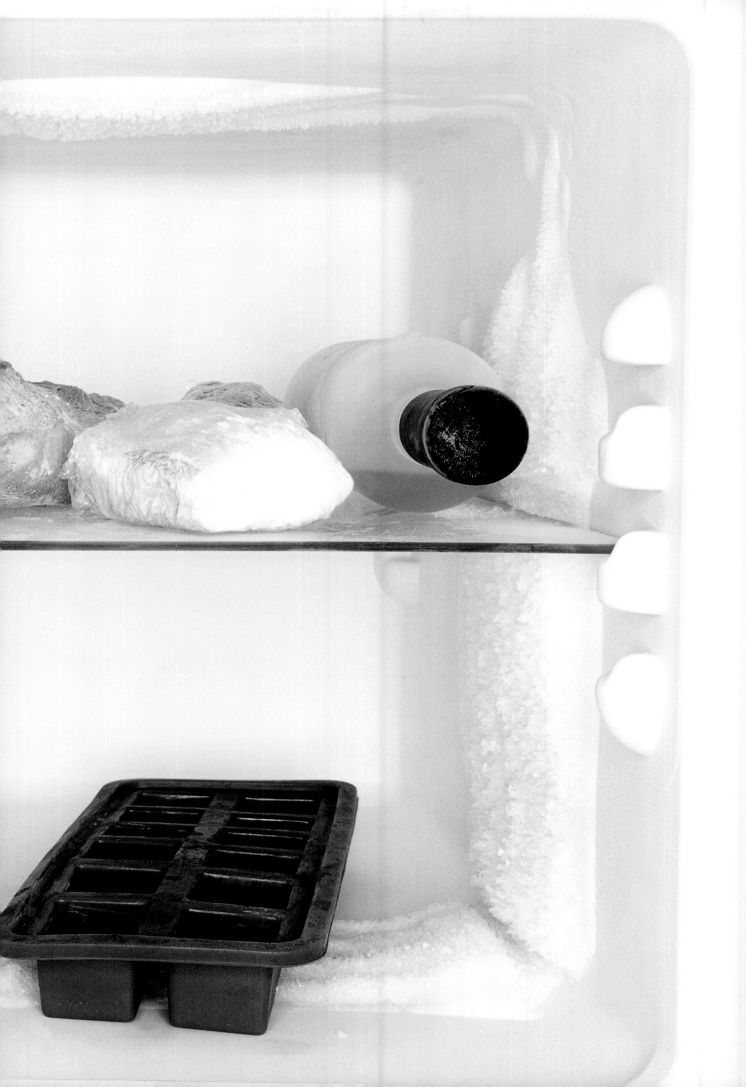

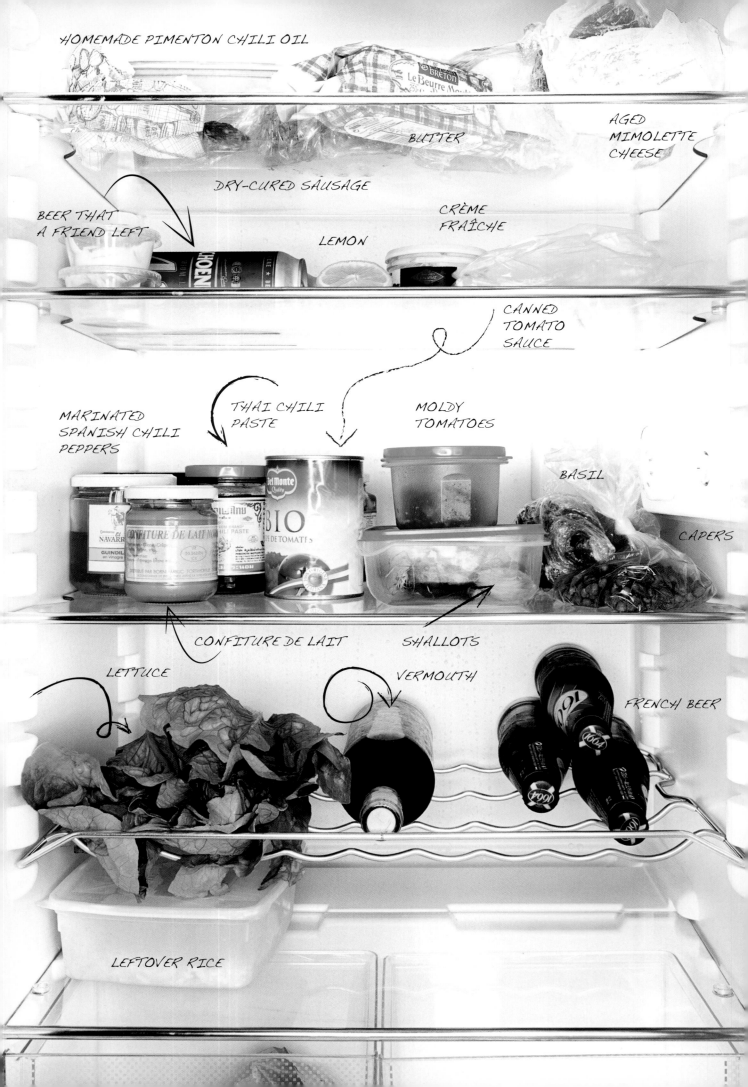

GUINDILLA PEPPERS

A Basque country staple, these Spanish red and green chili peppers are often preserved in white vinegar and served as tapas. When pickled, their flavor is usually sweet, and they are also very popular fried and consumed piping hot at bars across the region. Best washed down quickly with local cerveza and wines.

Aizpitarte always stocks a couple sauces or simple ingredients to pair with pasta when cooking for his son.

LIEBHERR
CTNES4753-2

FRIED EGGS
WITH CORN CHIPS

Serves 4

1 small shallot, minced
16g (2 Tbsp.) capers
20 basil leaves, chopped
½ lime, juiced
45g (1.5 oz.) corn chips, preferably Takis brand
15ml (1 Tbsp.) peanut oil
4 eggs

In a small bowl, combine shallot, capers, basil leaves, lime juice, and corn chips. Set the bowl aside. Heat peanut oil in a large skillet, and gently fry the eggs over low heat. Once the whites have set, carefully place the eggs onto 4 small plates. Spoon the corn-chip mixture on top of the whites of each egg.

LEFTOVER
CHICKEN SOUP

Serves 4

1L (4¼ cups) homemade chicken broth
1 small fresh red chili pepper, halved
320g (11 oz.) leftover chicken, thinly sliced
1 sweet onion, minced
4 limes, 3½ juiced and ½ sliced
100g (3.5 oz.) corn nuts
Handful fresh herbs, such as coriander (cilantro) or flat-leaf parsley

Warm the chicken broth in a saucepan over medium heat. Add chili pepper. Taste the broth as it heats to determine how spicy it is, then remove the chili pepper. Combine chicken and onion in a large bowl, and squeeze the juice of 3½ limes over. Mix well. Divide the chicken among 4 bowls. Sprinkle corn nuts over chicken, and top with broth. Serve soup with remaining lime and fresh herbs.

JOSÉ
AVILLEZ

BELCANTO

•·····················•

Lisbon, Portugal

Portugal's most enterprising and media savvy chef was born and raised in the charming coastal town of Cascais and always loved cooking as a child. Although his father was a restaurant owner (he created the first pizzeria in Portugal), his mother didn't want him in the family business and insisted that he go to university where he studied communication and management. His passion for food however soon bubbled to the surface and his degree thesis on Portuguese gastronomy made him think again about the direction he wanted his life to take. "Within two weeks, I became obsessed with the idea of cooking. It was like my heart started to beat for the first time."

What followed was a series of experiences in the restaurants of some of the world's most influential chefs (he passed through the kitchens of Antoine Westermann, Alain Ducasse, and Eric Fréchon), ending with a final and all deciding spell at El Bulli, the world's best restaurant at the time. "Ferran Adrià completely changed my life," he says. "He's not just a genius at cooking, but at everything. He's a great thinker and a philosopher."

Avillez sees himself as a harbinger of traditional Portuguese cooking with a contemporary twist, and laughs at the fact that his culinary heritage is much maligned. "People think we just eat *bacalhau* (a popular salted cod dish) all the time," he laughs, "but we are spoilt for choice with hundreds of diverse, regional dishes." Many of these dishes were born of necessity, he says, citing preserved foods like tuna escabeche, or desserts made as an after product of wine production: "The monks clarified wine with egg whites then used the yolks to make desserts, and even to stiffen their habits!" Portuguese travelers also crisscrossed the globe from their African colonies in Mozambique and Cape Verde, to Macau, Goa, and Brazil, mixing with locals and absorbing and assimilating their culture.

Being a successful chef doesn't leave a lot of time for home meals, but his pristine Bosch abounds in seasonal produce; ocean perch and sheep's milk cheese, cherries from his neighbor, and lamb tripe sausage, and the real family cooking is reserved for holidays in the Algarve. He also still misses what was once a solo passion. "Sometimes I'll just go to my restaurant at 8 a.m. and cook by myself with no one around," he says wistfully. "That's my rarest pleasure and freedom."

BOSCH CLASSIXX LOW FROST

JOSÉ **AVILLEZ**

INSIDE CHEFS' **FRIDGES**

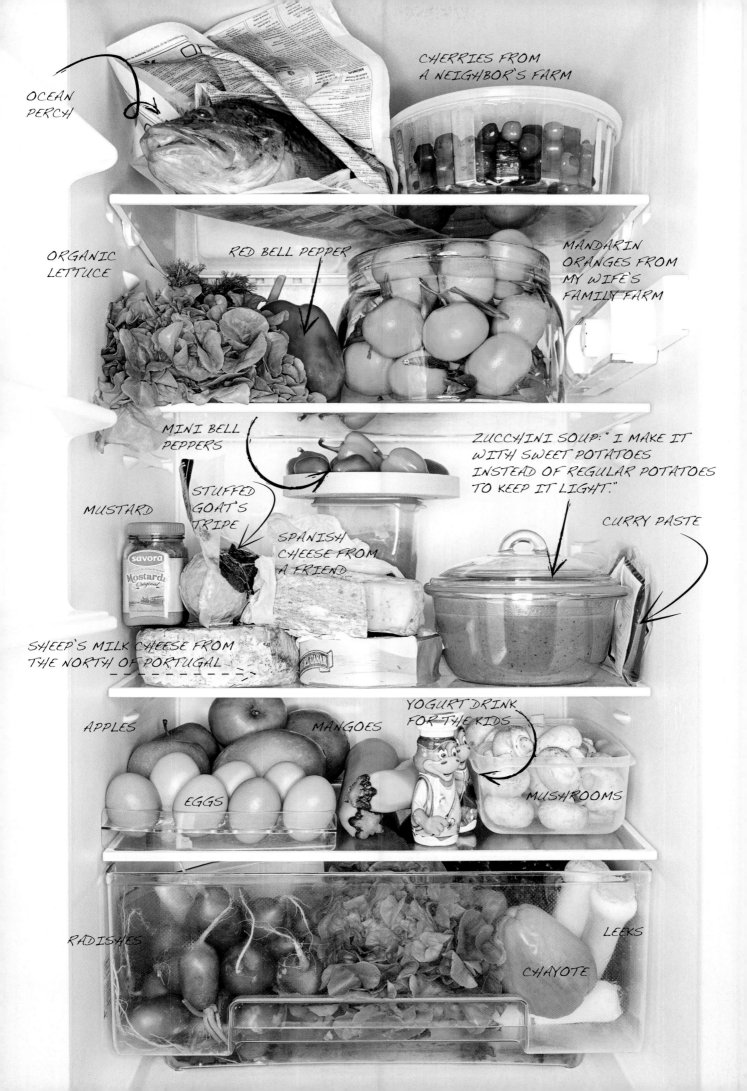

OCEAN PERCH

CHERRIES FROM A NEIGHBOR'S FARM

ORGANIC LETTUCE

RED BELL PEPPER

MANDARIN ORANGES FROM MY WIFE'S FAMILY FARM

MINI BELL PEPPERS

ZUCCHINI SOUP: " I MAKE IT WITH SWEET POTATOES INSTEAD OF REGULAR POTATOES TO KEEP IT LIGHT."

MUSTARD

STUFFED GOAT'S TRIPE

SPANISH CHEESE FROM A FRIEND

CURRY PASTE

savora
Mostarda
Original

SHEEP'S MILK CHEESE FROM THE NORTH OF PORTUGAL

YOGURT DRINK FOR THE KIDS

APPLES

MANGOES

EGGS

MUSHROOMS

RADISHES

CHAYOTE

LEEKS

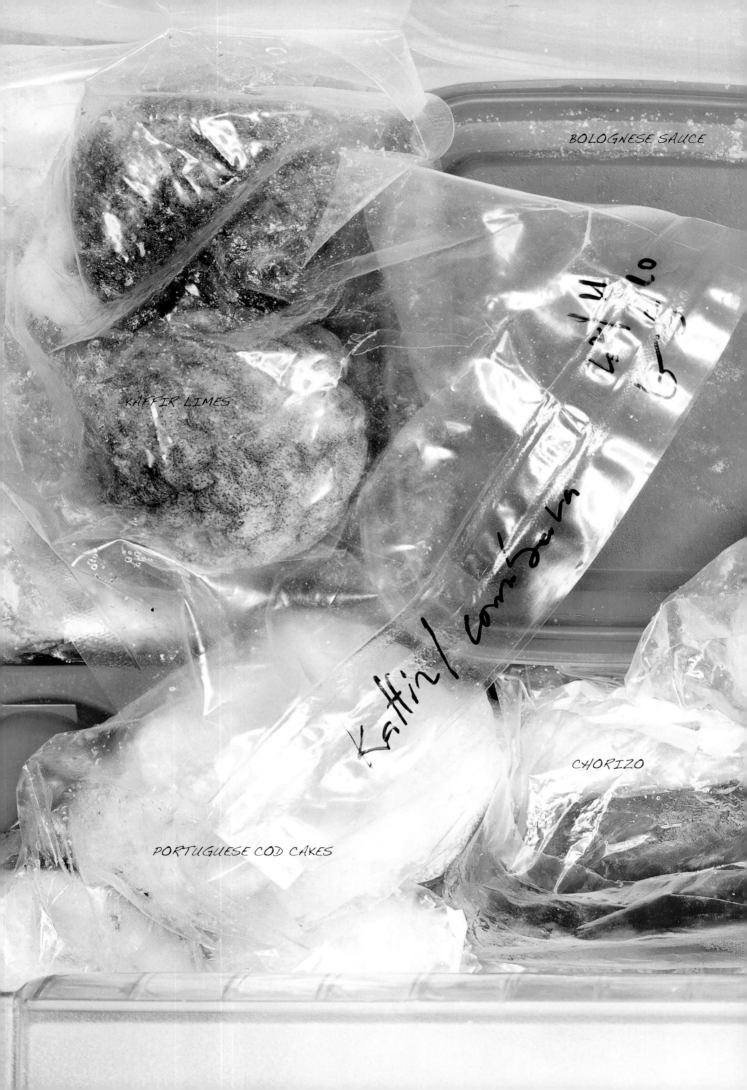

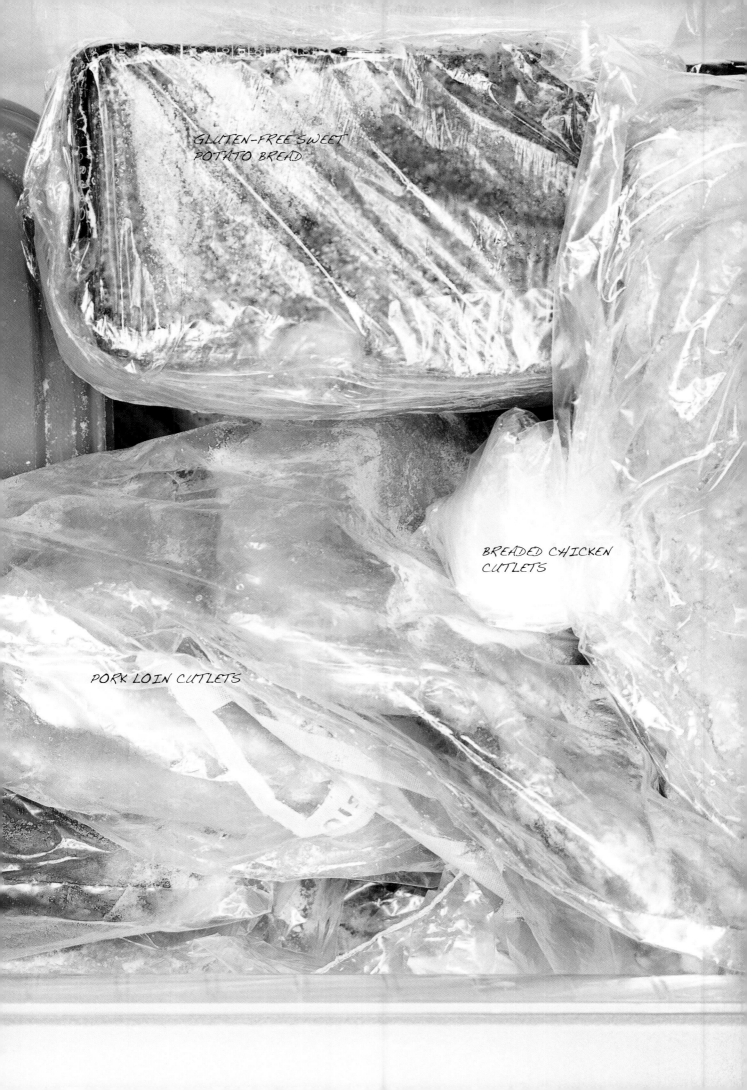

GLUTEN-FREE SWEET
POTATO BREAD

BREADED CHICKEN
CUTLETS

PORK LOIN CUTLETS

DUCK ESCABECHE
WITH APPLE PURÉE

Serves 4

Duck

3L (13 cups) water, plus more if needed

100g (6 Tbsp.) sea salt

75g (6 Tbsp.) sugar

1 onion, sliced into rings

2 oranges, sliced into rings

1 lemon, sliced into rings

½ head garlic, peeled, cloves crushed

100ml (6 Tbsp. plus 2 tsp.) white wine

3 sprigs rosemary

4 sprigs thyme

2 bay leaves

7 whole black peppercorns

1 duck, cleaned (offal, lungs, parson's nose and neck separated)

Apple Purée

5 Reineta apples, cored but left whole and unpeeled

50g (3½ Tbsp.) butter

25g (2 Tbsp.) muscovado sugar

5 cinnamon sticks

Vegetable Escabeche

Olive oil

400g (14 oz.) onions, finely chopped

150g (5 oz.) carrots, finely chopped

2 garlic cloves

1 bay leaf

4 whole cloves

30ml (2 Tbsp.) white wine vinegar

30ml (2 Tbsp.) red wine vinegar

Salt

Freshly ground black pepper

Duck:

Combine water, salt, and sugar in a large pot. Add onion, orange, lemon, garlic, white wine, rosemary, thyme, bay leaves, and peppercorns. Submerge duck in brine, and marinate in the refrigerator for 6 hours. Remove duck from brine, and place on a wire rack.

Preheat oven to 140ºC (300ºF). Remove 2 orange slices, 1 lemon slice, the sliced onions, and the garlic from the brine, and transfer them to a baking sheet. Add the duck neck and 1cm (⅓ in.) of water to the baking sheet. Set the wire rack with the duck on top of the baking sheet. Transfer to the oven, and roast the duck for about 2 hours. Let cool, then remove and discard the bone, and shred the meat.

Apple Purée:

Preheat oven to 140ºC (300ºF). Place apples on a baking sheet. In the center of each apple, place 1 cinnamon stick, 10g (⅔ Tbsp.) butter, and 5g (1½ tsp.) sugar. Bake until the apples are tender. (The time will vary depending on how ripe they are.) Once apples are cool enough to handle, discard the peel, and purée the flesh in a blender until creamy.

Vegetable Escabeche and Assembly:

Heat a generous drizzle of olive oil in a skillet. Add onion, carrot, garlic, bay leaf, cloves, and, if necessary, a little more olive oil. When the onion begins to turn transparent, add the vinegars, and cook gently until the vegetables are tender. Season to taste with salt and pepper, and remove from heat.

Once cooled, stir in the shredded duck. Serve the escabeche with the apple purée and, if you like, matchstick potatoes.

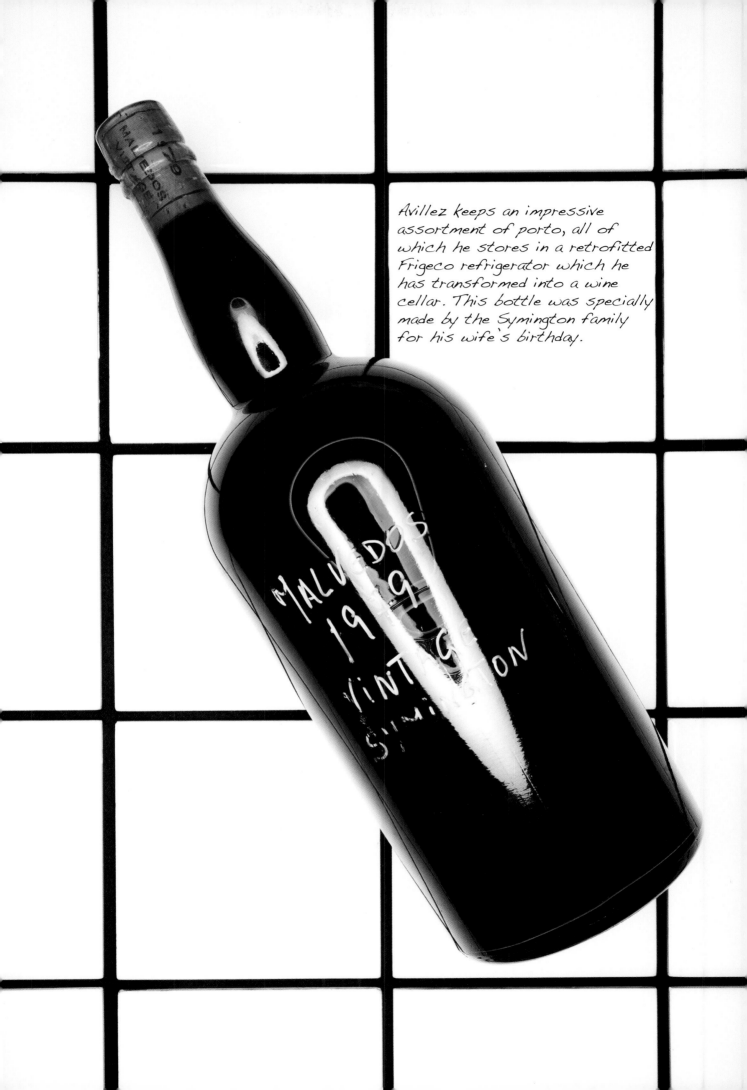

Avillez keeps an impressive assortment of porto, all of which he stores in a retrofitted Frigeco refrigerator which he has transformed into a wine cellar. This bottle was specially made by the Symington family for his wife's birthday.

SHRIMP
WITH GARLIC, LEMON, AND CORIANDER (CILANTRO) (*À BULHÃO PATO*)

Serves 4

800g (1⅔ lbs.) medium shrimp, peeled, deveined
6g (1 tsp.) salt
30ml (2 Tbsp.) olive oil
50g (2 oz.) garlic, peeled, thinly sliced
80ml (⅓ cup) white wine
4 mint leaves, thinly sliced
1 bunch coriander (cilantro) sprigs
with tender stems, chopped
Lemon juice

Season shrimp lightly with salt. Heat olive oil over low heat in a nonstick skillet. Add garlic and sauté for 30 seconds, being careful so that it doesn't brown. Add shrimp and gently sauté, flipping them often so that they cook evenly. Stir in white wine, mint, coriander (cilantro), and remove from the heat. Squeeze fresh lemon juice over shrimp, to taste. Check the seasoning, and add a little more salt if necessary.

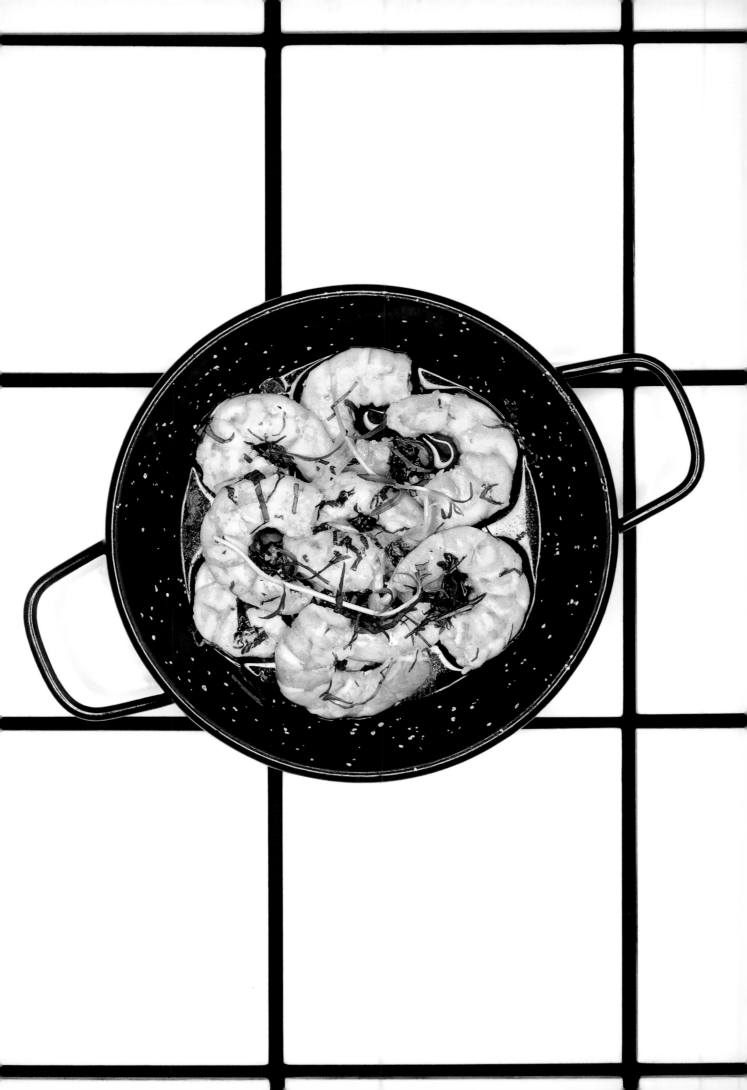

BO
BECH

GEIST

• •

Copenhagen, Denmark

GAGGENAU VARIO RB 280

One of Denmark's most well-known chefs, as much for his Michelin-starred past as for being host of the Danish version of "Kitchen Nightmares," Bo Bech is a diehard culinary romantic. "I love fine dining," he says. "Once you've stepped out onto the Place des Vosges with a beautiful lady on your arm, perching on her high heels, and you enter L'Ambroisie and the old waiter says, 'Welcome back, sir,' it's like you're wrapped in a veil of happiness."

Hanging from the kitchen ceiling, there are always garlic and bags of chilies ("I use them whenever I want, they never go bad"), and in the fridge products range from very Scandinavian pickled elderberry flower bulbs and hay milk cheese, to quintessentially Japanese fermented *ume* plums to unknown condiments left by ex girlfriends. And even though cooking at home may be similar to the restaurant, excellent produce is, in his words, "ten times more important than technique."

The dish he eats the most is plain spaghetti in classic sauces, but if friends are over he'll serve roast chicken or veal shank accompanied by what he calls a "mezcal kiss," small shot glasses of the Mexican spirit that just wet the lips and release an agave aroma.

"Today's chefs have forgotten the important things, that the cooking craft is all about love and devotion, not kitchen politics, that ideas are the reason behind what you do. Is there anything more attractive than someone who believes?"

He likens fine dining to making love. "The first time can be terrible. If you go to a top restaurant as an amateur, the staff can be arrogant, but once you get used to it, boom, they're all around you, and next thing you know you're talking to everyone around you and it's fantastic, but you have to play the part, and leave all of your shit at the door. It doesn't belong here."

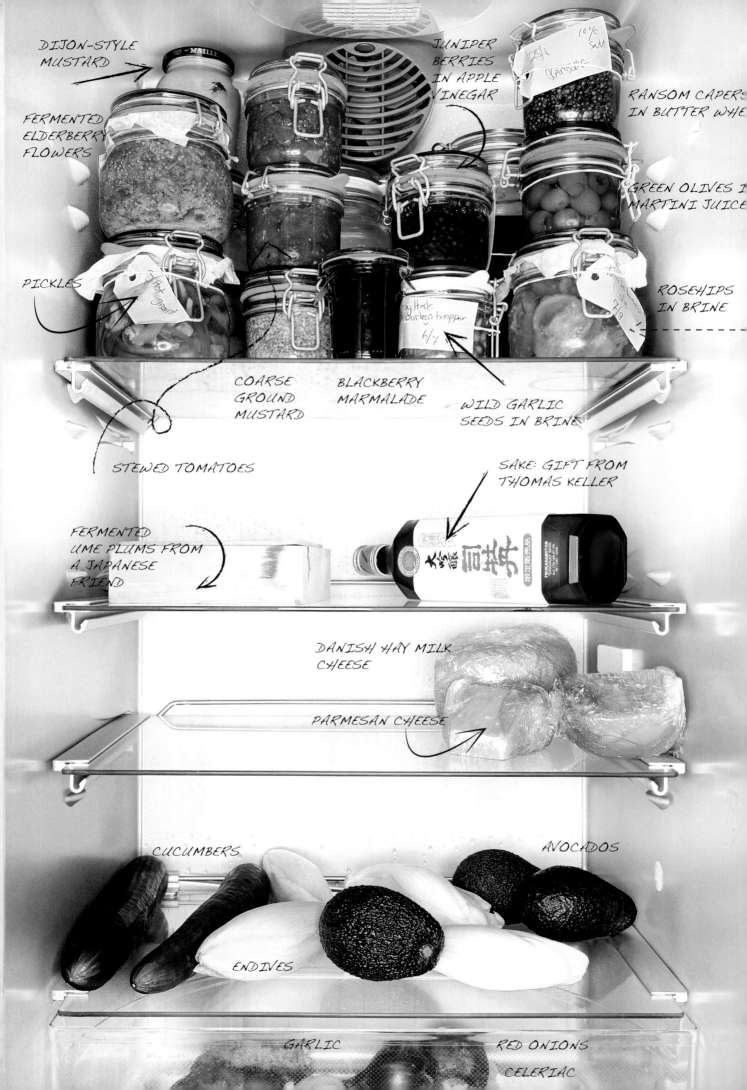

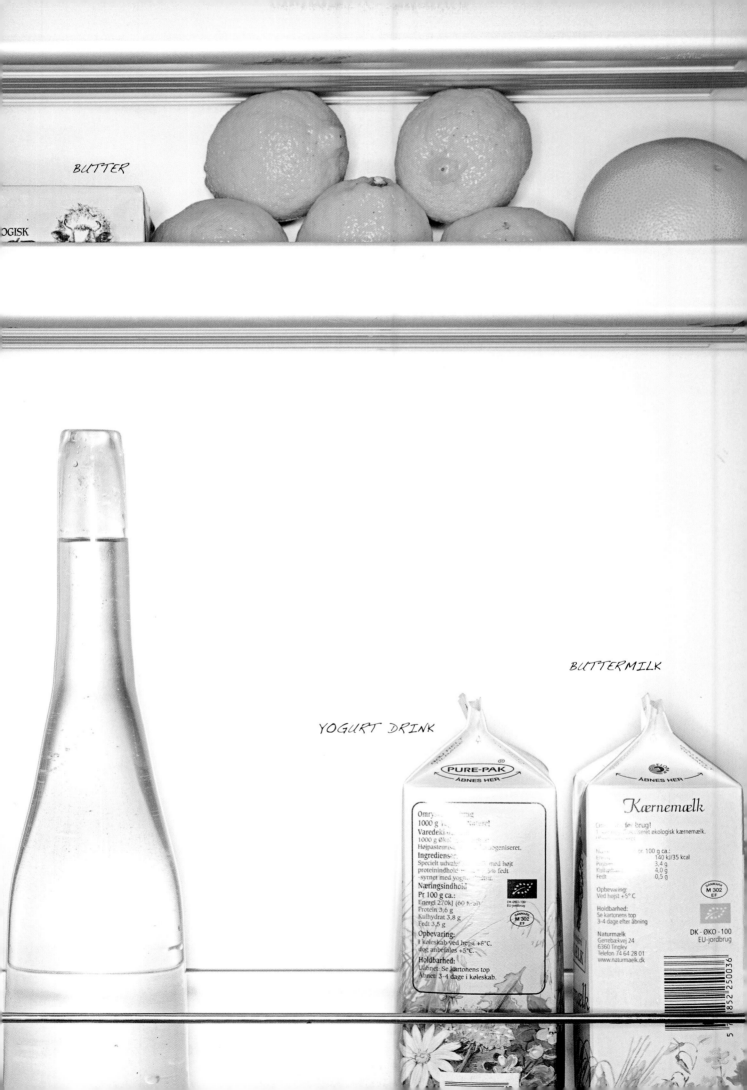

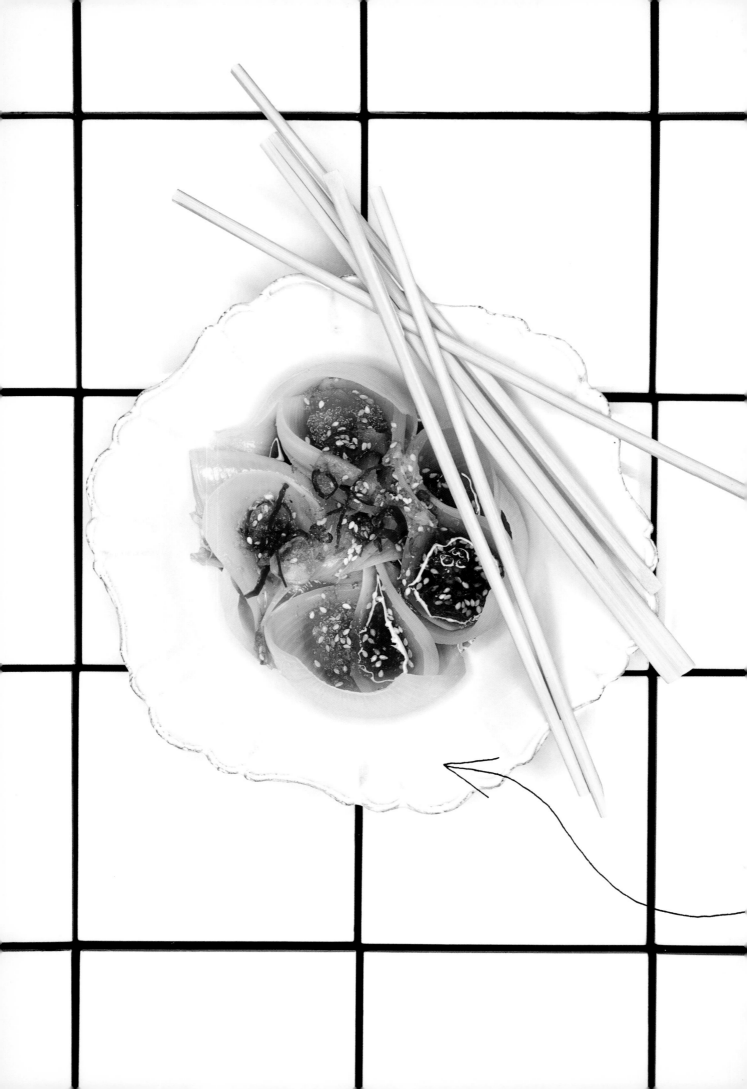

GRILLED AVOCADOS
WITH CURRY AND ALMOND OIL

Serves 4

1 lemon, halved
4 avocados, halved, pitted
6g (1 Tbsp.) curry powder
45ml (3 Tbsp.) toasted almond oil

Prepare a grill for medium-high heat.
Lightly oil grate. Grill lemon halves until charred.
Wipe oil from grate. Grill avocados, cut-side down,
just until burnt. Dust the burnt avocado
with curry powder, and fill the center halfway
with toasted almond oil. Serve with grilled lemons
for squeezing over avocados..

WHITE ONIONS
WITH ASIAN SAUCE

Serves 4

4 white onions
30ml (2 Tbsp.) tamari soy sauce
30ml (2 Tbsp.) honey
30ml (2 Tbsp.) rice vinegar
30ml (2 Tbsp.) lime juice
30ml (2 Tbsp.) sesame oil
1 small fresh red chili, thinly sliced
9g (1 Tbsp.) sesame seeds

Preheat oven to 180°C (350°F). Roast onions until
they are soft to the touch, about 1 hour. Let cool.

Meanwhile, prepare the sauce. Combine tamari,
honey, rice vinegar, lime juice, and sesame oil.
Set aside.

Peel and halve the onions, then carefully remove
each onion layer so that it forms a small vessel.
Divide the onions among 4 plates. Pour the sauce
over the onions so that it accumulates in the center
of each onion piece. Top with the sliced red chili
and sesame seeds.

ONIONS

Even though Bech is inflexible with
quality both in his restaurant and at home, and
his standards often lead him to buy high-end
niche products, he always has the basic staples,
the building blocks of any meal. White onions
are omnipresent, and are part of the base
of many of his home recipes.

AKRAME
BENALLAL

RESTAURANT AKRAME

• ································ •

Paris, France

The gastronomic dark horse of the Parisian dining scene, Akrame worked quietly in the shadows of the great before launching his own mini empire in the City of Light, including his eponymous two-star Michelin restaurant, a couple of steak-houses, a wine and cheese bar, and another establishment in Hong Kong, all at lightning speed.

Benallal, who grew up in Algeria and moved to France in his early teens, cut his teeth in his twenties in the kitchens of the *crème de la crème* of world gastronomy, with such masters as El Bulli's Ferran Adrià, Guy Savoy, and Pierre Gagnaire, before opening and closing a failed restaurant project or two. His enthusiasm and naïveté got the better of him yet taught him the importance of business acumen and keeping a cool head.

At thirty-three he opened his own place and hasn't looked back since, chang-ing the fine dining landscape with his humble demeanor and deep knowledge of seasonal produce, transformed through his technical mastery and served with love. As he says: "I started with nothing and did it all myself through hard work."

To say his home refrigerator is well stocked is an understatement. As with many a family chef, there is an obvious overcompensating in the chock-a-block fridge. Organic supermarket soups vie for space with yogurts and crème caramel desserts, *brik* (a kind of flaky North African tortilla wrap), ginseng concentrate, and pickled herring from IKEA rubs shoulders with heirloom vegetables from Joel Thiébault and homemade jams from chefs Christophe Michalak and Michael Troisgros. And for his kids, fresh strawberries, chocolate milk, and applesauce pouches for after school snacks.

The chef's awareness of his roots as well as his culinary identity is key to discover-ing his character. Their freezer is loaded with chickpeas, lamb, North African-style bread, massive quantities of parsley and cilantro—all the makings for traditional Algerian soups and couscous to be prepared by Benallal's wife on the weekends.

Benallal tries to keep Wednesday evenings free for the family, and his home cook-ing, the polar opposite of what he calls his "haute couture" wizardry at the restaurant, is based around simple shared dishes, not the perfect plating and inspired flavor associations of his professional life, although his culinary imagination does tend to cross-pollinate despite his best efforts: "Our favorite family dish is an easy Algerian specialty, *vermicelles au lait*, a kind of milk soup with angel hair pasta that can be served sweet or savory. We do it in the restaurant too," he says with a mischievous twinkle in his eye, "except that one is with hand cut pasta, extra helpings of aged Parmesan, and white Alba truffles."

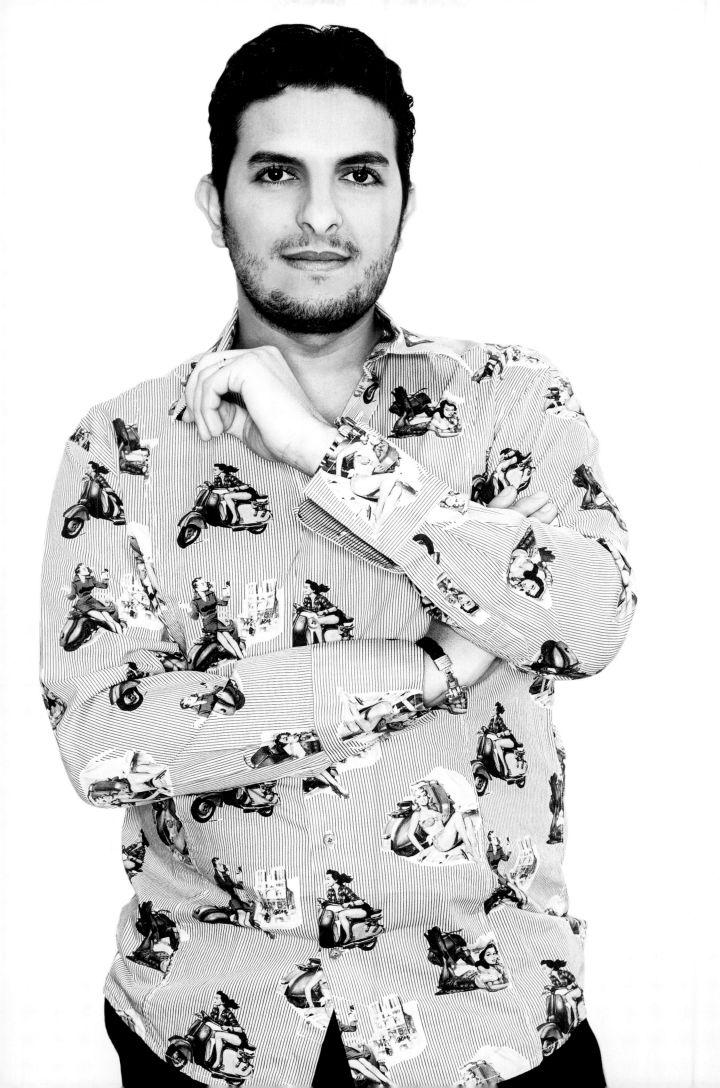

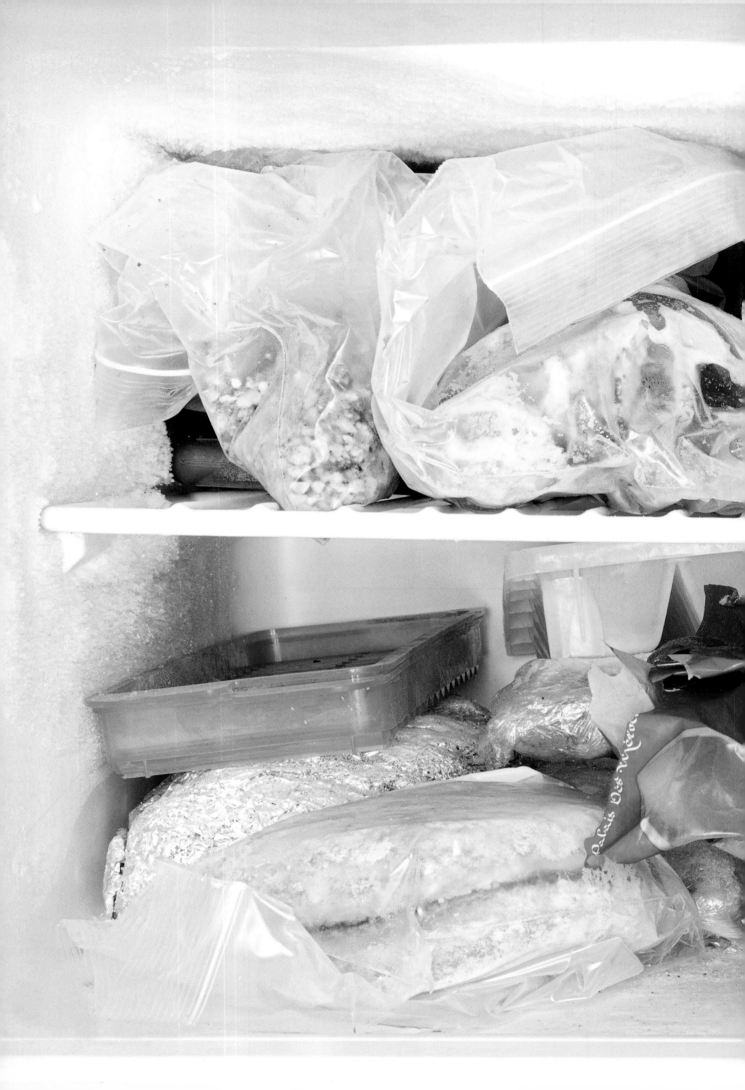

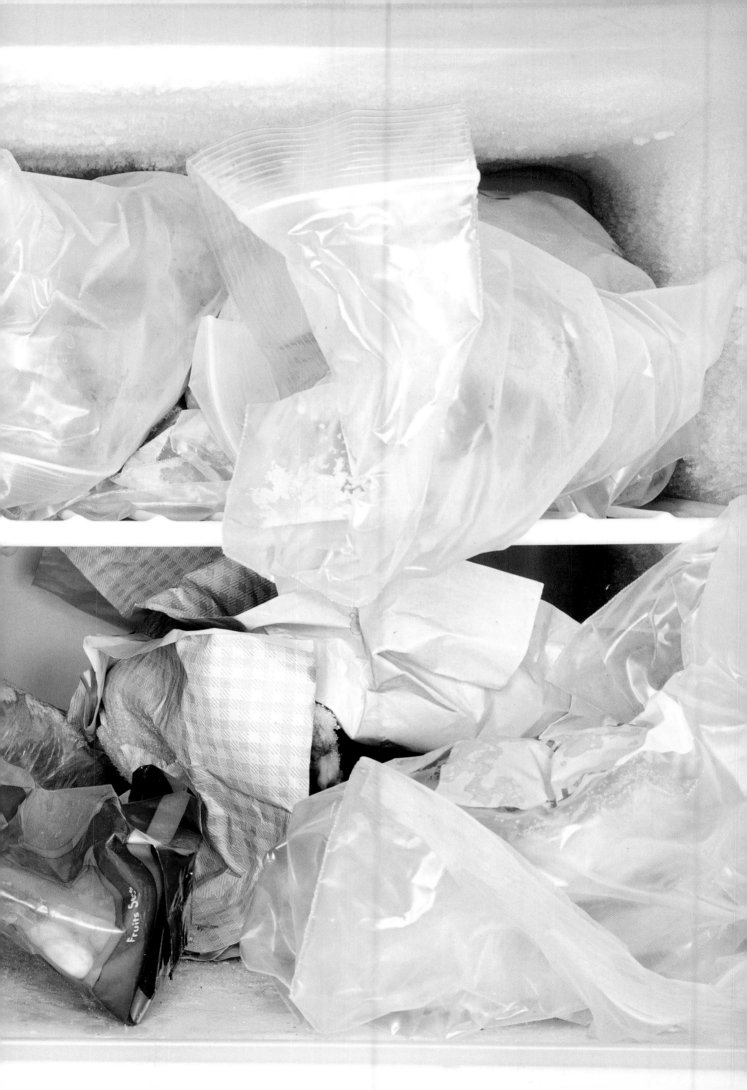

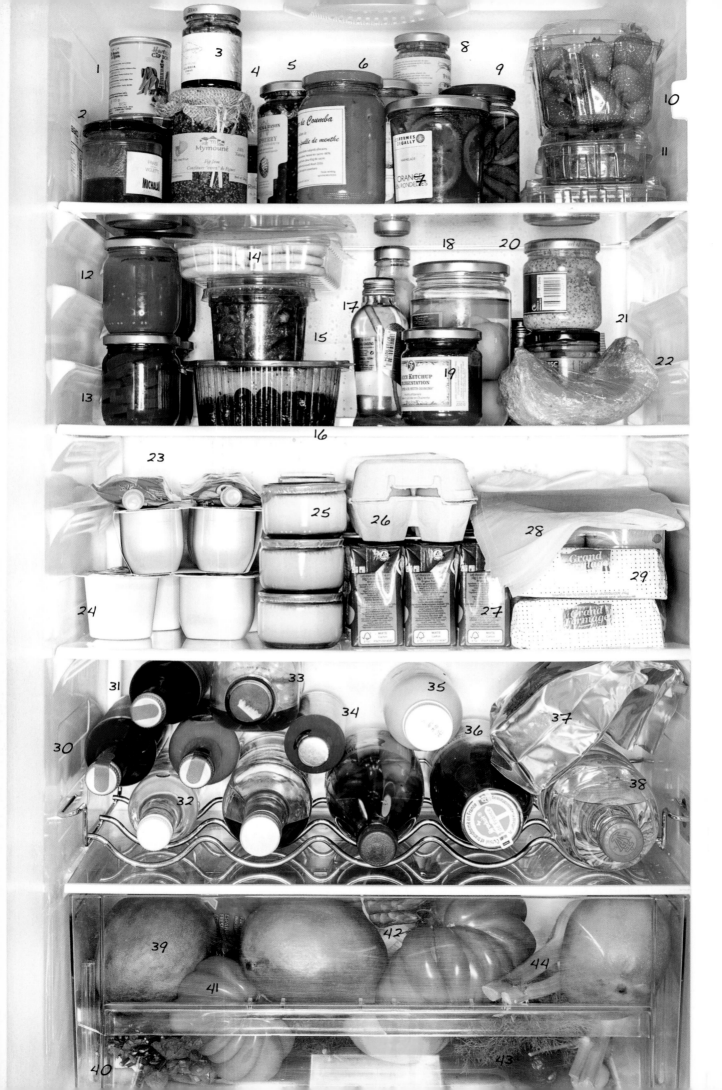

Paris, France

BEKO CF7914AP CF7914AP

Brik (pronounced " breek ")

This popular North African pastry, similar to
a samosa, is made of a half flour, half fine
semolina, water, and salt mix. The batter is
cooked crepe-like on a hot surface,
then allowed to rest for a few hours.
The resulting pastry is then reheated and
may be filled with a variety of different
ingredients (egg, tuna, minced meat, etc.),
then is commonly deep fried and served on
absorbent paper. The pastry can be kept
in the fridge for several days and frozen.

1	Harissa	14	Blinis
2	Strawberry violet jam from Christophe Michalak	15	Sun-dried tomatoes
3	Cherry jam	16	Olives
4	Fig jam	17	Ginseng concentrate
5	Raspberry jam	18	Preserved lemons
6	Mango and mint jam	19	Stone-ground mustard
7	Preserved orange slices	20	Artisanal ketchup from Françoise Fleuriet
8	Pesto	21	Aged Mimolette cheese
9	Cornichons	22	Pickled herring
10	Strawberries	23	Kid's applesauce
11	Raspberries	24	Yogurt
12	Tomato jam from Michel Troisgros	25	Caramel dessert
13	Grapefruit marmalade from Michel Troisgros	26	Eggs
		27	Chocolate milk
		28	Brik

29	Butter
30	Pomegranate juice
31	Beet juice
32	Green tomato juice
33	Apple juice
34	Sparkling water
35	Fermented milk
36	Organic soup
37	Coffee from Brazil
38	Water
39	Mango
40	Mint
41	Tomatoes
42	Asparagus
43	Avocado
44	Fennel

2 MILLIMETER OMELET
WITH OLIVES

Serves 4

20 Taggiasca green olives,
preferably organic
4 eggs
100g (7 Tbsp.) salted butter
½ red onion, minced
Salt
Freshly ground black pepper
¼ lemon, preferably organic
50g (1¾ oz.) aged Mimolette

Pit olives, and set aside. Crack eggs into
a large bowl, then whisk energetically.
Melt butter in a 30cm (12-inch) nonstick skillet
over medium heat. Add red onion and green
olives to the pan, and cook for 5 minutes. Transfer
sautéed onions and olives to bowl with beaten
eggs. Whisk again, and season with salt
and pepper. Return the egg mixture to the pan
(no need to clean the skillet), and cook for
2 minutes over high heat. Flip the omelet, and cook
2 minutes. Transfer the omelet to a plate.
Zest the lemon rind and Mimolette over the omelet,
and serve immediately.

TOMATO LYCHEE SOUP

Serves 4

125g (4 oz.) baguette
1 garlic clove, peeled
1 egg yolk
5ml (1 tsp.) stone-ground mustard
200ml (¾ cup plus 1½ Tbsp.) sunflower oil
5ml (1 tsp.) freshly ground black pepper
8 tomatoes, quartered, divided
150g (5¼ oz.) lychees
200ml (¾ cup plus 1½ Tbsp.) milk
200ml (¾ cup plus 1½ Tbsp.) water
10 chives, minced

Preheat oven to 200ºC (400ºF). Rub the baguette
with the garlic clove. Slice into crouton-size pieces,
and place on a baking sheet. Bake until golden
and crispy.

Meanwhile, prepare the mayonnaise. Whisk egg yolk
with mustard, then slowly incorporate the sunflower
oil, beginning a drop at a time and whisking
vigorously, until the mayonnaise is emulsified.
Refrigerate the mayonnaise until ready to use.

Using a food processor or immersion blender, purée
half the tomatoes until smooth. Transfer to a small
saucepan, and cook over medium-low heat until
reduced by half. Chill in refrigerator until cool.

While the tomato purée cools, use the food
processor or immersion blender to purée remaining
tomatoes, lychees, milk, and water. Transfer
tomato-lychee mixture to a saucepan, bring to a
simmer, and let cook 20 minutes. Chill in refrigerator
until cool.

Stir mayonnaise into chilled tomato purée, and
divide among 4 bowls. Top with a few croutons
and a sprinkling of chives, then pour tomato-lychee
mixture over.

MASSIMO
BOTTURA

OSTERIA FRANCESCANA

•⋯⋯⋯⋯⋯⋯•

Modena, Italy

Arguably the greatest Italian chef of modern times, and one of the most revered in the world, Bottura's first memories of the kitchen are of escaping a playful beating from his older brothers, into the arms of his grandmother, who was always cooking pasta for the family. "I'd hide under the table he says, and she'd pull out her rolling pin when my brothers came near. All the while I was in the corner stealing bits of food and eating tortellini!"

Bottura, a law school dropout and amateur DJ, bought a nightclub, which was wildly successful, then closed when the neighbors complained of noise pollution. To the disdain of his family, he fled their abode and proceeded to discover the world through foreign kitchens. After a first stop in New York, where he ran the kitchen of a Calabresian hairdresser who fancied himself a chef, he passed through the kitchens of various culinary luminaries turned mentors. "I worked at Alain Ducasse's Louis XIV when it was the best kitchen in the world; he taught me that technique and product meant everything." Afterward, he worked with Ferran Adrià at El Bulli, which was a crucible for some of the most intense culinary geniuses in the world (René Redzepi was a co-worker at the time).

"Fine cooking is like jazz music," proclaims Bottura. "You need to learn to play every instrument, and then forget it all. I needed to find out how to make not only the perfect classic Italian dish, but also the perfect Chinese dumpling. To transfer emotion you need to go deep into interest. Through passion you transfer emotion." His conviction that current traditional dishes come from innovation and that culinary evolution must continue are shown in his ever inventive and technologically inspired cooking. "I am always looking to the future, but with an eye on the past, never forgetting the past, but looking at it in a critical way."

Bottura's fridge, separated in a shrine-like room off of the insanely well equipped kitchen, is stocked with comforting foods, (many pre-prepared and sealed into Ziploc bags): lamb chops from his sous chef Davide's farm in central Italy, meat filled olives that you deep fry. "*I looove* those," he says.

Massimo is also a self-professed art freak. "For me, the three most important things in life are food, art, and music. Food is culture. I buy art because there's something about it other than the work, something behind it that drives you crazy. Like art, like a beautiful song, food can take you to another plane."

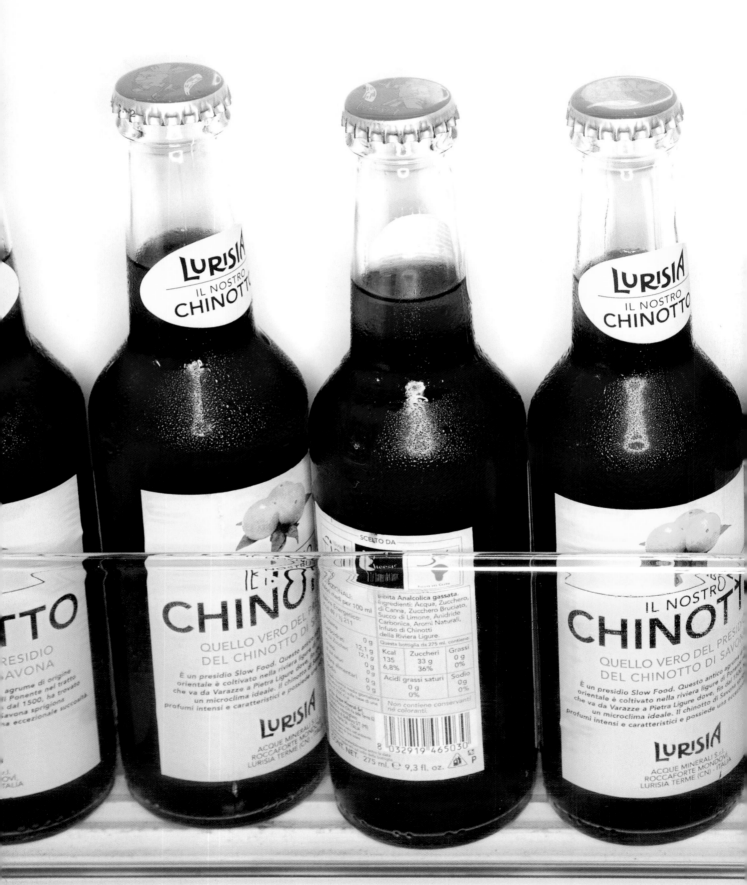

Chinotto

An Italian soda made from a fruit of the chinotto (myrtle-leaved orange) tree, this carbonated drink has a slightly bitter, caramel orange taste, as well as being less sugary than other popular soda beverages. The chinotto fruit flavors many Italian aperitifs, most notably Campari.

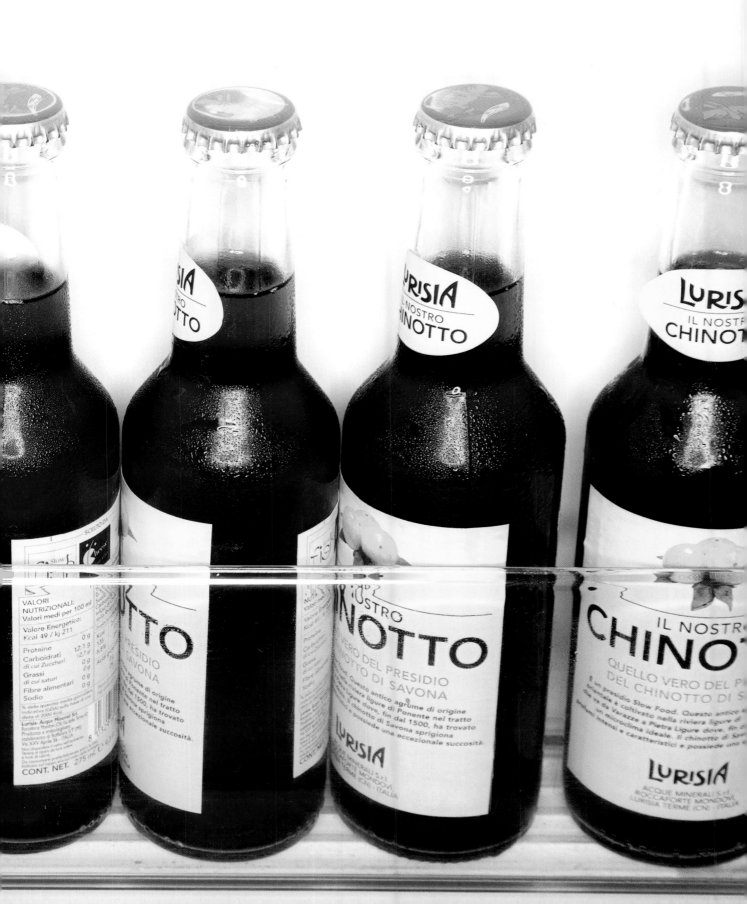

SPIEDINI 06/14

BRACOLE 4/1

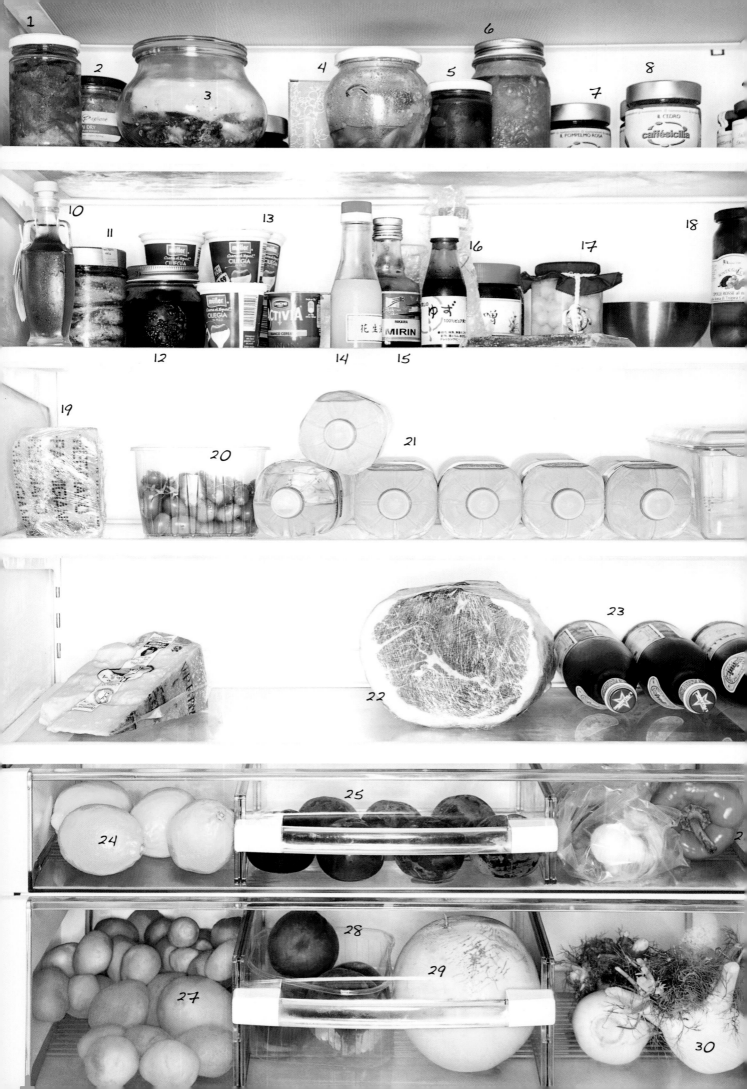

1 Marinated sun-dried tomatoes

2 Marinated yellow bell peppers

3 Marinated anchovies

4 Homemade apple mostarda

5 Apple-coffee mostarda

6 Homemade Sicilian
 orange marmalade

7 Pink grapefruit jam

8 Lemon jam

9 Cooked grape must

10 Traditional anchovy extract

11 Salted anchovies

12 Homemade sour cherry jam

13 Cherry yogurt

14 Taiwanese sesame oil

15 Mirin

16 Yuzu juice

17 Pickled pearl onions

18 Pickled Calabria onions

19 Parmesan cheese

20 Cherry tomatoes

21 Water

22 Prosciutto Crudo di Parma
 aged 30 months

23 Sparkling water

24 Lemons

25 Plums

26 Red bell pepper

27 Potatoes

28 Nectarines

29 Melon

30 Fennel

SUB ZERO ICBBI-36UFD

HOMEMADE BONE MARROW PASTA

(*PASSATELLI*)

Serves 4

120g (¾ cup) finely powdered breadcrumbs
120g (4 oz.) Parmigiano Reggiano
1g (¼ tsp.) lemon zest
2g (½ tsp.) freshly grated nutmeg
20g (.7 oz.) bone marrow
3 eggs
1L (1 quart) capon broth

In a large bowl, combine breadcrumbs,
Parmigiano Reggiano, lemon zest, and nutmeg.
On a cutting board, crumble the bone marrow,
and mash it with a spatula until it becomes creamy.
In a medium bowl, whisk the eggs just enough to
break the yolks. Stir in the breadcrumb mixture,
then add the creamy bone marrow. Knead with
your hands to make the mixture homogeneous.
Let rest 15 minutes. (Do not let the dough rest for
more than 3 hours, or it will get old. The older it gets,
the more it will crumble in the broth.)

Bring the capon broth to a boil in a large saucepan.
Pass the dough through a *passatelli* iron or
a potato masher with wide holes (about 5cm or
¼-inch wide). Slice the pasta into strips around 4cm
(1.5 inches) long, and cook in the broth about
1 minute. Serve really hot.

PARMIGIANO REGGIANO RISOTTO

Serves 4

1.5kg (3.3 lbs.) Parmigiano Reggiano,
preferably aged 30 months, grated
4L (1 gallon) still mineral water,
room temperature
15ml (1 Tbsp.) olive oil
500g (1.1 lbs.) Arborio rice, preferably
Vialone Nano

24 hours in advance, prepare the Parmigiano
Reggiano water. In a large pan, combine
Parmigiano Reggiano and mineral water. Slowly
heat the water until the Parmigiano Reggiano starts
to form threads at the bottom. A thermometer
should read 80–90°C (176–194°F). Remove pan from
heat, and let cool to room temperature. Cover with
plastic wrap and refrigerate overnight.

The next day, transfer the solid part that has formed
on top to a bowl. This will be used to cream the
risotto. Strain remaining solid part to collect the
Parmigiano Reggiano water. Cut the solid part into
thin slices, and cook in the microwave for a couple
of seconds. This is tasty with crackers!

Make the risotto. In a large saucepan set over low
heat, simmer Parmigiano Reggiano water. Pour
olive oil into a heavy-bottomed pan over medium-
low heat. Add rice, and toast until it starts to
warm up. Transfer a small amount of Parmigiano
Reggiano water to the rice pan. Stir, and continue
cooking, adding liquid as you would with any
risotto. About three-quarters of the way through
cooking, add a little bit of the solids that separated
from the Parmigiano Reggiano water. Cook until
rice is tender, about 30–35 minutes total. Remove
pan from heat, and briskly mix in the reserved
cheese to give the risotto a creamy texture.

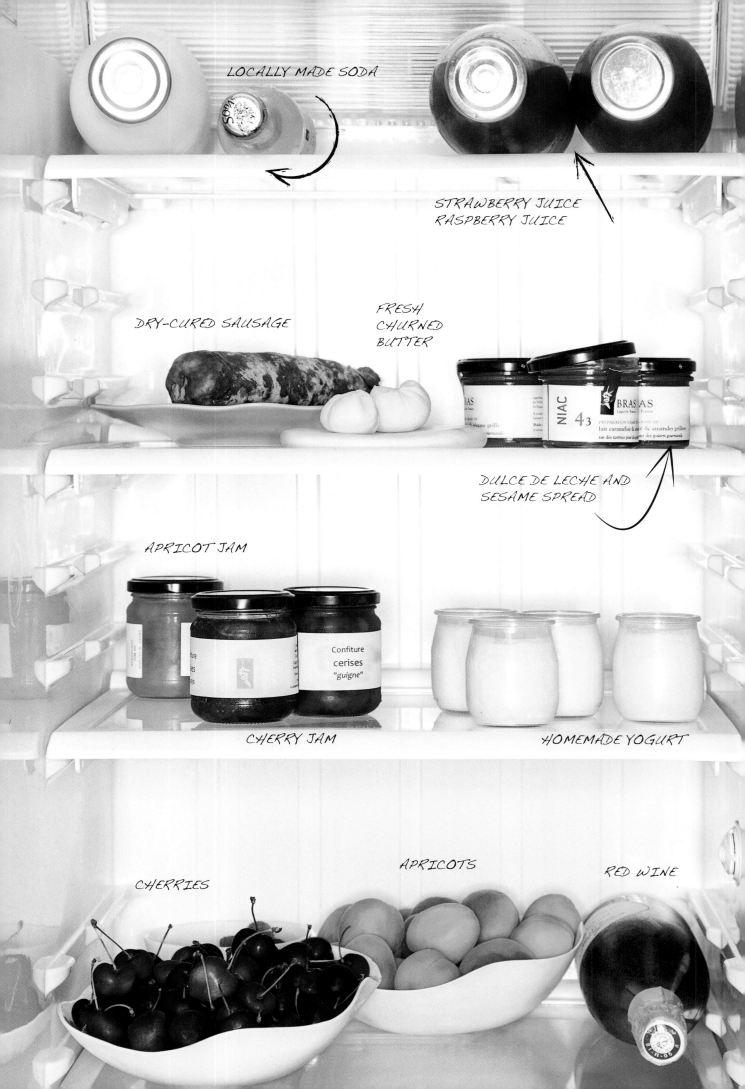

LOCALLY MADE SODA

STRAWBERRY JUICE
RASPBERRY JUICE

DRY-CURED SAUSAGE

FRESH
CHURNED
BUTTER

DULCE DE LECHE AND
SESAME SPREAD

APRICOT JAM

CHERRY JAM

HOMEMADE YOGURT

CHERRIES

APRICOTS

RED WINE

SÉBASTIEN
BRAS

LE SUQUET

•·····························•

Laguiole, France

One of the most well-known chefs in the world, Sébastien Bras, French culinary royalty if there ever was, follows in the footsteps of his legendary father Michel in the Aveyron region that has become synonymous with their name and three-star Michelin rated restaurant located in Laguiole. Known as much for his technique and risk taking as for his immense love of his native region and its bounty of herbs and legumes, Bras is one of France's most highly respected culinary masters.

Bras lives next door to the family business, and much of his food sourcing is done directly in the kitchen pantry, brought by foraging friends from nearby woods, or from the local Rodez market, the source of his first food memories, and where, as a child, he learned of the seasons and the local produce they brought. In the family fridge, there is homemade yoghurt and locally brewed beer, in the freezer, infusions of garden herbs, frozen in season, and perfumed essential oils.

As with many chefs, his personal rhythm depends on his professional schedule, and when the restaurant is closed, he cooks breakfast, lunch, and dinner for his family. When preoccupied with work, he "cooks when he can," and meals are "quick and tasty," like homemade pizza or curries. Dinner is often inspired by vacations in exotic locales such as Argentina, Cuba, Thailand, Vietnam, or Japan, and can be anything from a simple baguette, tomato stew ("I love the beefsteak variety") or sticky Japanese style rice.

And, as befitting a chef of his stature, the search for taste has no limits. "Sometimes we get gyromitre mushrooms ("brain mushrooms" or "false morels") in the surrounding woods, but they can be more or less rare depending on the season." He used to serve the forbidden delicacy in his restaurant, but now they're off the menu, because of safety regulations. "Cooked the wrong way, of course, they can be toxic, but they are delicious. A mourir," he says: literally, "to die for."

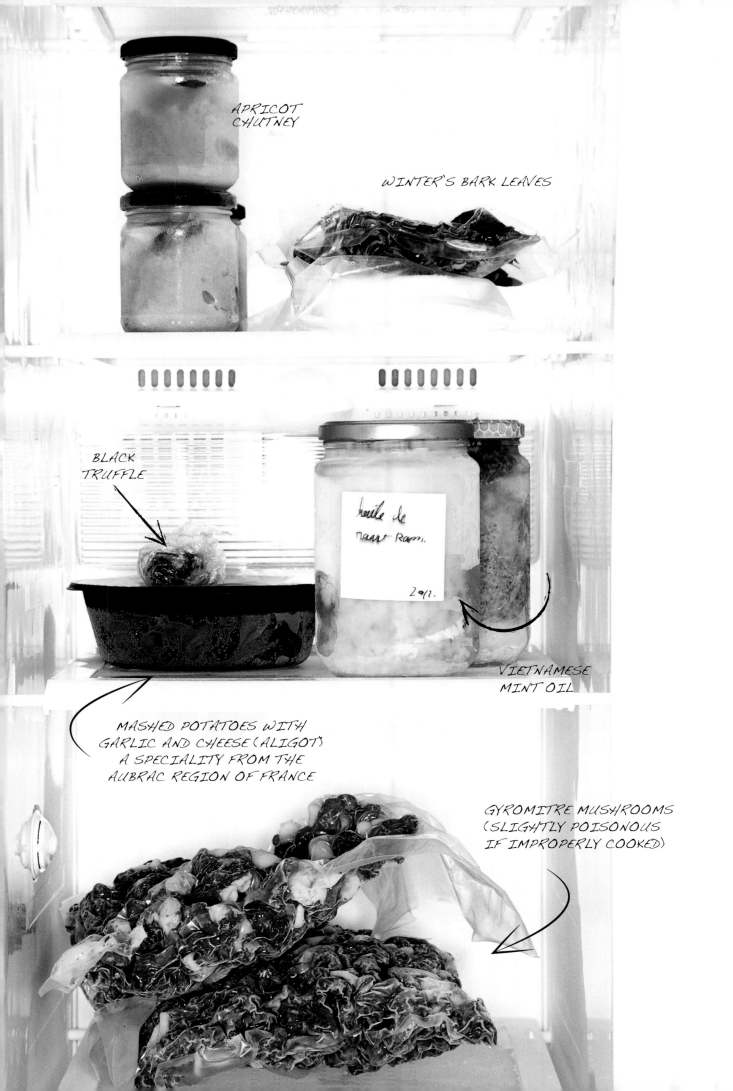

APRICOT CHUTNEY

WINTER'S BARK LEAVES

BLACK TRUFFLE

heule de
naut Rami.

2012.

VIETNAMESE MINT OIL

MASHED POTATOES WITH
GARLIC AND CHEESE (ALIGOT)
A SPECIALITY FROM THE
AUBRAC REGION OF FRANCE

GYROMITRE MUSHROOMS
(SLIGHTLY POISONOUS
IF IMPROPERLY COOKED)

SUMMER PIZZA

**Makes 4 individual pizzas**

Tomato Sauce

1.5kg (3.3 lbs.) ripe tomatoes

30ml (2 Tbsp.) olive oil

2 garlic cloves, minced

1 onion, minced

3 wild thyme sprigs

5 leaves wild alpine fennel, chopped

12g (1 Tbsp.) brown sugar

Pinch _Piment d'Espelette_ powder

Salt

Freshly ground black pepper

Crust

800g (1.8 lbs.) prepared pizza dough

60–75ml (4–5 Tbsp.) thyme oil

Flour, for the dough

Finely ground semolina

Assembly

15g (1 Tbsp.) dried black olives, pitted and chopped

30 green almonds, blanched

Several varieties basil from the garden

6g (1 Tbsp.) home-grown sprouts

150–200g (5–7 oz.) finely shaved Laguiole Tomme Fraîche cheese

Tomato Sauce:

Bring a large pot of water to a boil. Add tomatoes, and blanch for 30 seconds. Immediately peel tomatoes, and dice. Heat the olive oil over medium heat in a large skillet. Add garlic, onions, tomatoes, wild thyme, alpine fennel, brown sugar, _Piment d'Espelette_ powder, salt, and pepper, and simmer over low heat. Once the desired consistency has been achieved, set aside. If you like, blend into a purée.

Crust:

To wholly take advantage of all of the benefits of traditional yeast-risen bread, ask your baker to set aside 800g (1.8 lbs.) of dough that has just risen and been kneaded. Once home, knead the bread again, incorporating the thyme oil. Allow the bread to rise under a towel until it has doubled in size. Divide the dough into 4 equal parts, and roll each piece out on a well-floured surface until the dough is 3mm (⅛-inch) thick. Dust with a little semolina. Let dough rest for 10–20 minutes. Prepare grill for high heat. Grill dough until underside is golden, then flip and grill opposite side.

Assembly:

Spread the tomato sauce over the crusts. Garnish the pizzas with the toppings and return pizzas to the grill. Cover the pizzas with aluminum foil to help the cheese melt. Grill until cheese is melted and dough is cooked through and crisped.

LG GWP 2290 VCM

AUTUMN PIZZA

Makes 4 individual pizzas

Tomato Sauce
1.5kg (3.3 lbs.) ripe tomatoes
30ml (2 Tbsp.) olive oil
2 garlic cloves, minced
1 onion, minced
200g (7 oz.) celeriac, peeled, finely diced
3 lovage stalks, with leaves
2 winter's bark leaves
12g (1 Tbsp.) brown sugar
Pinch _Piment d'Espelette_ powder
Salt
Freshly ground black pepper

Crust
800g prepared pizza dough
60–75ml (4–5 Tbsp.) hazelnut oil
Flour, for the dough
Finely ground semolina

Assembly
30g (4 Tbsp.) freshly cracked walnuts
30 thin slices dried beef
20 celery stalk leaves
20 thinly shaved butternut squash shavings
150–200g (5–7 oz.) thinly shaved Laguiole cheese,
aged 4 months

Tomato Sauce:
Bring a large pot of water to a boil. Add tomatoes, and blanch for 30 seconds. Immediately peel tomatoes, and dice. Heat the olive oil over medium heat in a large skillet. Add garlic, onion, tomatoes, celeriac, lovage, winter's bark, brown sugar, and _Piment d'Espelette_ powder, and simmer over low heat. Once the desired consistency has been achieved, set aside. If you like, blend sauce into a purée.

Crust:
To wholly take advantage of all of the benefits of traditional yeast-risen bread, ask your baker to set aside 800g of dough that has just risen and been kneaded. Once home, knead the bread again, incorporating the hazelnut oil. Allow the bread to rise under a towel until it has doubled in size. Divide the dough into 4 equal parts, and roll each piece out on a well-floured surface until the dough is 3mm (⅛-in.) thick. Dust with a little semolina, which is an incomparable complement to the dough's texture. Let dough rest for 10–20 minutes. Prepare grill for high heat. Grill dough until underside is golden, then flip and grill opposite side. The success of the pizza depends on this initial grilling of the crust: It needs to be cooked enough but not dry.

Assembly:
Spread the tomato sauce over the crusts. Garnish the pizzas with the toppings, and return the pizzas to the grill. Cover the pizzas with aluminum foil to help the cheese melt. Grill until cheese is melted and dough is cooked through and crisped.

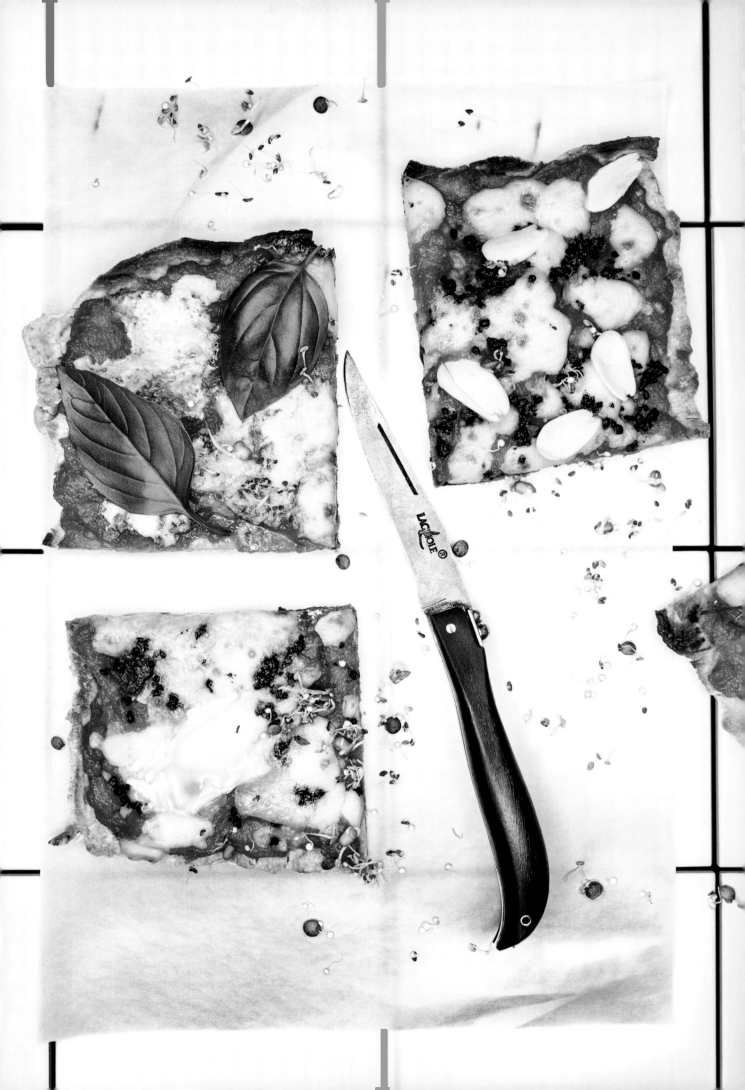

YVES
CAMDEBORDE

LE COMPTOIR DU RELAIS

•·······································•

Paris, France

Yves Camdeborde, iconoclastic restaurant owner and harbinger of the bistronomic movement, is both old school and cutting edge. As attuned as anyone to classic cuisine, he has his own unique way of seeing things that has helped him create a singular vision of good time eating that the dining public has been lapping up for more than a decade.

Although he started working at fourteen and did time at the Ritz, Crillon, and Tour d'Argent, his La Régalade, in the far-flung 14th arrondissement was the first gastro-bistro in town. The French press, who were against the idea that anyone could democratize gastronomy, at first snubbed him, but the idea broke new ground and eventually changed the Parisian dining scene forever. "I just wanted to make great food at reasonable prices for people my age."

Home is in his words, "complicated." There is always meat (his son eats three kilos per week): beef, veal lamb, and chicken, and air-dried beef. There are pickled onions, Sangria, shrimp for his daughter, who fancies herself an American, and who flies off to the US any chance she can get. There's lots of organic stuff his wife buys from the downstairs shop out of convenience, which he hates, especially the butter. "I get the real stuff," he says, "not that disgusting crap." There's charcuterie from his brother Philippe. Frozen meat in the freezer, and, tucked away in a corner, could those tiny little birds be ortolans?

His favorite toy is a prototype home-use Pacojet, a one of a kind device that screams like an F-16 taking off, waking the neighbors while ice creaming anything in its path. Despite the expensive gadgets, his philosophy is still down to earth: "It's all about the cooking element: a hot pan and great ingredients. Think about that piece of cake that falls off onto the stove and you scoop it up and eat it," he says, "that's it: pure taste."

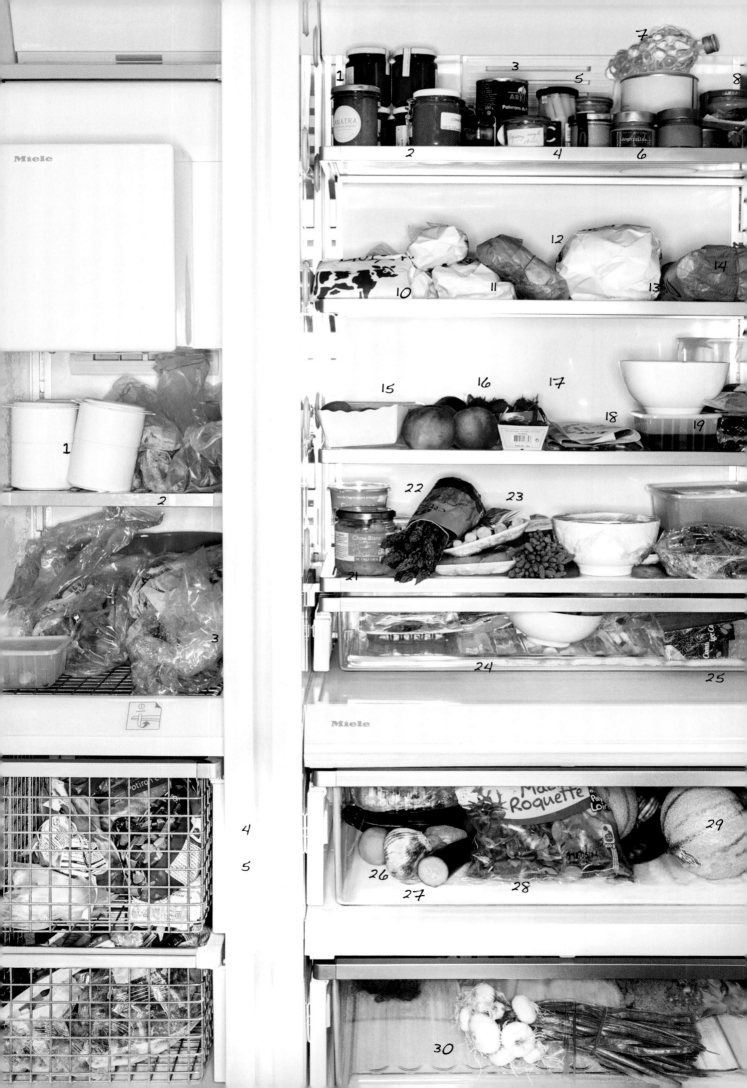

FREEZER

1 Homemade asparagus ice cream
2 Ortolans
3 Frozen shrimp
4 Frozen pumpkin
5 Frozen rhubarb

FRIDGE

1 Corsican orange jam
2 Lime and raspberry preserves
 from Raphael
3 Piquillo peppers
4 Lamb paté
5 White asparagus
6 Corsican dulce de leche
7 Eau de vie
8 Basque white tuna
9 Sardines
10 Veal
11 Lamb
12 Chipolatas
13 Chicken
14 Beef from Hugo Desnoyer
15 Apricots
16 Peaches
17 Raspberries and strawberries
18 Charcuterie from brother Philippe
19 Air-dried beef
20 Chorizo
21 Sauerkraut
22 Green asparagus
23 Wild asparagus
24 Sliced cheese
25 Comté cheese
26 Garlic
27 Zucchini
28 Arugula
29 Canteloupe
30 Spring onions

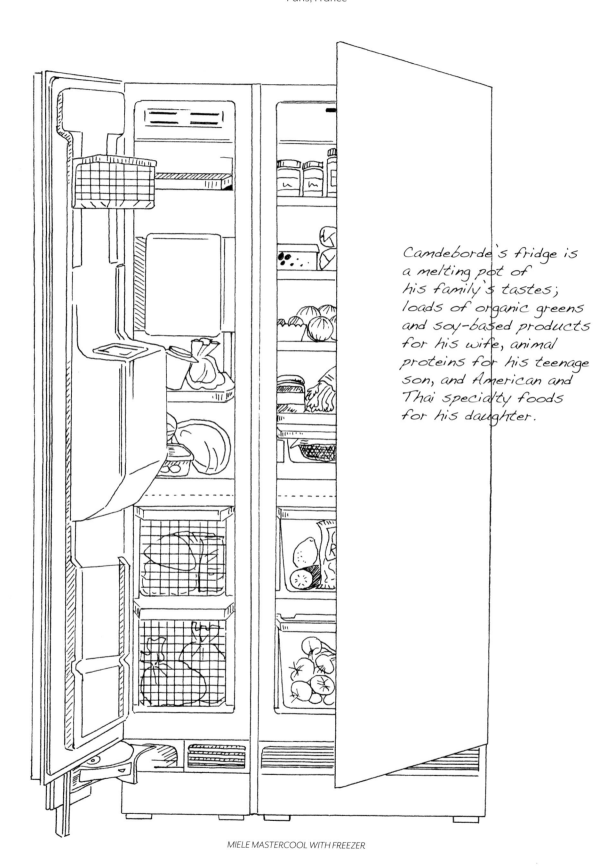

Camdeborde's fridge is a melting pot of his family's tastes; loads of organic greens and soy-based products for his wife, animal proteins for his teenage son, and American and Thai specialty foods for his daughter.

MIELE MASTERCOOL WITH FREEZER

PAN-FRIED SHRIMP
WITH GINGER AND LEMONGRASS

Serves 4

Shrimp Sauce

16 jumbo shrimp

50g (2 oz.) coconut oil

1 garlic clove, minced

1 large, ripe tomato, chopped

20g (.7 oz.) fresh ginger, peeled, chopped

¼ bunch coriander (cilantro) leaves, chopped

1 lemongrass stalk, chopped

1 yellow onion, minced

200ml (¾ plus 1½ Tbsp.) coconut milk

200ml (¾ plus 1½ Tbsp.) mineral water

Juice of 1 lime

Salt

Freshly ground black pepper

2g (½ tsp.) *Piment d'Espelette* powder

Chili Paste

1 garlic clove

Handful coriander (cilantro) leaves

2g (½ tsp.) salt

2g (½ tsp.) *Piment d'Espelette* powder

50ml (3 Tbsp. plus 1 tsp.) coconut oil

Assembly

1 large, ripe tomato

25ml (1 Tbsp. plus 2 tsp.) coconut oil

¼ red bell pepper, diced

¼ green bell pepper, diced

1 yellow onion, diced

Handful coriander (cilantro) leaves

Handful chives, minced

50g (1.7 oz.) toasted sunflower seeds

Shrimp Sauce:

Peel shrimp, and store in the refrigerator wrapped in paper towels. Reserve the carcasses, and crush them coarsely; refrigerate until ready to use.

In a large skillet, heat coconut oil over high heat, and sweat the shrimp carcasses for 2–3 minutes. Add garlic, tomato, ginger, coriander (cilantro), lemongrass, and onion, and sauté for 5 minutes. Pour in the coconut milk and mineral water. Add lime juice, and season lightly with salt, black pepper, and *Piment d'Espelette* powder. Cook over low heat for 10 minutes. Strain the shrimp sauce through a fine-mesh sieve; disard solids.

Chili Paste:

With a mortar and pestle (or in a food processor if you don't have one), mash garlic clove and add coriander (cilantro) leaves. Season with salt and *Piment d'Espelette* powder. Continue to mash the mixture. Add coconut oil. Set chili paste aside at room temperature.

Assembly:

Bring a medium pot of water to a boil.
Plunge tomato into boiling water for one minute.
Immediately transfer to an ice bath.
Peel and quarter.

In a large skillet over high heat, heat coconut oil. Cook shrimp 30 seconds on each side. Remove shrimp from heat, and set aside. Without rinsing the pan, add red peppers, green peppers, and onion. Cook vigorously for 1–2 minutes, then add the reserved shrimp sauce, and bring to a boil for 30 seconds. Add chili paste, bring to a boil again, and season to taste. Just before serving, add quartered tomato and shrimp to the broth, and simmer for 1 minute. Divide among four dishes, and serve topped with coriander (cilantro) leaves, chives, and sunflower seeds.

This dish is best accompanied with a nice robust bottle of rosé, such as a Corbière from Maxime Magnon.

SALTED SANGRIA, MELON, CHORIZO, AND HAM
(*JAMON Y MELON*)

Serves 4

500ml (2 cups) fruity red wine, such as Gamay

1 lemon, minced

1 orange, minced

1 whole clove

1 whole star anise

5 whole peppercorns

½ cinnamon stick

100g (½ cup) sugar

½ vanilla bean

Handful basil, stems and leaves separated

2 melons (charentais or cantaloupe), halved horizontally, seeded

100g (3.5 oz.) chorizo, thinly sliced

100g (3.5 oz.) Iberico ham, thinly sliced

Handful chives, roughly chopped

Spanish olive oil

Freshly ground black pepper

Pour wine into a large pot, bring to a boil, and flambé to get rid of any bitter flavor. Remove from heat, and add lemon, orange, clove, star anise, peppercorns, cinnamon stick, sugar, vanilla, and basil stems. Bring to a boil, then allow sangria to cool. Refrigerate.

Using a melon baller, scoop out melons. Try to make the melon balls equal in size. Divide melon balls among four deep plates or bowls. Top with chorizo, ham, chives, and basil leaves. Add a splash of olive oil (Spanish, of course!) and some freshly ground black pepper. Press the sangria through a fine-mesh sieve to filter out the fruits and spices. Discard solids. Pour sangria liquid carefully over the melon balls.

This dish is best eaten chilled. If you prepare the sangria the night before, it will be even better. This dish is best accompanied with a fizzy natural white wine such as the Gaillac from Bernard Plageoles.

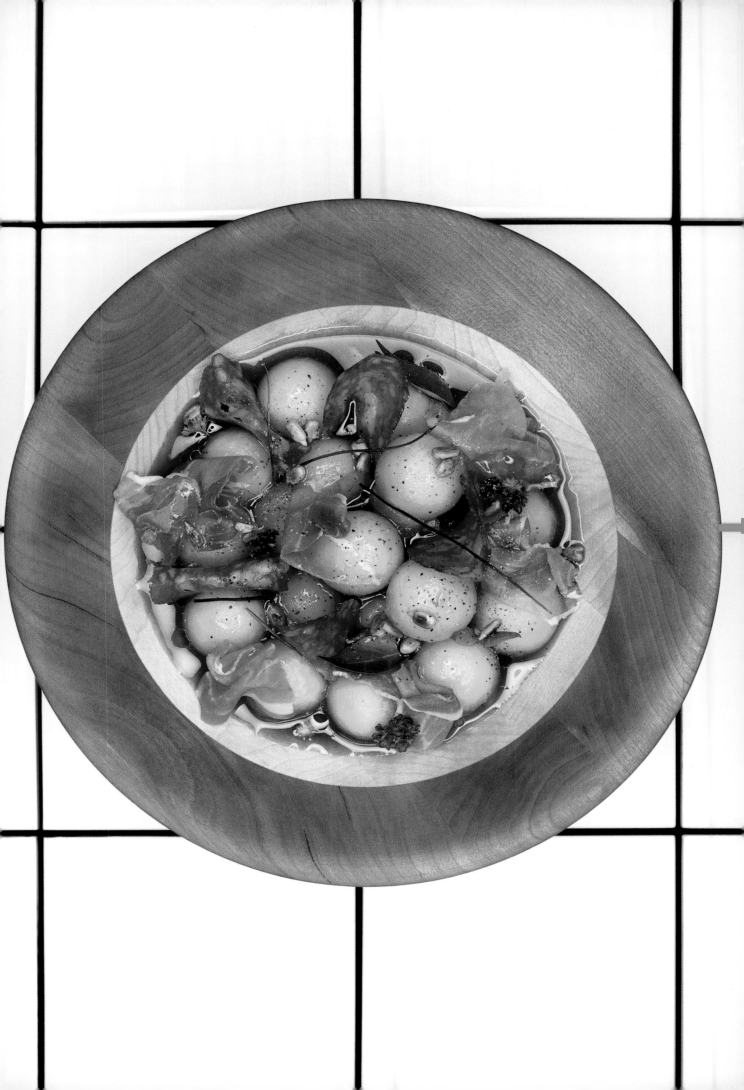

SVEN
CHARTIER

SATURNE

• ··························· •

Paris, France

Tucked away in the courtyard of a building in the gentrifying 2nd arrondissement, past parked vintage bicycles and baby carriages, lies the abode of one of Paris's most talented young chefs, Sven Chartier. With his tousled hair and two-week beard, he is the spitting image of many of the food-obsessed, bright young things that grace his always-packed restaurant Saturne.

Chartier, who was born in the Périgueux region, raised in Paris, and who attended cooking school in Biarritz, trained with L'Arpège's Alain Passard, where he worked for a little more than two years. An unorthodox environment and an extraordinary experience, L'Arpège's kitchen was simultaneously a place where the law of the jungle ruled, as well as being his first great culinary education, one where a young chef could express his creativity, take risks and learn his craft. "Everyone was tested and pushed to their limits. We didn't learn recipes but developed sensibilities to products and their reactions, and with vegetables coming from the chef's gardens three times a week, it was like gold in our hands."

After L'Arpège, he traveled and tasted his way around the world (Singapore, Vietnam, Japan, China, Malaysia, New Zealand) then met the iconoclast restaurateur and natural wine aficionado, Pierre Jancou, was offered head chef position at his cult bistro Racines, where he met sommelier and now restaurant partner Ewan Lemoigne. They left and with a clear mind, opened Saturne, one of Paris's premier chef-driven hotspots.

Their new venture, Saturne, started with a blank page, and Chartier didn't want to copy or recreate anyone else's work, avoided exotic produce and spices, and concentrated on letting seasonal ingredients do the talking. "My cuisine changes daily, is fresh and spontaneous, and quality and simplicity are the essential elements."

Like many busy chefs, Sven rarely cooks at home. With two toddlers, the idea is to prepare good meals quickly, with provisions such as line caught fish and organic veggies from the nearby niche grocers Terroirs d'Avenir or other local organic shops. The entire upper fridge shelf is devoted to condiments and sauces of various types, his dad's jams, mustard, and Japanese vinegars, a mishmash of store bought and pack rat acquired items. And of course, he good-humoredly turns a blind eye to the hidden corners of the freezer often stuffed with his wife Marianne's stash of frozen Asian food.

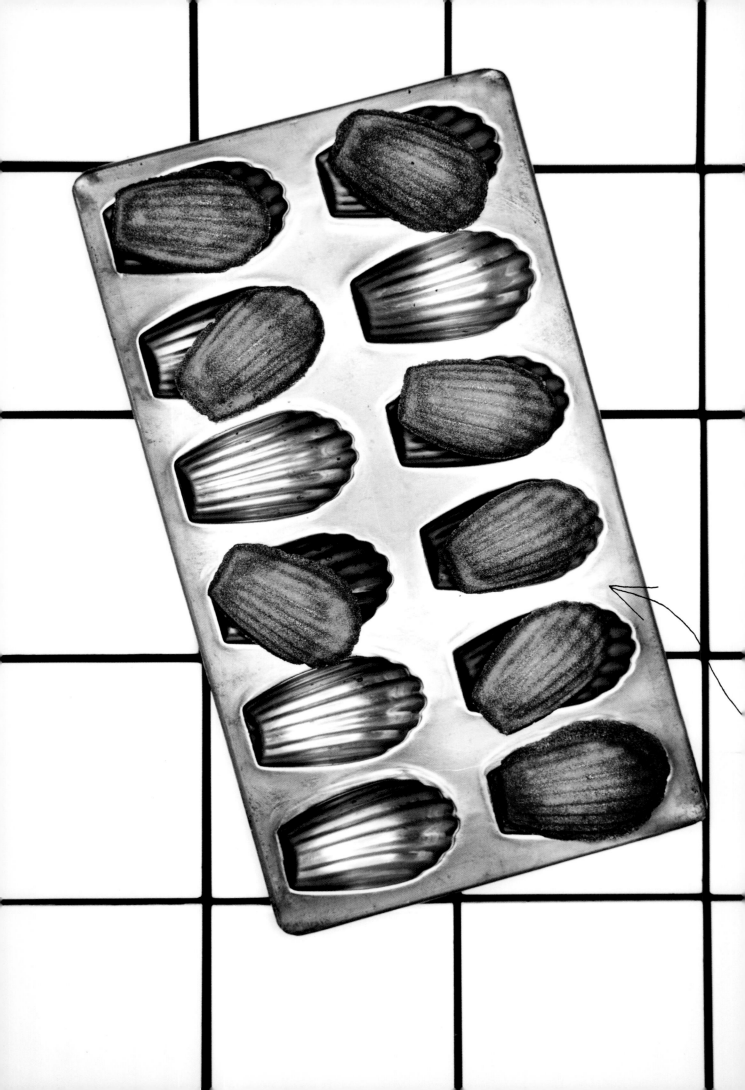

HONEY MADELEINES

Makes 12 madeleines

125g (9 Tbsp.) butter, sliced into small pieces
125g (1¼ cups) dark brown sugar
50g (1.7 oz.) almond powder, sifted
50g (⅓ cup plus 1½ Tbsp.) flour, sifted
112g (4 oz.) egg whites
15g (½ oz.) honey, preferably from white flowers

Melt the butter in a skillet over medium heat. After the butter foams, it will start to brown and smell nutty. Remove from heat, transfer to a bowl, and allow to cool to 40°C (105°F). In a large bowl, combine the brown sugar, almond powder, and flour. In a separate bowl, gently beat the egg whites. Stir in the honey and brown butter. Stir the dry ingredients into the egg mixture until just incorporated. Refrigerate the batter for 24 hours (or 12 hours if need be).

Fill madeleine molds two-thirds full with the batter. For best results, place molds in the freezer for 15 minutes before baking. Preheat oven to 180°C (350°F). Bake madeleines until they are golden brown, 12 minutes. For a crispy crust, remove the madeleines from the molds as soon as they come out of the oven.

MADELEINE

Although the exact origins of Proust's favorite cake are shrouded in history, the madeleine may date back to the 1700s, where most believe it was first made in the town of Commercy, in the Lorraine region of France. Regardless of whence it came, the small, spongy cake with a moist interior is a traditional treat for French children as a late afternoon goûter (snack), and often served with coffee at the end of a gastronomic meal.

BOSCH KIV34A21FF

1 Bitter orange jam
2 His father's homemade pâté
3 Bigorre Black Pig's ham
4 Dijon-style mustard
5 Tamari Sauce
6 Tonic Water
7 Crème fraîche
8 Fish sauce
9 Baby squid
10 Goat cheese
11 Butter
12 Organic soft tofu
13 Organic eggs
14 Extra firm tofu
15 "Sablés" Butter cookie dough
16 Purple cabbage
17 Swiss chard
18 Eggplant
19 Thyme
20 Cucumber
21 Red Chili peppers from
 his father's garden

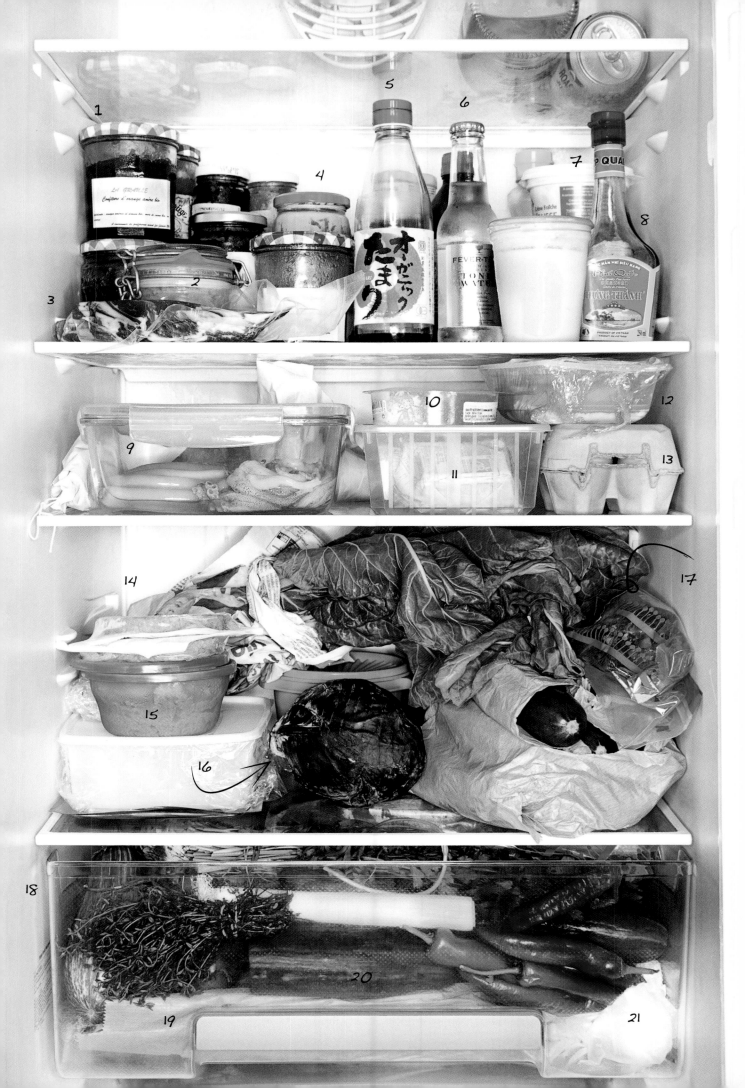

OVEN-BAKED
BASQUE SQUID

Serves 6

30ml (2 Tbsp.) olive oil
4 onions, finely chopped
2 garlic cloves, minced
1 sprig thyme
1 bay leaf
250ml (1 cup) white wine
1L (1 quart) tomato coulis
15ml (1 Tbsp.) squid ink
4 mild red chili peppers, minced
100g (3.5 oz.) Bigorre Black Pig's ham, chopped
A touch of *Piment d'Espelette* powder
500g (1.1 lbs.) squid, preferably
from Saint-Jean-de-Luz, cleaned
by your fishmonger
300g (11 oz.) white rice (basmati or Thai)

Preheat oven to 200°C (400°F). In a large skillet, heat olive oil over medium heat. Add onions, garlic, thyme, and bay leaf, and sauté gently over medium heat for 8 minutes. Pour in white wine and tomato coulis, and simmer until the liquid is reduced by half. Stir in squid ink, peppers, black ham, and *Piment d'Espelette* powder. Simmer 5 minutes. Place squid in a shallow baking dish, cover with the sauce (discarding bay leaf), and transfer to the oven. Bake until the squid is cooked through and the sauce has thickened, about 45 minutes. While the squid cooks, prepare the rice in a rice cooker, and keep warm. Serve the rice alongside the squid.

Rich, black ink is the precious little prize tucked deep inside a squid. It can be purchased at upscale food markets or carefully extracted by your fishmonger—or you can even do it yourself. To clean squid yourself, remove the head and the entrails in order to get to the small silvery, sack of ink. Remove the sack from the innards without breaking it. Carefully pierce the sack and squeeze into a bowl. Additional ink deposits can also be found behind the eyes of a squid.

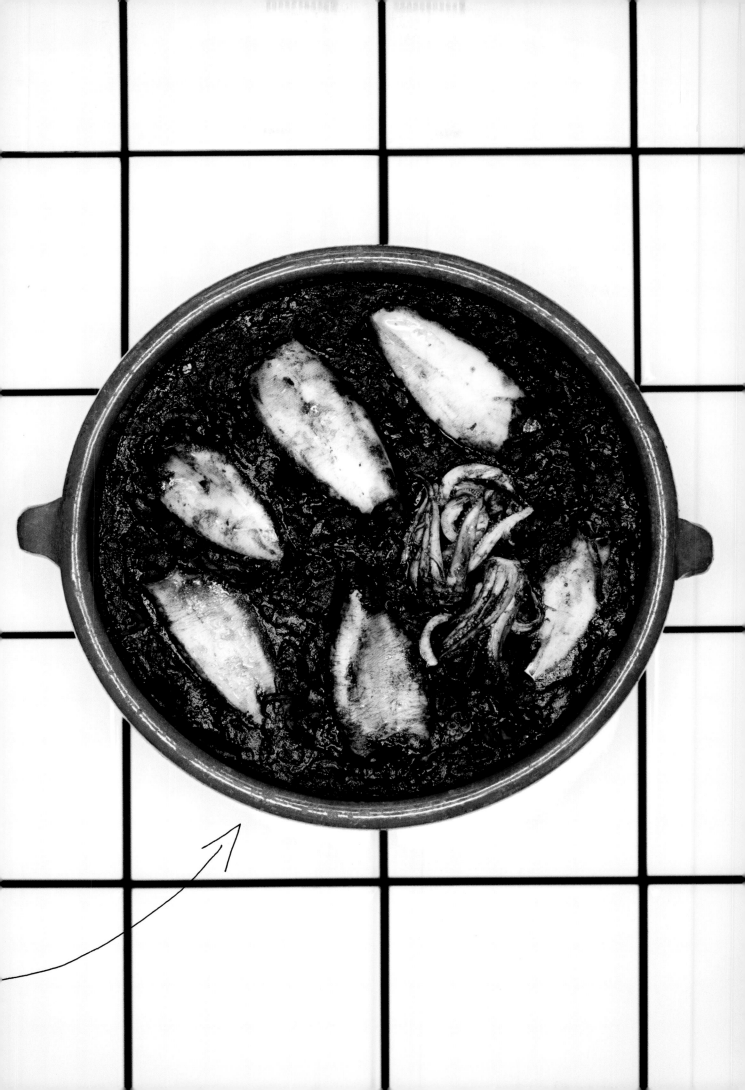

MAURO
COLAGRECO

MIRAZUR

●································●

Menton, France

Jovial Argentinian chef Mauro Colagreco is one of the most well-loved figures in contemporary French cooking, and his hilltop flagship overlooking the Cote d'Azur, is on the bucket list of every jet-setting gastronome.

Colagreco grew up in Argentina, where his entire family cooked, and the table was the point of reference for daily life. "My paternal grandparents lived in the countryside, and we'd go there for special occasions. They were full of love, and a great part of that love was cooking." His grandfather was Italian and his grandmother from the French Basque country so there was always a varied mix of different dishes from homemade tagliatelle and ravioli to Basque dishes like morue. "The fire was always lit," he says, "and these memories never left me."

He defines himself as an Argentinian chef with Italian roots who doesn't do Argentinian or Italian food, who was French trained, but who doesn't do French cooking. "My style is very personal because I've never been tied down to one thing, and for me it's all about simplicity and seasonality, totally product-based, with lots of technique and associations I feel."

At home, his small fridge has a mismatch of store bought produce, items from the restaurant, and crops from his fabulous backyard garden as well as the local French (Menton) and Italian markets (nearby, across the border in Ventimiglia, Italy). "It's funny how the products between the two countries are so totally different, yet they're only 10 kilometers away." Dry zucchini, Parmesan and exceptional mozzarella are Italian, and French Comté, goat's cheese and fresh almonds from Mirazur come from the French side. Homemade jams from visiting friends share space with supermarket chocolate and lots of yoghurt and *fromage blanc* for his child and wife.

The chef's home/restaurant garden is also a source of constant inspiration with dozens of varieties of vegetables, corn and potatoes from South America, many rare species, never having been planted in France before.

"Contact with the earth is essential for me," he says. "I make my cooks come up here to get vegetables for the restaurant, and I show visiting friends around. In the end, everybody needs to know where things come from."

BOSCH KSV

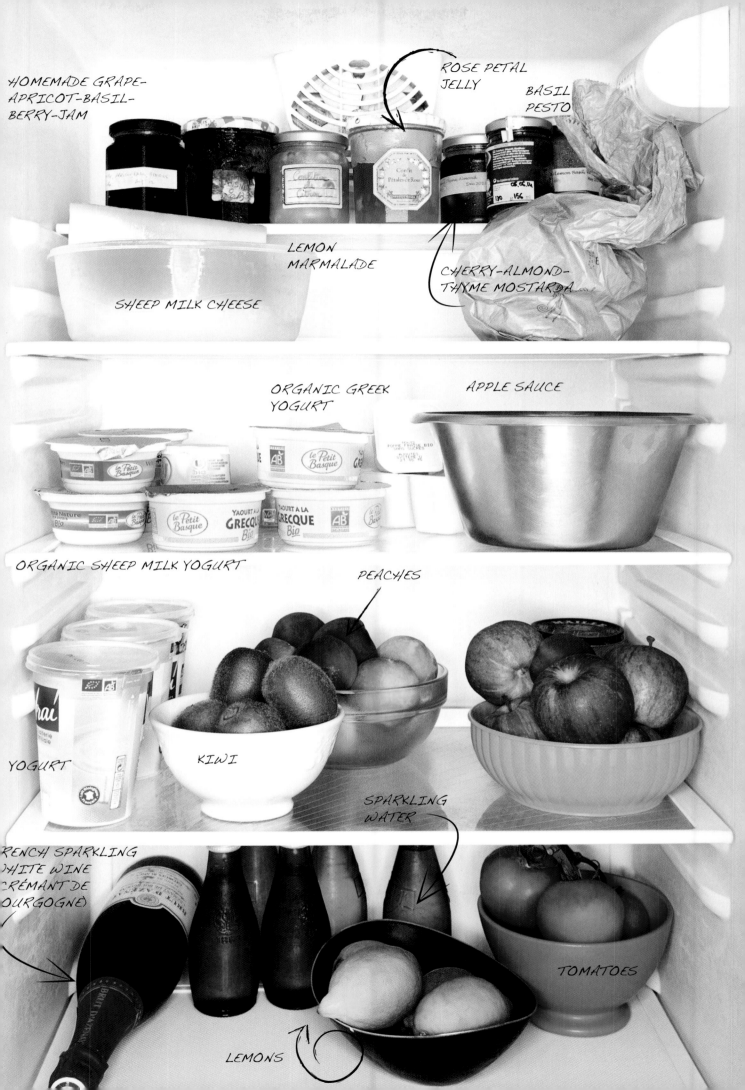

HOMEMADE GRAPE-
APRICOT-BASIL-
BERRY-JAM

ROSE PETAL
JELLY

BASIL
PESTO

LEMON
MARMALADE

SHEEP MILK CHEESE

CHERRY-ALMOND-
THYME MOSTARDA

ORGANIC GREEK
YOGURT

APPLE SAUCE

ORGANIC SHEEP MILK YOGURT

PEACHES

YOGURT

KIWI

SPARKLING
WATER

FRENCH SPARKLING
WHITE WINE
(CRÉMANT DE
BOURGOGNE)

TOMATOES

LEMONS

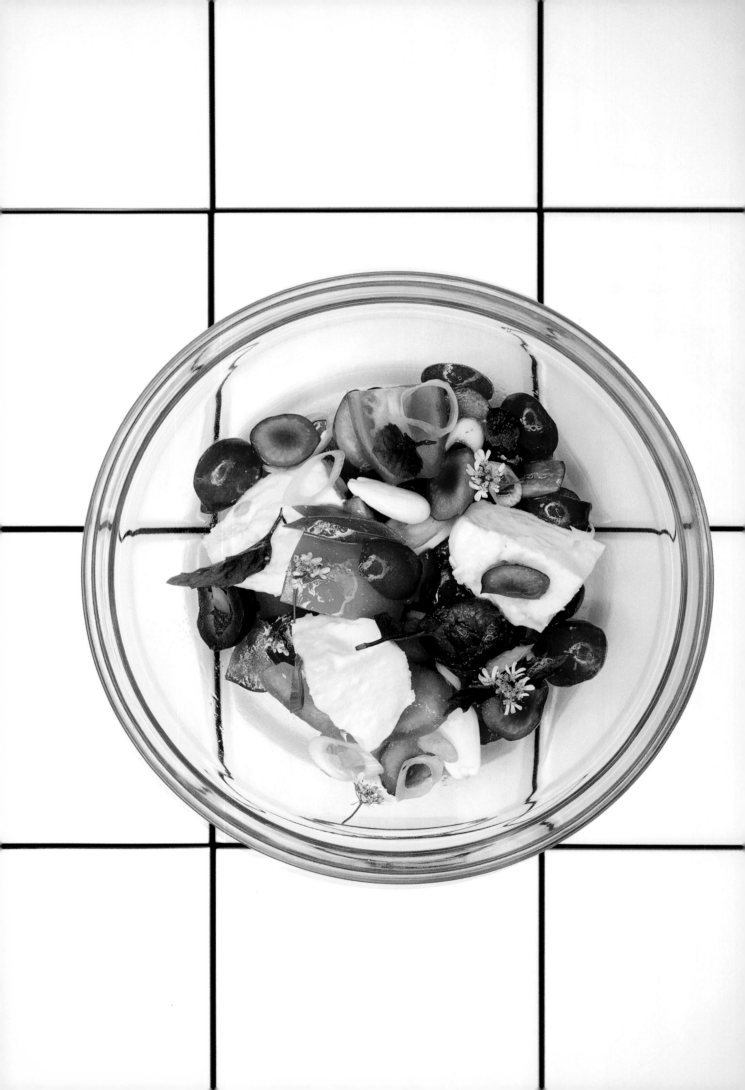

MY MOTHER'S SOUTH AMERICAN BEEF STEW
(PUCHERO)

Serves 6

1 beef kneecap
4 ossobuco (veal shanks), with marrow
1 onion, chopped
1 leek, chopped
1 turnip, chopped
½ red bell pepper
Handful parsley
Handful basil
2 garlic cloves, unpeeled
1 carrot, cut into large pieces
250g (9 oz.) medium potatoes, peeled, quartered
1 sweet potato, peeled, cut into large pieces
200g (7 oz.) pumpkin, peeled, cut into large pieces
1 ear corn, quartered
75g (2.5 oz.) chorizo, blanched
1 tomato, halved
1 zucchini, quartered
150g (5 oz.) green beans
150g (5 oz.) blood sausage
100g (5 oz.) Swiss chard leaves, torn into large pieces
100g (5 oz.) white cabbage, thinly sliced

Place kneecap, ossobuco, onion, leek, turnip,
bell pepper, parsley, and basil in a large pot.
Cover with water, and bring to a boil. Add garlic
and carrots, and cook 7 minutes. Add potatoes,
and cook 2 minutes. Add sweet potatoes, pumpkin,
corn, chorizo, tomato, zucchini, and green beans,
and cook 10 minutes. Add blood sausage,
Swiss chard leaves, and white cabbage.

Remove pot from heat, and let the stew rest until
the leaves wilt. Serve hot as a soup, or strain meat
and vegetables and serve broth in a separate
bowl alongside.

TOMATO, CHERRY, AND OLIVE SALAD

Serves 2–4

2 large balls fresh buffalo mozzarella,
torn into irregular pieces
20 cherries, pitted, halved
12 large black olives, pitted, halved
4 medium tomatoes, quartered
2 spring onions, thinly sliced on the bias
Olive oil
Balsamic vinegar
Sea salt
16 purple basil leaves
12 coriander (cilantro) flowers

Combine mozzarella, cherries, olives, tomatoes,
and spring onions in a large bowl. Dress
with a generous drizzle of olive oil, a little balsamic
vinegar, and a sprinkle of sea salt. Toss, and top
with purple basil and coriander flowers.

HÉLÈNE DARROZE

RESTAURANT HÉLÈNE DARROZE

• ... •

Paris, France and London, England

Hélène Darroze, one of France's most well-known and revered chefs grew up in the family restaurant started by her great-grandfather in the south of France, yet her family persuaded her to attend a prestigious business school, far from the heat of the kitchen. And although her most potent childhood memories were of the family farm, the local market, and hunting in the nearby woods, upon graduating she embarked on a career in the offices of Alain Ducasse's Louis XV in Monaco. It wasn't long before the super-chef stepped in, and said: "I think you should cook." And Darroze knew it was time: "When you're mature enough to know what your passion in life is and want to live it, you either do it or you don't."

After a few months in Ducasse's kitchen, Darroze returned to her family restaurant for a time and proceeded to open her restaurant in Paris and, later, London, where she quickly gained Michelin stars, and solidified her prestigious career.

Darroze's life divided between the French and English capitals is sometimes, understandably, a challenge, especially with two young daughters. She keeps two apartments, and private dining is all about time and convenience. "I do most of my shopping at the Bon Marché, load up my trolley, and have them deliver—it's less complicated."

Although there's always pristine produce in the fridge, like foie gras and Champagne, jams from her friend Christine Ferber, and fresh sardines, Parmesan, and aged Comté cheese, it doesn't bother her in the least to have a frozen pizza and supermarket ice cream in the freezer, or Caprice des Dieux industrial cheese pushed to the back of the rack.

Home cooking for her is almost always based around a "big, shared dish in the middle of the table," and "the most important thing is good products, but I'm open to other things as well." If she's cooking, it could be a classic with a twist: a Sunday afternoon *pot au feu* with herbs, spices and *nuoc mam* sauce or spiced pork ribs with a yogurt sauce and a rice dish brought by an Afghani friend. "I'm very lucky because my kids eat everything," she says. "I don't know if it comes from me or my travels, or their own palates, but I'm so happy they're curious eaters."

Darroze's cooking style speaks, she says of her "emotions, journeys, generosity, and life," where respect of the product is king, and honest flavors and textures are the key to a perfect dish. "The product is what it is all about," she says, then reflects, "that being said, I do think a lot about my heritage and the genetic component as well. Cooking must come from a kind of memory."

WOOD PIGEON
IN SAUCE
(SALMIS DE
PALOMBES)

LIEBHERR NO FROST

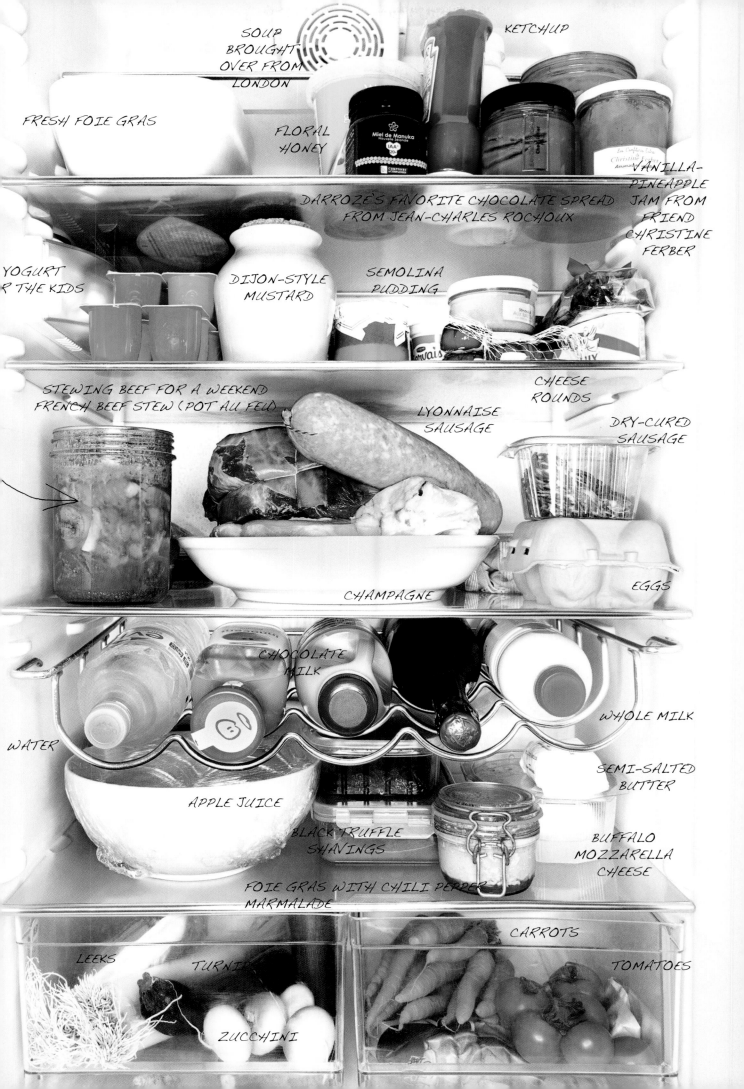

WOOD PIGEON
WITH FOIE GRAS AND
TRUFFLE SAUCE
(*SALMIS DE PALOMBES*)

Serves 8

Wood Pigeon and Sauce
4 wood pigeons
40g (1.5 oz.) duck fat, divided
50g (1.7 oz.) foie gras
2 garlic cloves, unpeeled
10 sprigs thyme
5 sprigs rosemary
5 bay leaves
3 shallots, minced
50ml (3 Tbsp. plus 1 tsp.) Armagnac
500ml (2 cups) dry red wine
200ml (¾ cup plus 1½ Tbsp.) game stock
50ml (3 Tbsp. plus 1 tsp.) truffle juice
Salt
Piment d'Espelette

Mushrooms, Bacon, and Onions
50g (2 oz.) duck fat, divided
50g (2 oz.) bacon, diced
150g (5 oz.) pearl onions
250ml (1 cup) chicken stock
150g (5 oz.) button mushrooms
Salt
Piment d'Espelette

Wood Pigeon and Sauce:

Ask your butcher to break down the wood pigeon, removing the thighs and breasts and reserving the carcass, heart, and liver. Preheat oven to 200°C (400°F). In a large cast-iron pot, heat 20g (.75 oz.) of the duck fat; add garlic. Add wood pigeon carcasses, heart, and livers, and brown over medium heat for 10–15 minutes.

Prepare a bouquet garni by tying together thyme, rosemary, and bay leaves with kitchen twine. Add the bouquet garni and shallots to the pot, and continue to cook until shallots are tender. Deglaze with Armagnac, and continue to cook until all liquid evaporates. Pour in red wine and game stock, cover, and simmer for 30–45 minutes. Strain the sauce through a fine-mesh sieve, pressing on the carcasses to obtain maximum flavor. Add truffle juice, and reduce for another 10 minutes. Stir in foie gras, mixing until the sauce is smooth.

While the sauce is reducing, prepare the wood pigeon. Rub the remaining duck fat over the breasts and thighs, and season with salt and Piment d'Espelette. Roast the wood pigeon in a large roasting pan, uncovered, for 15–20 minutes. Add the roasted wood pigeon breasts and thighs to the foie gras sauce, and cook over low heat for 5 minutes.

Mushrooms, Bacon, and Onions and Assembly:

Heat 10g (.35 oz.) of the duck fat in a skillet over high heat. Fry the bacon quickly; reserve. In the same pan, add a little more duck fat, reduce the heat, and gently sauté pearl onions for 10 minutes. Transfer pearl onions to a baking sheet, and season with salt and Piment d'Espelette. Pour chicken stock over onions, and cover with a sheet of parchment paper. Confit the onions in the oven for 10 minutes. In the same skillet, heat the remaining duck fat, and cook the mushrooms over medium heat for 10 minutes. Season with salt and Piment d'Espelette. Just before serving, add the mushrooms, bacon, and onions to the pot with pigeon and sauce.

MUSTARD

By far the most popular condiment
in chef's fridges, mustard is prepared
in a myriad of ways: Dijon-style; hot
and spicy; stone-ground; with small
grains; Savora; and heavy on the spices.
And then there is Italian mostarda, with
candied fruit in mustard syrup; or English
Piccalilli with pickled vegetables and
mustard and turmeric seasoning.
Evidence has been found of mustard
cultivation thousands of years ago,
and there is even a mustard recipe dating
back to the first cookbook by Apicius
in Roman times.

BEET AND BUFFALO MOZZARELLA TART

Serves 4

Crust

375g (1⅔ cups) butter, cut into small pieces

10g (½ Tbsp.) salt

10g (2½ tsp.) sugar

1 egg yolk

100g (3½ oz.) milk

500g (4 cups) flour

1g (¼ tsp.) _Piment d'Espelette_ powder

1g (1 tsp.) thyme flowers, minced

Beets

80g (3 oz.) white beets, medium size

80g (3 oz.) yellow beets, medium size

80g (3 oz.) pink beets, medium size

80g (3 oz.) Crapaudine heirloom beets,
medium size

Salt

Pepper

Piment d'Espelette powder

250ml (1 cup) olive oil

Assembly

40g (1½ oz.) puntarelle

10ml (2 tsp.) olive oil

3g (½ tsp.) salt

3g (½ tsp.) _Piment d'Espelette_ powder

150g (5 oz.) Buffalo Mozzarella,
roughly chopped

Crust:

Preheat oven to 180°C (350°F). Using an electric mixer fit with a flat beater, mix together all ingredients, being careful not to overwork the dough. Let the dough rest for 20 minutes. On a lightly floured surface, roll out the dough onto a pastry circle. Transfer to a baking sheet, and bake until light golden brown, 30–40 minutes. Let cool.

Beets:

Preheat oven to 160°C (325°F). In a large bowl, combine beets. Season salt, pepper, _Piment d'Espelette_ powder, and olive oil. Wrap each beet separately in aluminum foil. Cook the beets for 2 hours. Allow beets to cool in foil. Carefully remove the aluminum foil, transfering the juices from the cooked beats to a medium bowl. Whisk olive oil into beet juice. Peel the beets and slice very thinly, into 4mm (⅛-in.) slices. Using a round, 15mm (½-in.) cookie cutter, cut out small circles from each beet slice. Set aside the beet rounds on a large tray covered with plastic wrap.

Assembly:

Toss puntarelle with olive oil, salt, and _Piment d'Espelette_ powder. Evenly place the beet slices over the crust. Top with mozzarella, then the seasoned puntarelle. Drizzle the beet-juice mixture over the tart, and serve immediately.

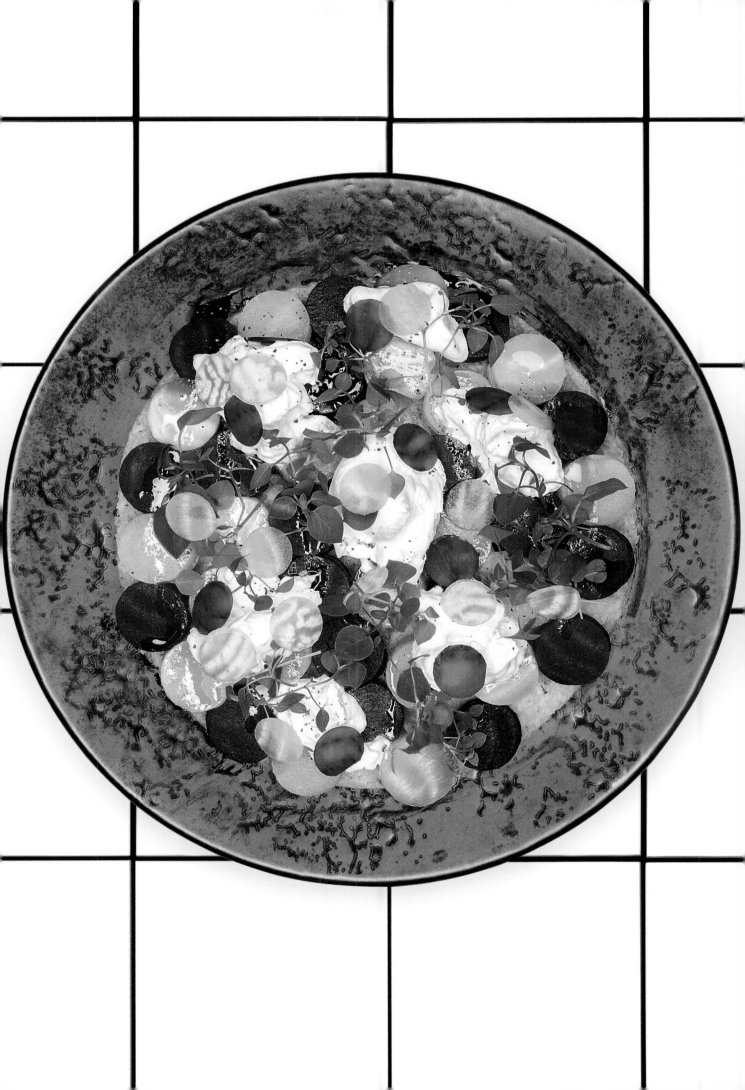

SANG HOON
DEGEIMBRE

L'AIR DU TEMPS

• •

Éghezée, Belgium

Brought from his native Korea as an adopted five-year-old boy, this visionary two-star Michelin rated chef is a self-taught sommelier, cook, and passionate student of the basic scientific underpinnings of cuisine. His aborted pharmaceutical studies gave him a taste for chemistry and creating new affinities between disparate products, and some naysayers have dared called him molecular, something he denies flatly. "I may use high tech in my kitchen, but I'm looking for elegance in my cooking, not provocation."

Sang cooked for his adoptive family at home and longed to become part of a professional kitchen, but was never given the chance, and studied as a sommelier to become part of the restaurant ambiance but he was never deterred. The first time he became a chef was when he opened his first restaurant, and a large part of his education was testing other restaurant's cooking, being disappointed with their techniques and doing better himself.

Sang often sees parallels between his Korean roots and his adoptive Belgian homeland. Both cultures, despite being worlds apart, have a culture of small gardens and niche products, and both are in touch with the seasons. Here in Belgium, he gets local pigeon, dairy products, pork and beef all with a radius of less than twenty kilometers. In Korea, he says, the diversity is impressive, especially with seafood, and people eat more colors, because color equals health, but of his birthplace he has no memories. That being said, the first time he returned, it was like something in his memory was activated, and he says: "I could smell I was home."

His bipolar culinary culture gets high tech treatment via sous-vide, immersion heating, and ultrasound, and Sang Hoon turns the familiar into fantastic, juxtaposing seemingly incongruous elements, and reinventing tradition. But at home, it's old school: vintage homemade kimchis, Japanese and Korean condiments (fermented bean pastes, vinegars of all sorts), and speculoos ("I gobble it down") all share space with his kids' cupcake experiments and tubs of Häagen-Dazs, his wife's Péché Mortel.

"We're made to eat everything, we're omnivores," says Sang. "We're not made to live 150 years." Although, he says, from time to time, we just need a bit of balance.

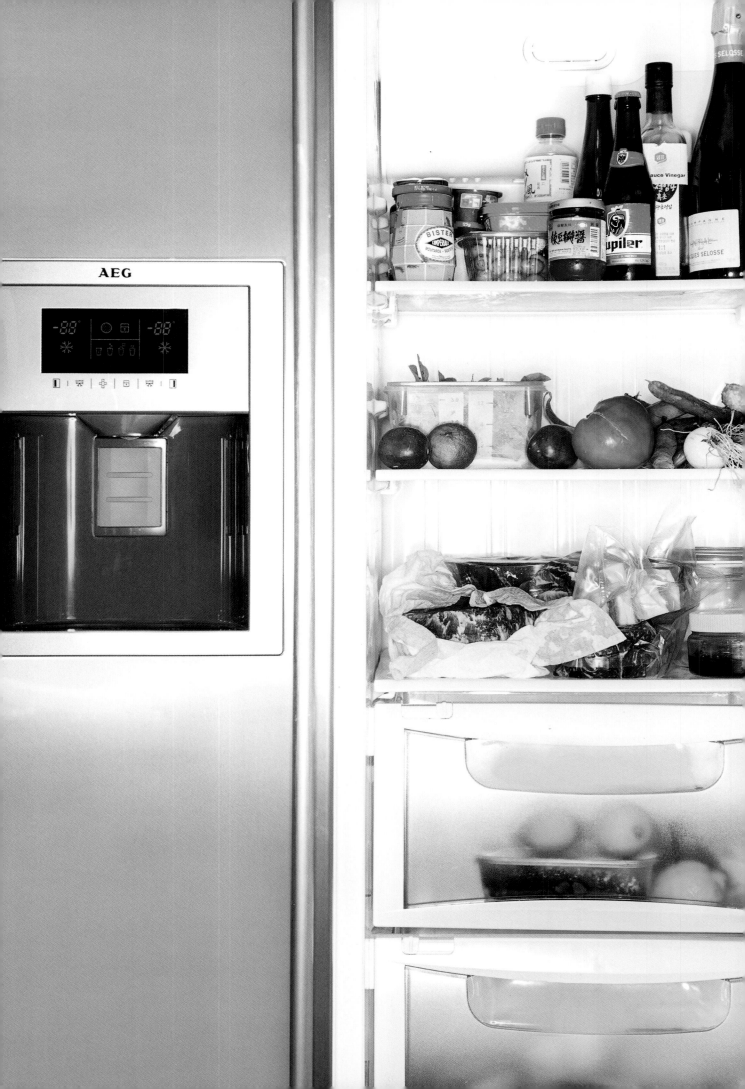

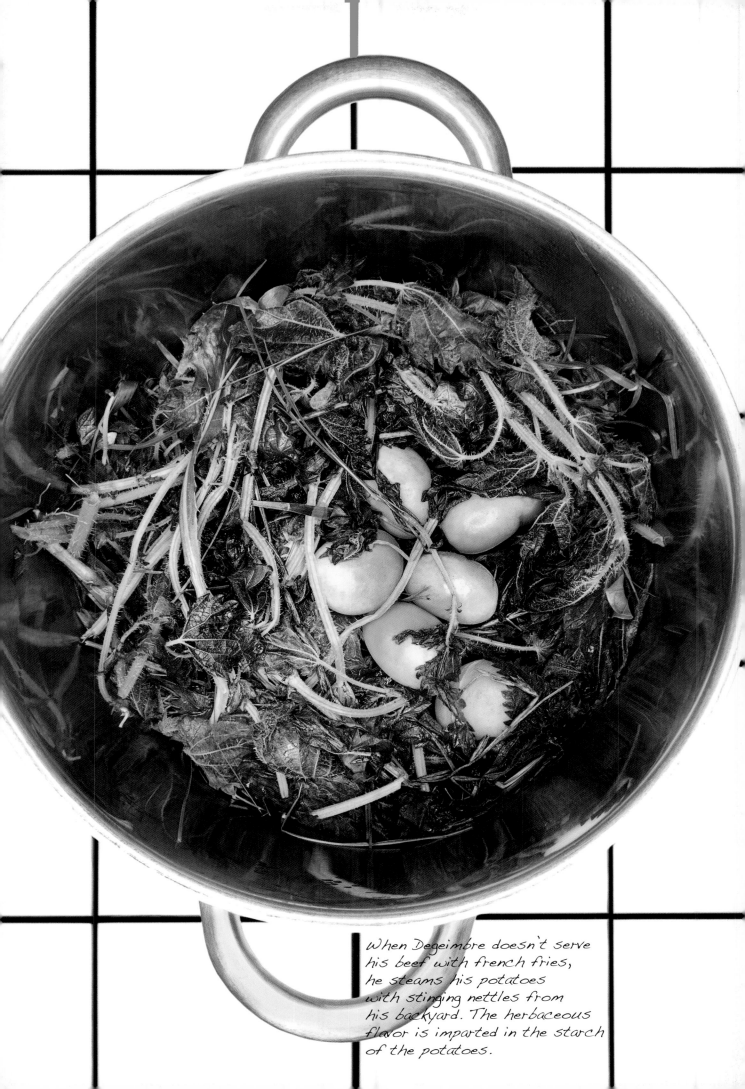

When Degeimbre doesn't serve
his beef with french fries,
he steams his potatoes
with stinging nettles from
his backyard. The herbaceous
flavor is imparted in the starch
of the potatoes.

1 Black bean garlic sauce
2 Strawberry yogurt
3 Mirin
4 Ssamjang
5 Green olives
6 Dijon-style mustard
7 Hot broad bean paste
8 Sesame oil
9 Belgian mustard
10 Soy sauce
11 Fresh herbs
12 Tomatoes from the garden
13 Broad beans
14 Beef from Rondou butcher, Leuven, Belgium
15 "Dong chi mi" fermented Daikon juice
16 Fermented Korean sansho buds

AEG S8609

COCKLES
AND ARTICHOKES

Serves 4

2 x 15cm (6 in.) strip of dried kombu
15ml (1 Tbsp.) soy sauce
4 Camus artichokes
Ascorbic acid
Salt
200g (7 oz.) dongchimi (radish water kimchi)
3g (.1 oz.) agar agar
20ml (1 Tbsp. plus 1 tsp.) lemon juice
40 large cockles
50g (3½ Tbsp.) salted butter

In a medium pan, simmer kombu and soy sauce in an abundant quantity of water for 1 hour. Meanwhile, steam artichokes until tender, 20 minutes. Once artichokes have cooled, peel away the outer leaves, and reserve the inner leaves and the hearts. Cut 2 of the hearts into small cubes, and soak in cold water with a little ascorbic acid and a pinch of salt. Place the 2 remaining artichokes hearts, along with the tender inner leaves and the butter, into a blender or food processor. Blend well, then pass through a sieve, discarding filaments. Season the purée with salt, and set aside. In a deep saucepan, bring dongchimi, agar agar, and lemon juice to a boil. Remove from heat, and transfer to a large bowl to cool. Purée this broth with an immersion blender until a gel-like consistency forms. Set aside. Once the kombu is cooked, slice it thinly and rinse it with water. Just before serving, heat a large, dry pan over medium heat. Toss cockles into the hot pan, and quickly cover. Remove cockles as they start to open, reserving cooking juice. Divide the artichoke purée among 4 deep bowls. Top with dongchimi sauce, cockles, and artichoke cubes. Serve the reserved cockle juice alongside.

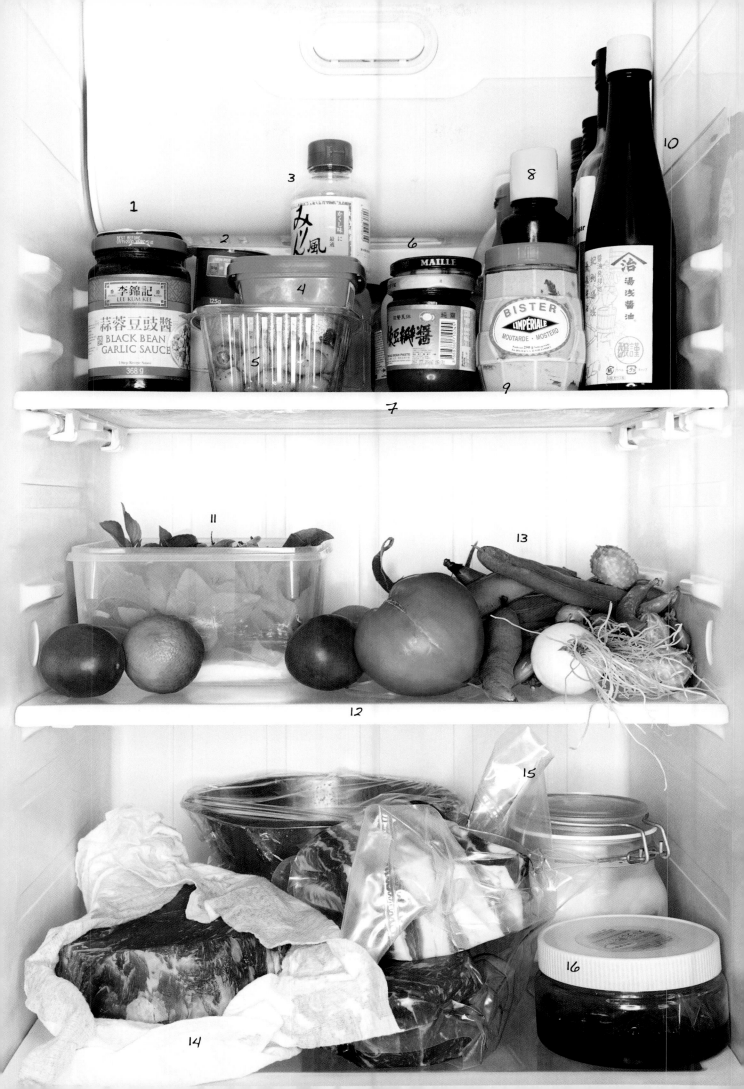

BLANC DE BŒUF / BEEF DRIPPINGS

Fallen out of fashion and replaced for the most part by healthier vegetable oils, there are still hard-core fans of rendered beef fat, which many believe make the best fish and chips, French fries, and pastries. It can even be found in sandwich form in some parts of Yorkshire, known as the "mucky fat sandwich" or buttie.

AGED BEEF
WITH FRENCH FRIES
AND *SSAMJANG* BUTTER

Serves 4–6

Ssamjang Butter

18g (.6 oz.) of hazelnut butter
54g (2 oz.) *ssamjang* (Korean "wrapping sauce" found in Asian markets)
14g (.5 oz.) ginger juice
8g (.3 oz.) pineapple juice

French Fries

6 large Bintje potatoes, peeled and sliced into fry-sized pieces
500g (1.1 lbs.) beef dripping
Salt

Côte de Boeuf

1.5kg (3.3 lbs.) côte de boeuf
30ml (2 Tbsp.) grapeseed oil
Maldon salt
Freshly ground black pepper

Prepare *ssamjang* butter by combining hazelnut butter, *ssamjang*, ginger juice, and pineapple juice in a medium bowl. Mix until a uniform paste has formed. Transfer to a flexible, 2.5cm half-sphere mold or a ramekin, and chill until firm.

Rinse and dry potato slices to remove starch. Heat beef dripping in a deep pot over high heat until dripping reaches 150°C (300°F). Fry potatoes in the beef dripping for 5–8 minutes. Using a slotted spoon or tongs, transfer potatoes to a paper towel–lined baking sheet to cool. Set aside.

Preheat oven to 80°C (175°F). Remove côte de bœuf from the refrigerator, and let come to room temperature. Lightly season the surface of the meat with salt. Heat grapeseed oil in a large skillet over high heat. Sear beef, flipping every 30 seconds, for 3 minutes total. Transfer côte de boeuf to a roasting pan, and place in the oven for 30 minutes. Repeat this process (browning the meat for 3 minutes, then letting it rest in the low-heat oven for 30 minutes) 4–5 times, until it's evenly cooked and has reached the desired temperature.

While beef is resting, finish the fries. Increase beef-dripping temperature to 190°C (375°F), and fry potatoes a second time, until golden brown. Remove from oil, transfer to paper towels to drain, and season with salt.

Season the steak with Maldon salt and freshly ground black pepper. Top with a large pat of *ssamjang* butter, and serve with fries.

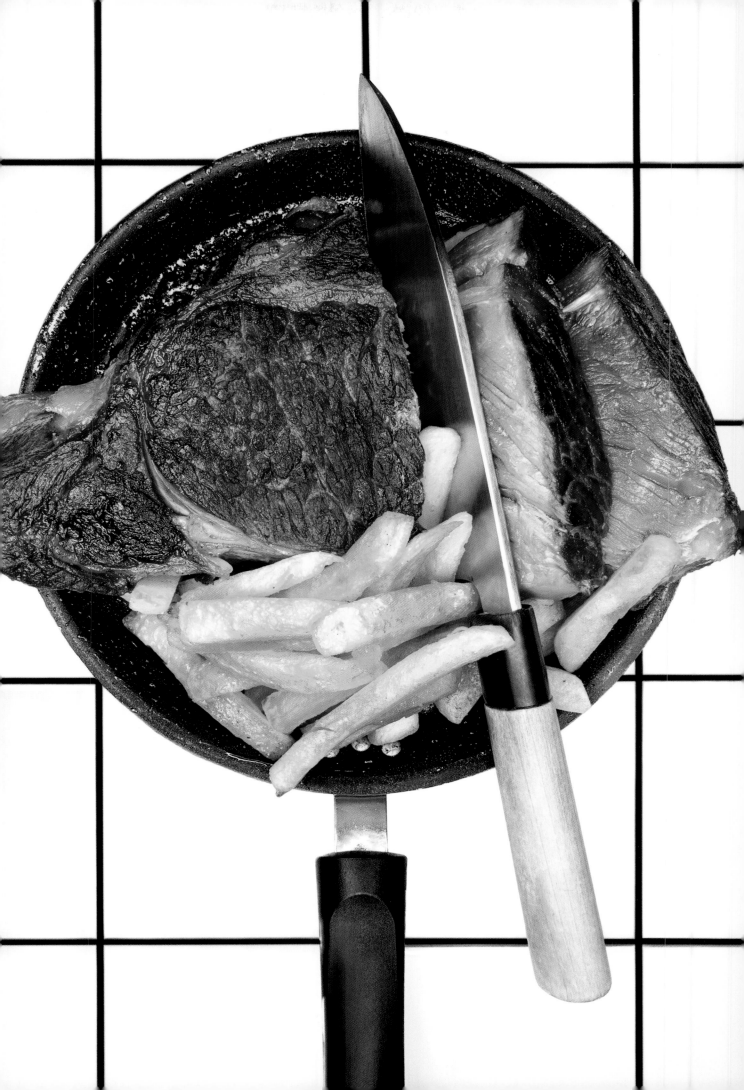

KOBE
DESRAMAULTS

IN DE WULF

Heuvelland, Belgium

This wild looking country boy has become a symbol of the new cutting edge generation of Belgian chefs who churn out innovative dishes that attract destination diners from around the globe. Desramaults spent his childhood in Dranouter and his teens roaming the countryside and getting into trouble. It was only when his mother, tired of his antics, sent him away to apprentice with three-star Michelin rated chef Sergio Herman that he discovered not only his passion for cooking, but exciting new techniques that would allow him to harness a creativity which formerly had no outlet. He ended up buying the family restaurant, forging his own culinary style and quickly gained a reputation as one of the Benelux regions bright new culinary stars. His use of rigorously locavore products, with most herbs, vegetables, and protein served coming from the dark and foreboding surrounding woods, has become his trademark.

His retro style home kitchen, designed by his artsy wife, is dominated by a faux-vintage SMEG, and the fridge is half-filled with food gifts from his foreign interns and visiting chefs. Pickling jars full of experiments (fermented carrots and onions) share space with everyday supermarket goods (Carrefour pickles, Heinz ketchup), and comforting foodstuffs (speculoos, confiture de lait) rub shoulders with the exotic (Korean black bean garlic sauce) and the luxurious (Jacques Selosse Initial Champagne).

His beloved hometown also has a dark streak, an ominous history. The same woods where he harvests his herbs were once home to the largest population of wolves in Europe, he says, before deforestation killed them off. People were burned here for witchcraft too. He seems visually rooted here too, with tattoos of the surrounding woods, dark branches inked up and down his arms, and despite his vagabond youth, he's changed. "I've always been a rebel," he says, "but, now I know what I want to do and it's in a more controlled way, this place will always be my home, but now it seems, it's the world that's coming to my doorstep."

SMEG FABIOLP

ELDERFLOWER VINEGAR
Practically impossible to procure commercially,
elderflower vinegar is made by steeping handpicked flowers
of the ornamental elderflower shrub in vinegar.

Pickled carrot
13/6/14

PICKLED CARROTS

Makes 1 large jar

200ml elderflower vinegar
200ml (⅔ cup plus 1½ Tbsp.) water
50g (¼ cup) granulated sugar
2g (¼ tsp.) salt
1kg (2.2 lbs.) mini (baby) carrots,
preferably organic (If mini carrots aren't
available, use organic carrots sliced
into small sticks.)

Bring vinegar, water, sugar, and salt to a boil
in a medium pot. Remove from heat and
cool completely. Wash the mini (baby) carrots
and place in a glass jar. Pour the cooled liquid over
the carrots, making sure that carrots are completely
submerged. Wipe rims, seal, and let pickle
for 1 month in refrigerator. Store the pickles
in the refrigerator or a cool environment.

SPÄTZLE
WITH BROAD BEANS AND
PICKLED CARROTS

Serves 4

350g (12 oz.) spätzle
150g (5 oz.) broad beans, shucked
20g (1½ Tbsp.) butter
2 small shallots, minced
Handful lovage leaves
30ml (2 Tbsp.) sushi vinegar
30ml (2 Tbsp.) soy sauce
100g (3.5 oz.) pickled carrots, chopped
100g (3.5 oz.) Oud-Brugge cheese, grated
Sea salt

Bring a large pot of water to a boil. Cook spätzle
until tender, 8 minutes. During the last minute of
cooking, add the shucked broad beans.
Drain the pasta and beans. Heat butter in a large,
non-stick skillet. Add spätzle, broad beans, shallots,
lovage, sushi vinegar, and soy sauce.
Sauté for a few seconds. Add carrots, season to
taste with sea salt, and sprinkle grated Oud-Brugge
cheese on top.

CACOUYARD COW'S
MILK CHEESE
"TASTES LIKE
A REBLOCHON
FINISHED WITH
NUTMEG"

FERMENTED
FISH SAUCE

AGED GOUDA
CHEESE

SPECULOOS
SPREAD

BELGIAN
CHOCOLATE SPREAD

PICKLED CARROTS

BELGIAN BEER

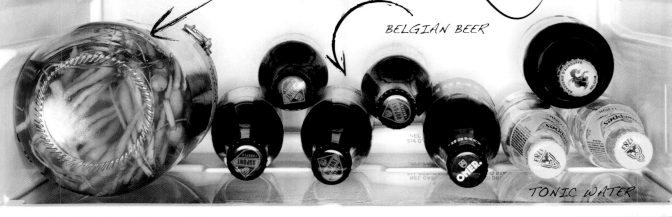

TONIC WATER

SPRING ONIONS

RADISHES

CELERY

NIKLAS
EKSTEDT

RESTAURANT EKSTEDT

•··•

Stockholm, Sweden

One of Sweden's foremost celebrity chefs, cook show hosts, and cookbook authors, Niklas Ekstedt once hoped to become a professional snowboarder until an accident literally broke his back. No longer able to seriously pursue his sporting passion, he turned to his second area of interest, food. Ekstedt went to cooking school in his native northern Sweden (where Magnus Nilsson was an alumni) then trained with some of the greatest chefs in the world (Charlie Trotter, Heston Blumenthal, Ferran Adrià), eventually opening his eponymous restaurant in Stockholm.

Ekstedt turned pre-established dining notions on their head when it opened and quickly garnered a Michelin star for its high quality and innovative cooking.

"I wanted to do a really rustic, yet high-end restaurant, inspired by ancient Nordic techniques, but with a very contemporary presentation," Ekstedt explains. "We didn't want to be just another Noma, that would have been ridiculous."

Ekstedt's novel concept was based on Swedish fire pit cooking, an outdoor pursuit that seemed to have gone the way of the dinosaur, and his kitchen has no electricity whatsoever, except for necessary ventilation and refrigeration: "We didn't even want that much technology, we wanted it real old school," he muses. "But the safety inspectors thought otherwise." That being said, Ekstedt is widely recognized as one of the most forward thinking restaurants in Scandinavia, as much for its haute technique driven approach, as for the primordial dining experience provided by the battery of birch wood fired stoves and smoking cast-iron pans.

The chef always makes time to cook at home as his wife is, in his words, "not the best cook" (he invokes past meals of destroyed meat and rock hard cake), and there's always something on the table. Family favorites include pasta "macaroni and cheese is, believe it, a very Swedish thing"), mozzarella ("my kid eats ½ kilo per week"), raw vegetables from his city garden, and a kid-driven fusion cuisine: "They love homemade chili sauce with everything; rice, even with Swedish meat-balls, and they won't eat chicken without Vietnamese plum sauce." The industrial size fridge also has its own funky culture: vats of fermenting chili and marinating rhubarb, lots of pickled fish delicacies for the children and a latent fish meets lingonberry odor that emanates from the top shelf. The adjoining, spacious freezer, however, only hides away a few sad, forgotten birthday cakes from days gone by.

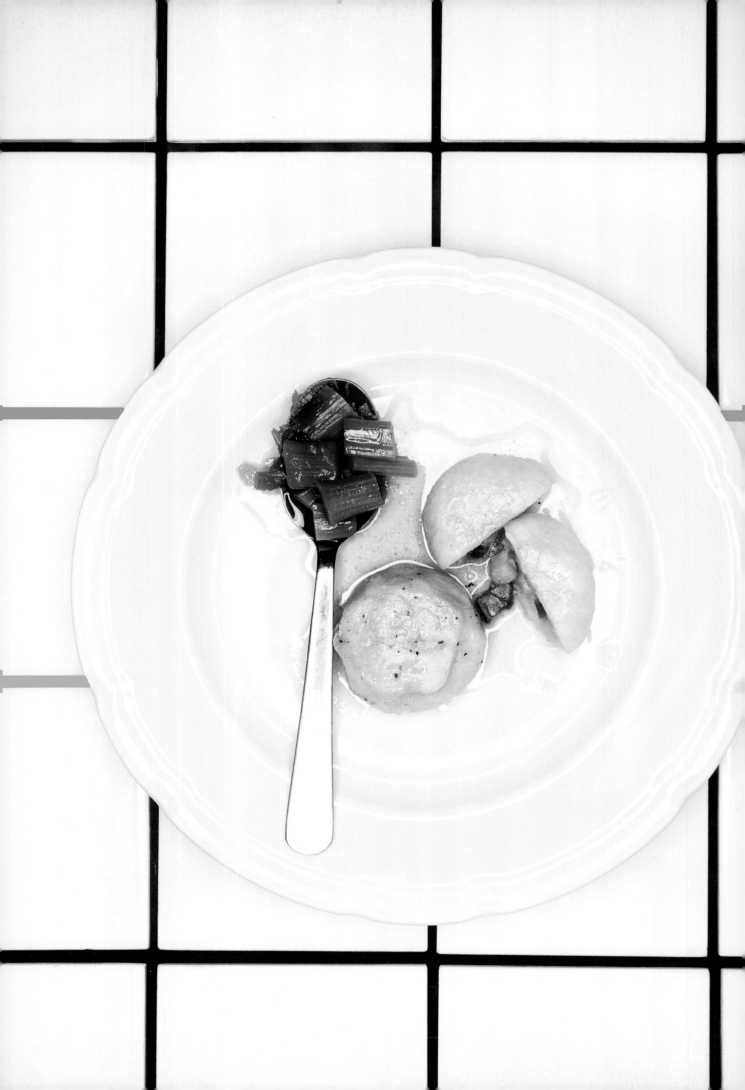

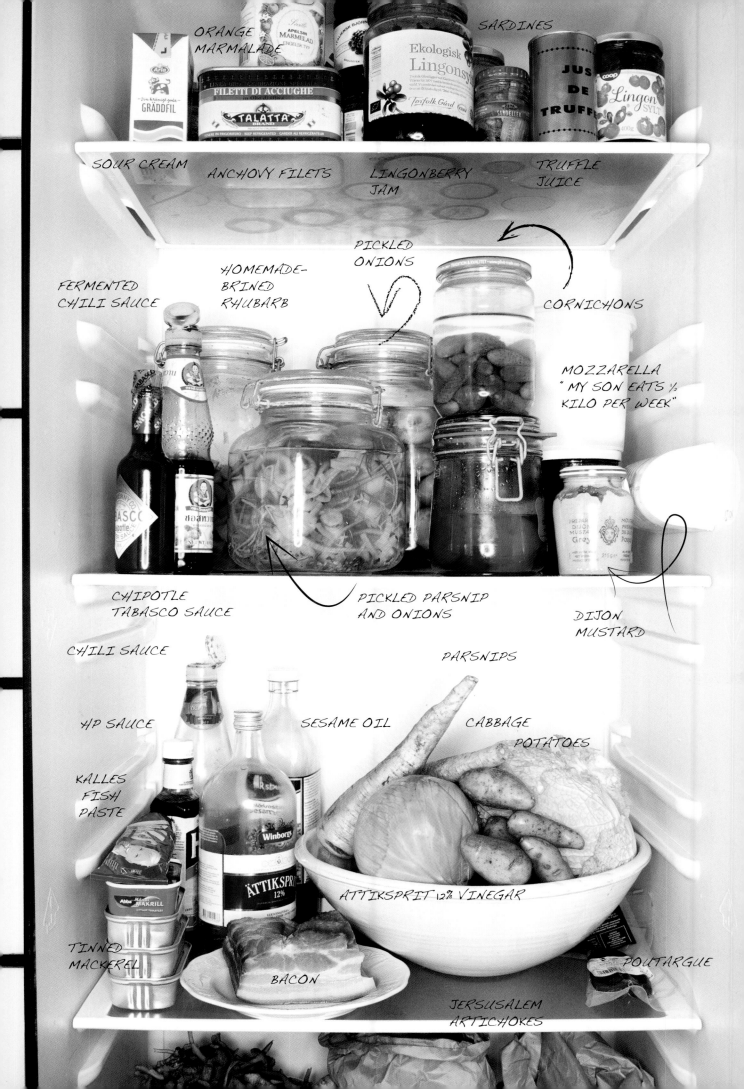

ORANGE
MARMALADE

SARDINES

SOUR CREAM ANCHOVY FILETS LINGONBERRY TRUFFLE
 JAM JUICE

FERMENTED
CHILI SAUCE

HOMEMADE-
BRINED
RHUBARB

PICKLED
ONIONS

CORNICHONS

MOZZARELLA
" MY SON EATS ½
KILO PER WEEK"

CHIPOTLE
TABASCO SAUCE

PICKLED PARSNIP
AND ONIONS

DIJON
MUSTARD

CHILI SAUCE

PARSNIPS

HP SAUCE SESAME OIL CABBAGE
 POTATOES

KALLES
FISH
PASTE

TINNED
MACKEREL

BACON

ATTIKSPRIT 12% VINEGAR

POUTARGUE

JERSUSALEM
ARTICHOKES

BOILED POTATO DUMPLINGS
(KROPPKAKOR)

Makes 8 Dumplings

150g (11 Tbsp.) butter, divided
700g (1.5 lbs.) potatoes, peeled, chopped
3 egg yolks
150g (5 oz.) potato starch
5ml (1 tsp.) salt
400g (14 oz.) thick-cut salt-cured bacon, finely chopped
1 yellow onion, finely chopped
2 pinches ground allspice
Lingonberry sauce (for serving)

Melt 100g (7 Tbsp.) butter in a saucepan until the milk proteins start to color. Set aside. Boil potatoes in salted water until tender. Drain potatoes. Once cool enough to handle, mash potatoes, and stir in remaining butter, egg yolks, potato starch, and salt to form dumpling dough. Cover with plastic wrap and let chill 30 minutes.

Cook the bacon in a small skillet over medium heat until crisp. Remove from pan; do not wipe out skillet. Sauté onion in the bacon fat, and season with allspice.

Roll out the dough on a clean, lightly floured surface. The dough should not be sticky; if it is, ad a little bit of flour. Divide the dough into equal-size pieces, and roll into 8 golf ball-sized dumplings. Make a small indentation in each ball. Place a couple tablespoons of the bacon and onion filling inside. Pinch edges of dough around filling to seal, and roll into a uniform ball. Bring a large pot of water to a boil. Add dumplings. When dumplings float to the surface, remove from water using a slotted spoon. Serve with lingonberry sauce and the reserved brown butter.

OLLE'S PICKLED RHUBARB

Makes 2 Jars

70g (5½ Tbsp.) sugar
400ml (1⅔ cups) vinegar
4cm (1½ in.) ginger, peeled
2g (½ tsp.) whole cloves
1 bay leaf
2kg (4.4 lbs.) rhubarb, peeled, cut into 2cm (¾-inch) pieces

In a large pot, boil sugar and vinegar until sugar dissolves. Add ginger, cloves, and bay leaf. Remove from heat. Let liquid cool for 30 minutes. Return pot to heat, add rhubarb, and cook over medium heat for 10 minutes. Strain rhubarb, reserving liquid. Once the liquid and the rhubarb have cooled, divide the rhubarb among a couple jars, and cover with the liquid. Cover jars with lids and seal. To process jars, bring a large pot of water to a boil, and boil each jar for 15 minutes. The pickled rhubarb is ready to eat after 1 week.

Special thanks to Ekstedt's friend Olle Tagesson for sharing his recipe.

SMEG FAB50PS

SVEN
ELVERFELD

AQUA

• •

Wolfsburg, Germany

In the heart of the German automobile industry lays the unlikely home of one of Germany's greatest chefs. Formerly a long-haired musician who worked his way through pastry, cooking, and hotel schools in Crete, Tokyo, and Kyoto, then working in the wilds of Dubai, Elverfeld has created one of the world's best restaurants in this octane-fueled region.

His home kitchen is in a modern duplex in an anonymous part of old Wolfsburg, and although the kitchen is ultra high tech, with many of the same devices in use that power his three-star Michelin table, the Thermomix here has been adapted to making baby food for his young child at the moment.

Elverfeld finds his inspiration in everything. "Once you start ignoring things, you're finished," he says. His time as a junior chef in Dubai or Greece inspire him as much as discovering new dishes in Tokyo or Hong Kong. He canvasses markets and street stalls, learns new techniques and uses what he learned to go back to his roots to remix, so to speak, new taste experience s.

He mixes up his fridge contents too: he has Cretan specialties (he's a big Greek food geek), like root vegetables unavailable in mainland Europe, to bootleg raki, feta, and tzatziki, and the top shelf is reserved for homemade jams from momma and his mother-in-law. One staple is his favorite green Frankfurt sauce, made with watercress and herbs, and he eats it with hardboiled eggs cut with a Japanese mandolin. As a special touch he sometimes adds quark (a German cottage cheese), instead of the more usual sour cream.

"I tend to like the simple things that harken back to my roots. One thing I will always love is scrambled eggs, spinach, and cooked potatoes, which I used to eat all the time as a kid. Everything fits so well together, and it's even inspired my dishes. Except now that version has black truffles, of course, *Ja*?"

MIELE KF

Grüne Soße / Green Sauce

Frankfurter green sauce, a seasonal herbal sauce found in the area
around Frankfurt and Hessen, is a well-loved local favorite,
not found elsewhere in Germany, but likely originating in the Near
East. The sauce, comprised of at least seven herbs (borage, chervil,
chives, garden cress, parsley, salad burnet, and French sorrel)
is mixed with buttermilk and sour cream (or yogurt), hard-boiled
eggs, oil, vinegar, salt and pepper.

Other popular variants might include mayonnaise, onion, mustard,
sugar, and lemon juice. German food law protects the sanctity of
green sauce, and only sauces from herbs originating in the Frankfurt
area may carry the name Grüne Soße. It is served cold and
typically eaten with eggs and potatoes.

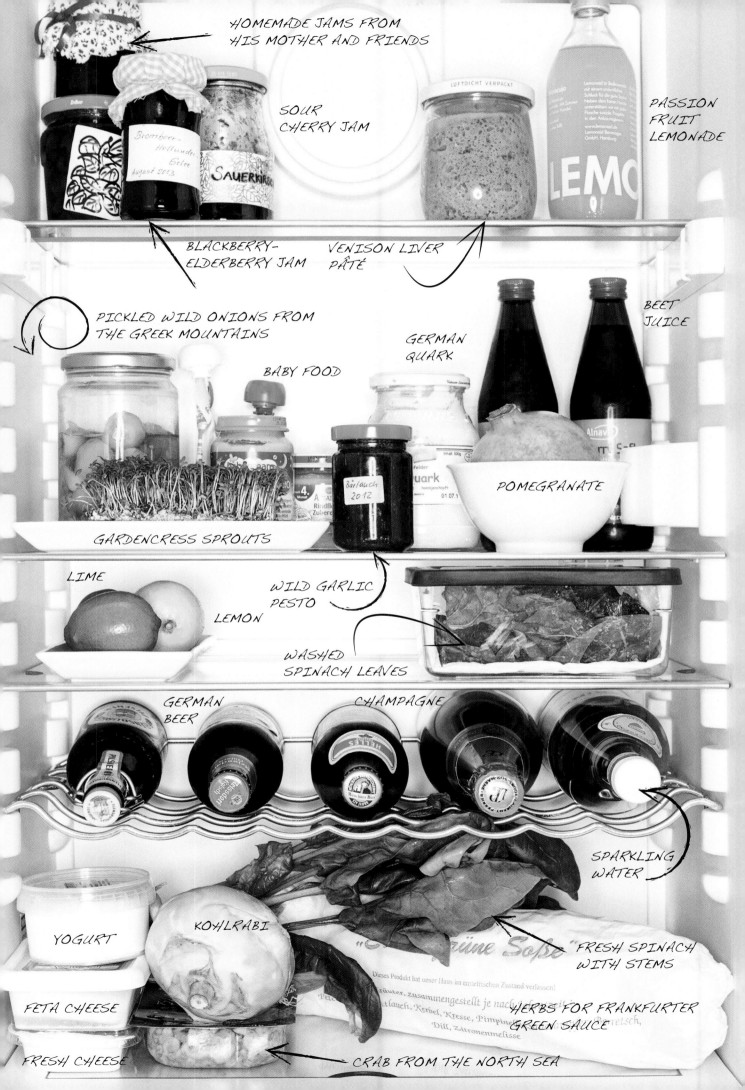

BEETROOT WITH SPINACH, POMEGRANATE SEEDS, AND POTATO CHIPS

Serves 4

Beetroots
40g (3 Tbsp.) butter
Sea salt
8 small beetroots (preferably a mix of white, yellow, and red), scrubbed, unpeeled

Vinaigrette
5ml (1 tsp.) white wine vinegar
5ml (1 tsp.) 12-year-aged balsamic vinegar
1 shallot, finely diced
3g (½ tsp.) Savora mustard
80ml (⅓ cup) vegetable broth, warmed
90ml (6 Tbsp.) olive oil, preferably from Crete
15ml (1 Tbsp.) hazelnut oil
15ml (1 Tbsp.) Argan oil Salt
Freshly ground white pepper

Potato Chips and Assembly
400ml rapeseed oil
4 small waxy potatoes, peeled, thinly sliced on a mandolin
2g (1 tsp.) purple curry powder
Sea salt
30ml (2 Tbsp.) olive oil, preferably from Crete
1 bunch young spinach leaves
Freshly ground white pepper 40g (1.4 oz.) deep red pomegranate seeds
1g (1 tsp.) dried wild mountain oregano, preferably from Crete
120g (4.2 oz.) feta cheese, grated

Beetroots:
Preheat oven to 150°C (300°F). Cut 8 pieces of aluminum foil. Divide butter and salt among the aluminum foil pieces. Place a beetroot on each square, and close foil tightly around beetroot. Transfer packets to a large pot or baking dish, and roast until tender, 60–90 minutes, depending on the size of the beetroots.

Vinaigrette:
Whisk together white wine vinegar, balsamic vinegar, shallot, mustard, and warm broth. Whisk in olive, hazelnut, and Argan oils, little by little, emulsifying vinaigrette. Season with salt and pepper. Once beetroots are cool enough to handle, remove the foil. Peel beetroots and cut into .5cm (¼-inch) slices. Gently toss the beetroots with the vinaigrette, and allow to marinate while you fry the potato chips.

Potato Chips and Assembly:
Heat oil in a deep pot. Once the oil reaches 130–140°C (270–280°F), deep-fry the potatoes until they turn golden. While the potatoes are deep frying, keep them in constant motion. Remove the chips with a skimmer, and drain on paper towels. Sprinkle immediately with sea salt and purple curry powder.

Heat oil in a skillet over medium heat. Add spinach, season with sea salt and pepper, and cook, stirring occasionally, for a few minutes. Divide the beetroot slices with vinaigrette and spinach leaves among 4 plates. Sprinkle with pomegranate seeds, feta cheese, oregano, and the potato chips.

CRAB AND EGG "TACOS"
WITH FRANKFURT GREEN SAUCE

Serves 4

½ loaf brown bread

180g (6 oz.) mixed herbs, such as curly parsley, chives, chervil, sorrel, borage, garden cress, tarragon, lovage, lemon balm, burnet, and dill

50ml (1 Tbsp. plus 1 tsp.) grapeseed oil, divided

2g (½ tsp.) sugar

5ml (1 tsp.) lemon juice

Salt

Freshly ground black pepper

2 eggs, preferably free-range

250g (9 oz.) crab meat, preferably from Büsum (on Germany's North Sea coast)

100g (3.5 oz.) watercress, stemmed, chopped

1 shallot, finely chopped

5ml (1 tsp.) white balsamic vinegar

140g (5 oz.) quark, cottage cheese, or natural yogurt

70g (2.5 oz.) sour cream

3g (1 tsp.) mustard

Two hours in advance, place bread in the freezer. Preheat oven to 120°C (250°F) on a convection setting. Remove the frozen bread from the freezer, and cut 4 very thin slices (about 2–3mm or ⅛-in. thick) with an electric bread knife or electric slicer. The bread should be sliced thinly enough that it is pliable. Hang the slices on a grill rack in the oven, allowing sides to drape down, and bake for 10 minutes, until they hold their shape. While baking, the bread should form an upside-down taco.

Meanwhile, prepare the sauce. Toss mixed herbs together. Set aside a handful of the herb mixture. In a blender or with an immersion mixer, purée the remaining herbs. Press through a fine-mesh sieve, and discard the filaments. Refrigerate green sauce. In a separate bowl, whisk together 20ml (1 Tbsp. plus 1 tsp.) grapeseed oil, sugar, and lemon juice. Season with salt and pepper. Refrigerate vinaigrette.

Place eggs in a medium saucepan. Add water to cover, and bring to a boil. Immediately remove from heat, cover, and let stand 10 minutes. Peel eggs and mash with a potato press. Season with salt and pepper. Don't stir. Cover and reserve.

Just before serving, warm crab meat in the remaining 20ml (2 Tbsp.) grapeseed oil in a skillet. Fill each "taco" with the crab meat. Top with watercress and reserved fresh herbs, and finish with the vinaigrette. Pour the green sauce into 4 deep plates, and place the prepared tacos on top of the green sauce.

KLAUS **ERFORT**

GÄSTEHAUS KLAUS ERFORT

• •

Saarbrücken, Germany

With a restaurant at the crossroads of Germany, France, and Luxembourg, Klaus Erfort might be the most important German chef you've never heard of. Ensconced in the industrial city of Saarbrücken, a city that has had a mercurial existence throughout history, and which is a stone's throw from the French border, Erfort creates some of the most perfectly wrought cooking in the region. From an elegant townhouse replete with beautiful park views on the edge of town, his elegant, precise cuisine, with exceptional products from across the French border entices gastronomes from near and far.

Erfort, who trained under such notable German chefs as Claus-Peter Lumpp and at Harald Wohlfahrt's famous Black Forest establishment, is known as much for his media shy discretion as for his complete absorption in his craft, unswayed by the media frenzied world of other star chefs. "Truth is," Erfort says, "on the plate," and he seeks to recapture the original taste of products and keep dishes as simple and true to their own nature as possible. The humble chef gained his three Michelin stars in the record time of six years, and even this he downplays: "Three stars for us was a nice reward, but not an objective we were working towards, it just happened."

"I'm not often at home and I always eat at the restaurant," says Erfort of his marathon working days. "However, there is always fresh, healthy food in the fridge for the weekend, and good bottles of wine." On weekends, he'll have a croissant and some eggs, but during the week, it's just a cup of coffee before he runs off to work. When Erfort does get time off, he treats himself to similar food as served in his fine dining establishment: fresh langoustines with artichoke hearts, and good Champagne (Pommery, Dom Ruinart), although his top shelf doesn't rule out pedestrian supermarket food, and jars of Maille mustard, Heinz ketchup, and Nutella seem to get pretty good usage. On rare moments, he might eat a bowl of mass-produced potato chips.

And in those moments where service is over and the demands of work and family are far away, Erfort grabs his chilled Porsche water bottle out of the fridge and goes for a high speed jaunt in his Teutonic sports car through the surrounding countryside before going home to rest and attacking the day again.

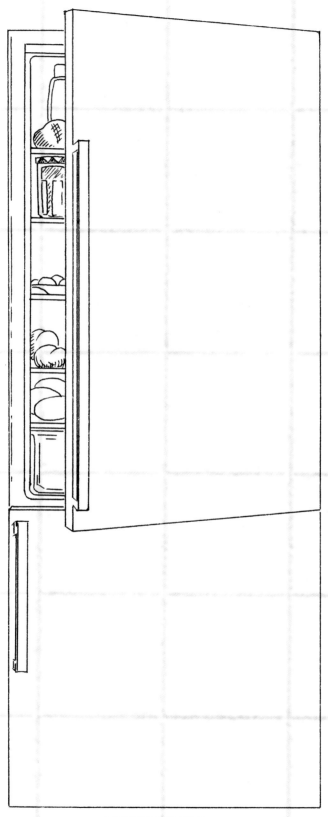

GAGGENAU VARIO RT 289

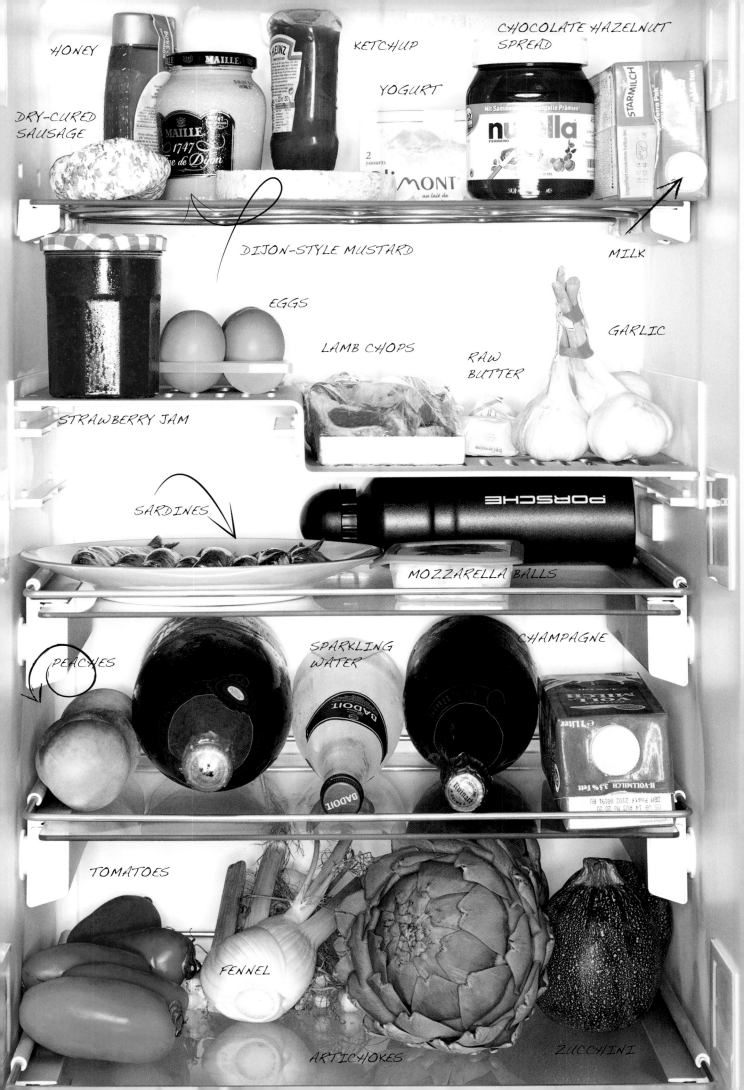

ALSATIAN STEW
(*BAECKEOFFE*)

Serves 8

500g (1.1 lbs.) boneless beef chuck roast,
cut into 5cm (2 in.) pieces
550g (1.2 lbs.) boneless leg of lamb,
cut into 5cm (2 in.) pieces
550g (1.2 lbs.) boneless pork loin,
cut into 5cm (2 in.) pieces
4 leeks, white parts only, cut into 5cm (2 in.) pieces
2 large onions, cut into wedges
4 garlic cloves, finely chopped
Freshly ground black pepper
750ml (1 bottle) pinot blanc, preferably from Alsace
1 bouquet garni (1 small stalk celery with leaves,
1 bay leaf, 1 sprig flat-leaf parsley, and 1 sprig thyme,
tied together with kitchen twine)
75g (5 Tbsp.) butter, divided
1kg (2.2 lbs.) potatoes, peeled, thinly sliced
Sea salt

In a large bowl, combine beef chuck roast, leg of
lamb, pork loin, leeks, onion, and garlic.
Season with freshly ground black pepper.
Cover mixture with wine, and add bouquet garni.
Marinate overnight in the refrigerator.

The following day, preheat oven to 160°C (320°F).
Remove meat, vegetables, and bouquet garni
from the marinade. Reserve marinade. Heat 60g
(4 Tbsp.) butter in a large skillet over medium heat.
Add meat, and cook until browned on all sides.
Set meat aside.

Grease a large cast-iron pot with remaining butter.
Layer ¼ of the potatoes on the bottom of the pot,
and season with sea salt and freshly ground black
pepper. Add ⅓ of the meat mixture, then ⅓ of the
vegetables and the bouquet garni. Repeat twice,
seasoning each time between layers.
Finish with a layer of potatoes. Pour reserved
marinade over top, seal with aluminum foil, cover
with lid, and bake until meat and vegetables are
tender, 2½ hours.

SARDINES WITH EGGPLANT AND TOMATO RAGOUT

Serves 4–6

100g (3.5 oz.) black olives, finely chopped
8g (1 Tbsp.) icing (powdered) sugar
20 plum tomatoes
2 garlic cloves, minced
2g (2 tsp.) rosemary, minced, divided
2g (2 tsp.) thyme, minced, divided
200g (7 oz.) canned, skinless tomatoes
1 eggplant, halved lengthwise
30ml (2 Tbsp.) olive oil, plus more
15ml (1 Tbsp.) balsamic vinegar
Salt
Freshly ground black pepper
24 sardine filets
1 bunch basil, freshly chopped
Freshly ground black pepper

Preheat oven to 80°C (175°F). Dust olives with icing
(powdered) sugar. Place olives on a parchment-
lined baking sheet, and dry olives in the warm oven
for about 1 hour. Set dried olives aside.

Meanwhile, bring a large pot of water to a boil,
and very briefly blanch the plum tomatoes.
Peel and quarter tomatoes. Toss with the garlic
and a generous pinch of both the rosemary
and thyme. Place the tomatoes on a separate
parchment-lined baking sheet, and transfer to
the warm oven to dry for 1 hour. Combine the dried
tomatoes and the canned tomatoes in a deep
saucepan. Bring to a boil, reduce heat, and simmer
until reduced to a ragout, 25 minutes.

Raise oven temperature to 160°C (325°F). Season
eggplant with a generous pinch of rosemary and
thyme and a drizzle of olive oil. Roast in the oven
until soft, 25 minutes. Remove eggplant from oven,
and dice. Toss eggplant with balsamic vinegar,
salt, pepper, the remaining thyme and rosemary.
Heat 30ml (2 Tbsp.) olive oil in a skillet, and lightly
sauté the sardine filets.

Divide the tomato ragout among 4 plates, and set
sardine filets on top. Add eggplant caviar, drizzle
with olive oil, and sprinkle with freshly chopped basil
and the dried olives.

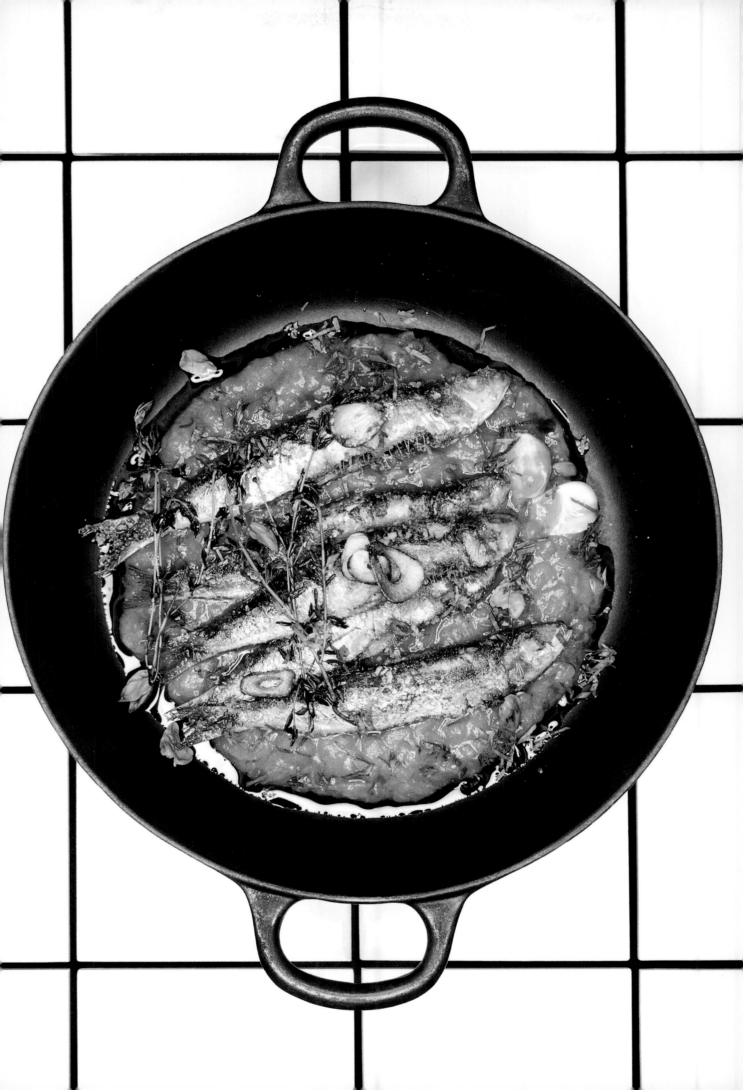

ANNIE
FÉOLDE

ENOTECA PINCHIORRI

•·································•

Florence, Italy

The first female chef to obtain three Michelin stars outside of France (the first were the legendary Mère Brazier and Mère Bourgeois in the 1950s in Lyon), Annie Féolde originally came to Italy to improve her language skills, and found work in a little restaurant. She met her sommelier future husband Giorgio when he worked at a restaurant called Buca Lapi, then at the Enoteca Nazionale where, as was normally done in wine bars, he was serving wine without any accompanying food. This moment sparked her interest in cooking. She started complimenting his wine choices with appetizers, then added a buffet, pasta, meat, all the while improving the quality of the products, and her technique. After much trial and error, word got out, and the Enoteca Pinchiorri started to draw the ultimate accolades from all the top local and international publications as well as a well-heeled clientele looking for very high level cooking in the Florentine city.

Féolde is rarely at home, and most days she eats at her restaurant, although there are always a few staples in her tiny, functional fridge. The upper shelves have ham and mozzarella, mayonnaise and tom yum paste, anchovies, caviar, and anchovy cream. "You can do great stuff with this, easily, like salad sauces, it is so good." Her freezer has delicacies from the restaurant such as veal sweetbreads and tongue, and a portion of one of her grandmother's "wonderful" recipe: red cabbage and chestnut stew with salted pork.

Her favorite comfort food though is from Asia: "I love Thai cooking and whenever I go, I bring back products. I love their soups with coconut milk and lemongrass, to which I add king prawns and mushrooms I bring back from over there. The taste is totally different."

And even though she is a French woman who has lived in Italy for four decades, she still has no idea if the Italians have adopted her or not. "When I say chez moi, I still don't know whether I'm talking about Nice or Florence. In fact, I love all the countries in the world, because what I love is traveling and meeting people."

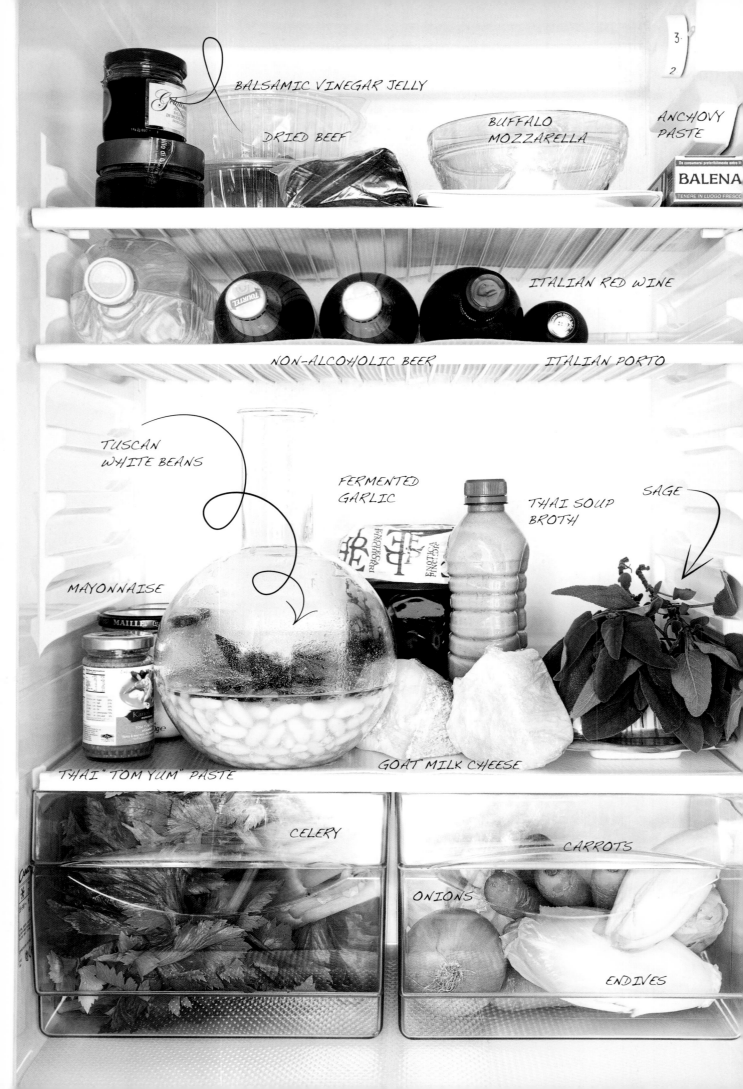

BALSAMIC VINEGAR JELLY

DRIED BEEF

BUFFALO MOZZARELLA

ANCHOVY PASTE

BALENA

ITALIAN RED WINE

NON-ALCOHOLIC BEER

ITALIAN PORTO

TUSCAN WHITE BEANS

FERMENTED GARLIC

THAI SOUP BROTH

SAGE

MAYONNAISE

GOAT MILK CHEESE

THAI "TOM YUM" PASTE

CELERY

CARROTS

ONIONS

ENDIVES

ORZO (*RISONI*)
WITH LIME AND GARLIC BREADCRUMBS

Serves 4

10ml (2 tsp.) olive oil
1 garlic clove, smashed
50g (⅓ cup) panko (Japanese breadcrumbs)
Salt
Freshly ground black pepper
70g (5 Tbsp.) butter, divided
20g (1 Tbsp.) shallots, minced
200g (1 cup) *risoni* (orzo)
20ml (1 Tbsp. plus 1 tsp.) white wine
½ L (2 cups plus 2 Tbsp.) chicken stock
20g (1 Tbsp.) Parmesan
1 lime, zested

Heat olive oil over medium in a nonstick skillet.
Add garlic, followed by panko. Season with salt
and pepper. Sauté until breadcrumbs are golden
and crunchy, stirring occasionally. Set aside.

Melt 50g (3½ Tbsp.) butter in a large saucepan over
medium heat. Add shallots and *risoni*, and sauté
until shallots are tender, stirring occasionally.
Add white wine, and cook until it evaporates.
Continue cooking, adding the chicken stock little by
little and stirring often, until the *risoni* reaches
a risotto-like consistency, about 10 minutes.
Remove from heat.

Stir in remaining butter, Parmesan, and lime zest.
Season with salt and pepper to taste.
Top with a sprinkling of garlic breadcrumbs.

TUSCAN BEANS

Serves 6

300g (11 oz.) cannellini beans
Olive oil
Salt
Freshly ground black pepper (optional)

Cover beans by two inches with cold water
and let soak for 12 hours. Drain and rinse beans.
Transfer to a large saucepan. Add 900ml (4 cups)
water, and bring to a boil. Reduce heat to a simmer,
and cook until beans are tender, about 2 hours.
To avoid breaking the beans, simmer very gently.
Drain beans. Season with a good drizzle of olive oil,
salt, and, if you like, freshly ground black pepper.

CANDY

ALEXANDRE GAUTHIER

LA GRENOUILLÈRE

•••••••••••••••••••••••••••••

La Madelaine-sous-Montreuil, France

Alexandre Gauthier was born a chef. After six years at a French hotel school, he spent three and a half years touring the great chefs' kitchens, coming back at his parents' behest to help keep the family restaurant La Grenouillère afloat. "I really wasn't planning on it, but I couldn't tell them no, I thought I'd stay two, three years maximum, but I never left."

When he arrived, his father stepped aside to help him find his way, discover his own identity, and how to run the kitchen staff. Alexandre started a dialogue with his father's old farmers and producers, and with a new perspective he transformed the menu with local produce and his own personal style.

Gauthier's style of cooking is, in his own words, a French cuisine liberated from all of its complexes, avoiding a proud, chauvinistic view and any sort of unfounded ideas about what French cuisine is. "It took me four years to find out what I wanted to do, to design the place, to find the team I wanted to work with. La Grenouillère has become like me and I have become La Grenouillère. Here I do my signature cuisine."

Home is a few kilometers away in town in a loft with an open kitchen and tiny fridge, and away from the restaurant he keeps it simple: "I've always got cheese, a bottle of wine, fruit, and yoghurt. I make pasta with zucchini and parsley, I fry up mandolin-cut broccoli with a bit of oil and *fleur de sel*."

"Nowadays, everybody is talking about New Nordic cuisine and its adherence to locavore principles. But there's nothing new about that. My land is France and this region. Here we're lucky to be close to the producers and the land, the sea, the rivers, the prairies, the forests, and the beaches . . . which allows us fishing, gathering, hunting, raising livestock, and gardening . . . all in a rich land that offers us a rare diversity of products."

Ch'ti beer

Fabricated by the same family brewery since the early 20th century, this pale ale, hailing from Nord pas de Calais close to the French / Belgian border is emblematic of this proud and hardworking region. The beer is a biere de garde (" keeping beer"), which was developed from the process in which farmhouse ales were stored in the springtime and kept until warmer seasons came along. The beer has fruity, malty, and spicy notes with a slightly bitter aftertaste.

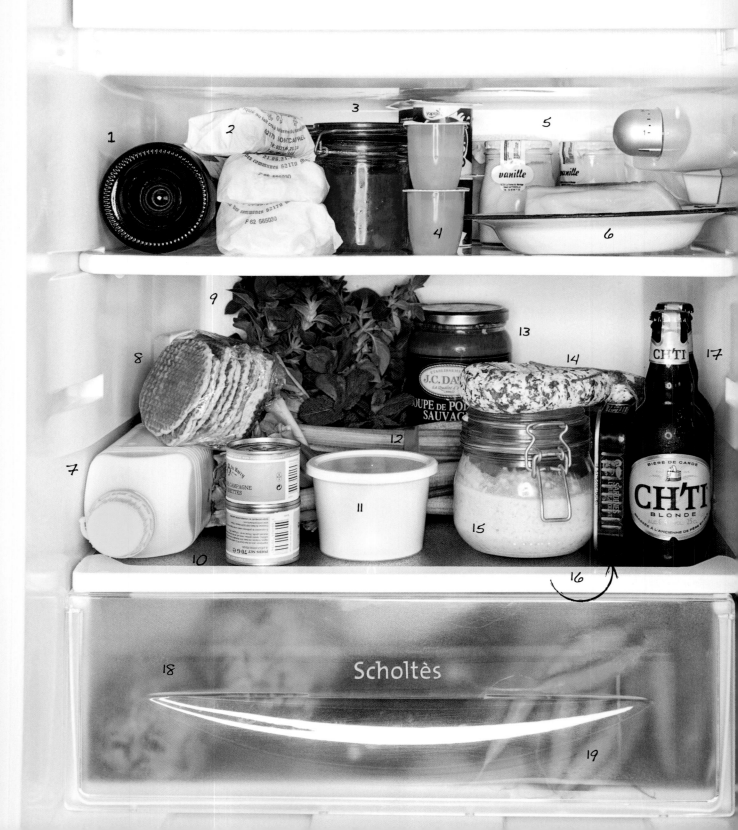

1	Wine (Chardonnay)	11	Crème fraîche
2	Butter from Montcarvel	12	Rhubarb
3	Fruit jam	13	Fish soup
4	Kid's yogurt	14	Sausage
5	Vanilla yogurt	15	Rice pudding
6	Chimay monastic cheese	16	Sardines
7	Whole milk	17	Local beer from Northern France
8	Waffles	18	Artichokes
9	Fresh herbs	19	Carrots
10	Quail terrine from his mother's shop		

RICE PUDDING
(*RIZ AU LAIT*)

<u>*Serves 4*</u>

500ml (2 cups plus 2 Tbsp.) whole milk
⅓ vanilla bean
100g (½ cup) sugar, divided
100g (½ cup) round Arborio rice
200ml (¾ cup plus 1½ Tbsp.) whipped cream

Bring milk to a boil in a large saucepan.
Scrape in seeds from vanilla bean; add bean.
Rinse the rice under cold water for a minute or two,
until water runs clear; drain. Add rice and half of
sugar to milk, cooking over low heat for 12 minutes.
Add remaining sugar, and cook until rice is tender
and mixture is creamy, about 10 minutes.
Prepare an ice bath. Transfer the saucepan to ice
bath to stop the cooking. Cover the saucepan with
plastic wrap, and chill thoroughly in the refrigerator.
Once the rice has cooled, stir in the cream.
Serve, chilled, for breakfast or dessert.

COCKLES WITH PARSLEY

<u>*Serves 4*</u>

20ml (1 Tbsp. plus 1 tsp.) olive oil
1 bunch flat-leaf parsley, stems minced
and leaves left whole
250g (9 oz.) parsley root, peeled
and sliced into rounds
Salt
Freshly ground black pepper
16 large cockles
5ml (1 tsp.) Chartreuse

In a large skillet, heat olive oil over medium heat,
and quickly crisp up the parsley leaves.
Remove from oil with a slotted spoon, and transfer
to paper towels. Reserve oil.

Bring a large pot of salted water to a boil.
Add parsley root, and boil until quite tender, about
12 minutes. Purée the parsley root in a blender.
Stir in reserved olive oil, and season with salt and
pepper to taste. Cover and set aside. Rinse
the cockles well. Bring a large pot of water to a boil.
Add cockles, and cook just until they open.

Divide the parsley purée among 4 bowls, then top
each with cockles, crispy parsley leaves, raw stems,
and a few drops of Chartreuse.

ADELINE GRATTARD

YAM'TCHA

• · •

Paris, France

As a young girl, Adeline Grattard's parent's garden in Burgundy was a source of inspiration, and was her first introduction to new tastes, which she had a natural attraction to acquiring. But it wasn't until meeting an expat aunt who lived in Hong Kong, and then her Chinese-born, French-raised husband Chi Wa, that she decided to explore new culinary traditions.

Her training, with such Michelin three-star chefs as Yannick Alléno and Pascal Barbot, was complemented in Hong Kong at the two-star Michelin-rated Bo Innovation. On top of this, Grattard worked in a popular busy local dim sum restaurant, with intense shifts cooking for the masses. It was during this time that the idea of the yam'Tcha, a traditional Hong Kong dim sum snack accompanied by tea, became one that she thought could work in Europe. She returned to Paris with her graphic artist turned tea sommelier husband, and a new concept.

While "fusion" has become a dirty word in many circles, often producing clumsy mixes of East meets West dishes, Grattard's cooking is fresh and provides an elegant and unique dialogue between French and Chinese traditions. From her cupboard-sized kitchen, Grattard melds the best of French seasonal produce with Asian herbs and products that she steams or wok cooks, and has created her own inimitable style.

Her home kitchen funnily enough, is bigger than her restaurant kitchen and her refrigerator mirrors her cooking ethic: organic veggies from the La Vie Claire organic shop just down the road, mare's milk, (the animal milk closest in composition to human milk), Chinese sausages, and a chili paste made by her husband. Between shifts, the super chef takes time off to be super mom.

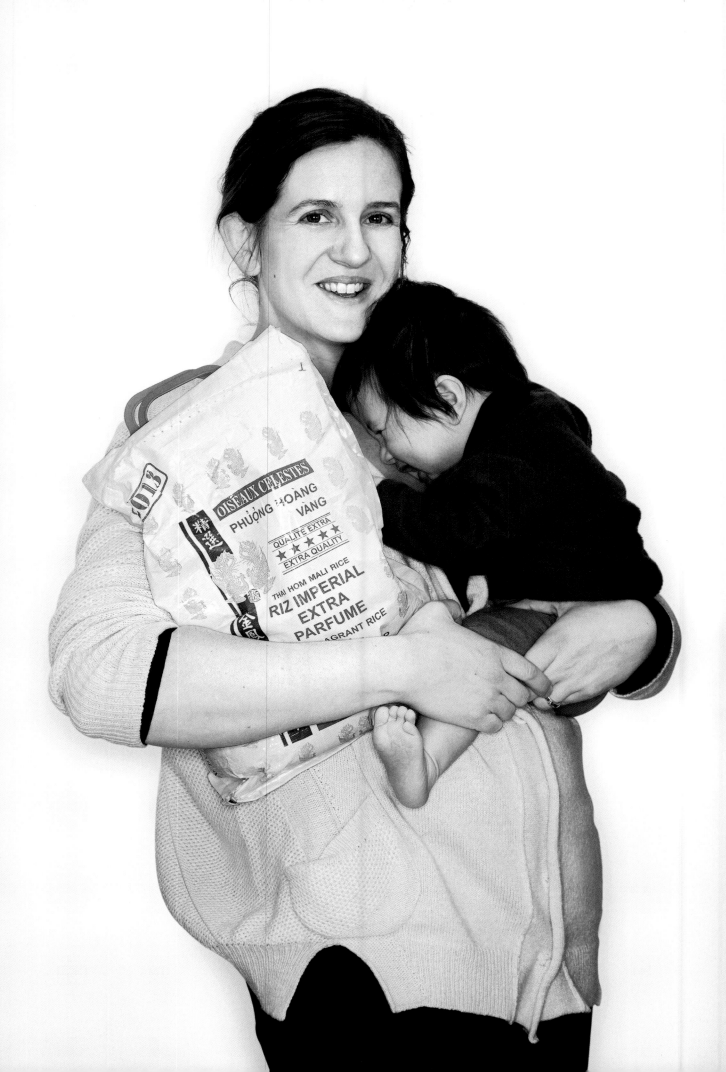

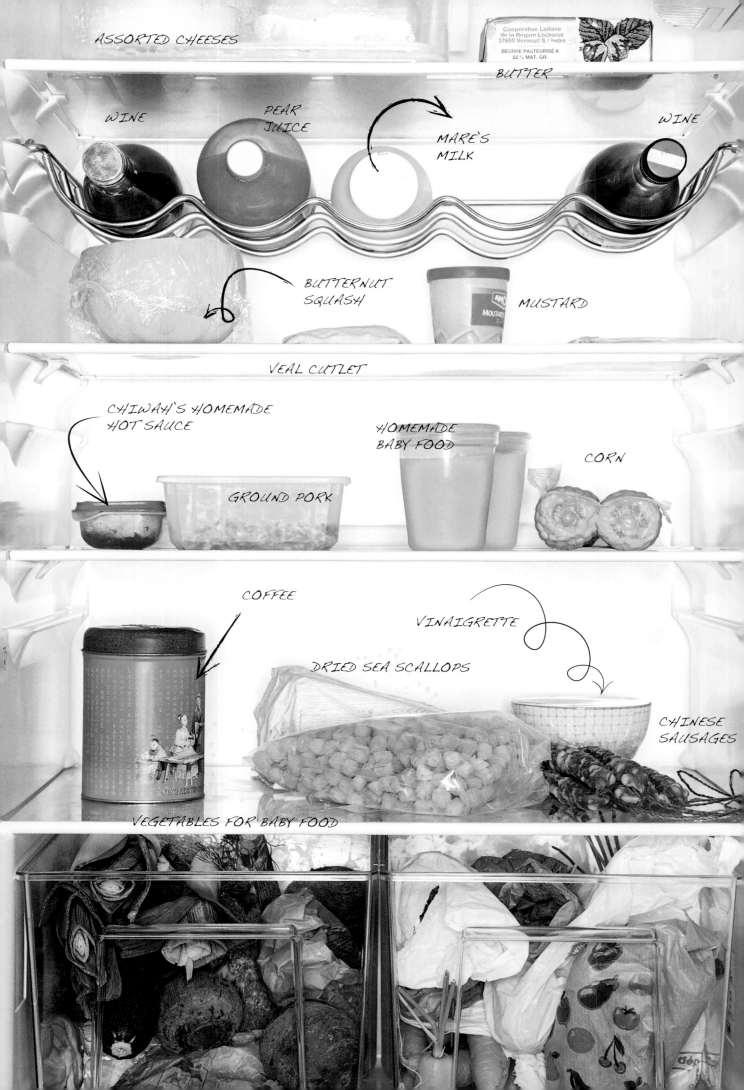

ELECTROLUX EN2400AOX

MARE'S MILK

Used since the times of antiquity, horse milk is a relatively unknown dairy product that has gained a loyal following for a number of different health benefits. Those who consume it praise the vitamin and mineral rich milk, saying it promotes healthy digestion and intestinal flora, bolsters sensitive skin, as well as boosting the immune system. Mothers have started to use it as well, as mare's milk is chemically the closest to human milk, with less than half the fat content of cow's milk, and a sweeter taste.

RICE PORRIDGE (*CONGEE*)
WITH DRIED SCALLOPS AND CHINESE SAUSAGE

Serves 4

200g (1 cup) long-grain white rice, preferably jasmine
5ml (1 tsp.) sunflower oil
1½ L (6 cups) water
80g (3 oz.) dried scallops
Pinch kosher salt
1 dried Chinese sausage, minced
2 scallions, thinly sliced

Place rice in a fine-mesh sieve and rinse under cold water for a couple minutes, until water runs clear. Drain, and stir in sunflower oil.

In a large pot, bring water to a boil. Add rice, dried scallops, and salt. Reduce heat, and simmer 1½ hours, stirring from time to time so that the rice doesn't stick to the bottom of the pot.
Once the soup has thickened, add the sausage, and cook 5 minutes.

Divide the porridge among 4 bowls, and top with scallions.

BAKED EGGS (*ŒUFS COCOTTE*)
WITH SHIITAKE MUSHROOMS

Serves 4

80g (3 oz.) dried shiitake mushrooms
20g (1½ Tbsp.) butter, plus more for ramekins
½ garlic clove, minced
30ml (2 Tbsp.) soy sauce
Handful flat-leaf parsley, minced
200ml (3/4 cup plus 1½ Tbsp.) crème fraîche
30ml (2 Tbsp.) white balsamic vinegar
2ml (½ tsp.) sea salt
2ml (½ tsp.) freshly ground black pepper
4 large eggs, preferably organic

Preheat oven to 180°C (350°F). Fill a medium-size metal baking pan halfway with boiling water, and place in oven. Butter 4 small ramekins. Cover dried shiitake mushrooms with boiling water, and let soak 30 minutes. Drain and rinse the mushrooms. Trim stems, and mince mushrooms.

In a small skillet set over medium heat, melt the butter, and add the mushrooms, garlic, and soy sauce. Cook, stirring often, until mushrooms are golden brown. Distribute mushroom mixture among ramekins, and sprinkle each with parsley. In a small bowl, combine crème fraîche, white balsamic vinegar, salt, and pepper. Crack 1 egg over mushroom mixture in each ramekin.
Spoon crème fraîche mixture over each egg.

Carefully place the ramekins in the water bath, and bake until whites are gently set but yolks are still soft, about 6 minutes.

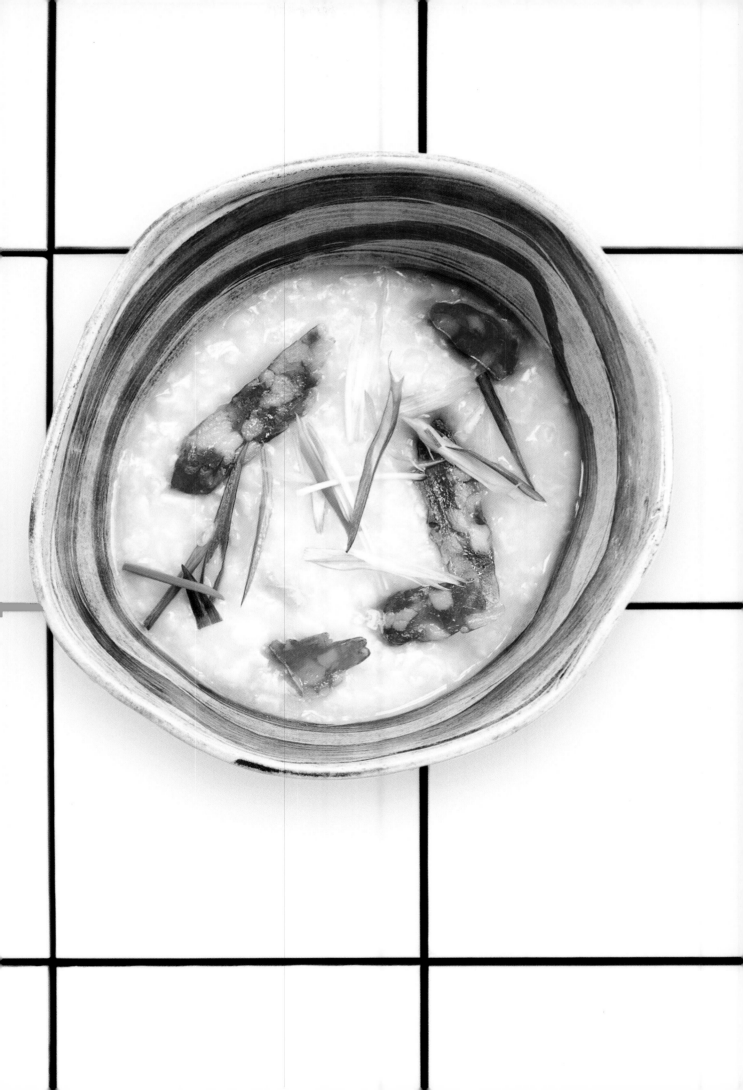

BERTRAND GRÉBAUT
&
TATIANA LEVHA

SEPTIME - LE SERVAN

•·································•

Paris, France

Patron/chef of perhaps Paris's hottest and hardest to book table, Septime ("Vous êtes Beyoncé qui? Jay who?"), Bertrand Grébaut seeks simplicity when cooling his heels at home—comfort for him means easy recipes and good products.

Grébaut, an alumni of Alain Passard's hugely influential L'Arpège, got into the famous kitchen by chance, helped by his culinary school, and there learned both "survival and great cooking." But he tips his hat to another chef, Bernard Pineau, formerly of Michelin-starred fish restaurant Marius et Janette. "This is where I learned everything from preparing and cooking fish and seafood to making hollandaise and béarnaise sauces, a real education."

His girlfriend Tatiana (chef at trendy cross-cultural bistro Le Servan), who is of Filipino and French origin, and who has lived variously in France, Thailand, Hong Kong, and the Philippines, brings flavor to the household and the culinary couple often eats Asian style cooking at home. "It's quick, good, and easy to do," says Bertrand. "All you need are vegetables, a piece of pork, chili peppers, and it's super good." Having traveled across Asia, he appreciates southeastern Asian cuisine, their techniques, herbs, even their junk food ("they've got lots of great fried stuff"), but he is against any idea of fusion cooking. "It's totally not my style. There are other people who have done real research and who have legitimate stories to tell, like Adeline Grattard (of Yam'Tcha) or Pascal Barbot (of L'Astrance), but I needed my own, French, direction."

On weekends, the couple eats out a lot, always going to the same, tried and true places ("We love the old school bistro cooking at Le Baratin in Belleville and sushi at Tsukizi"). And although they almost never eat at home, the tiny fridge is full of well sourced products: seafood from the Marché d'Aligre's Paris Peche fishmonger, meat from the Boucherie Les Provinces, fresh roast chicken, bread in the freezer and "like 10,000 bottles of water. We almost never go shopping." And sometimes, hidden in the corners, the odd jar of "shitty supermarket pickles" and Kinder brand chocolates: "Hey, we always try to eat healthy at home, but you never know."

Whether in her restaurant kitchen or at home, Tatiana uses a palette of what many Parisians would consider exotic ingredients, yet which for her, despite her classic training at gastronomic powerhouses L'Arpège and L'Astrance, are part of her culture and childhood education. Whether used in full-on Thai or Filipino recipes or traditional French cuisine, herbs, chilies, and spices bring a bright blast of flavor to her cooking.

INSIDE CHEFS' **FRIDGES**

—

IKEA FROSTFRI

INSIDE CHEFS' **FRIDGES**

———

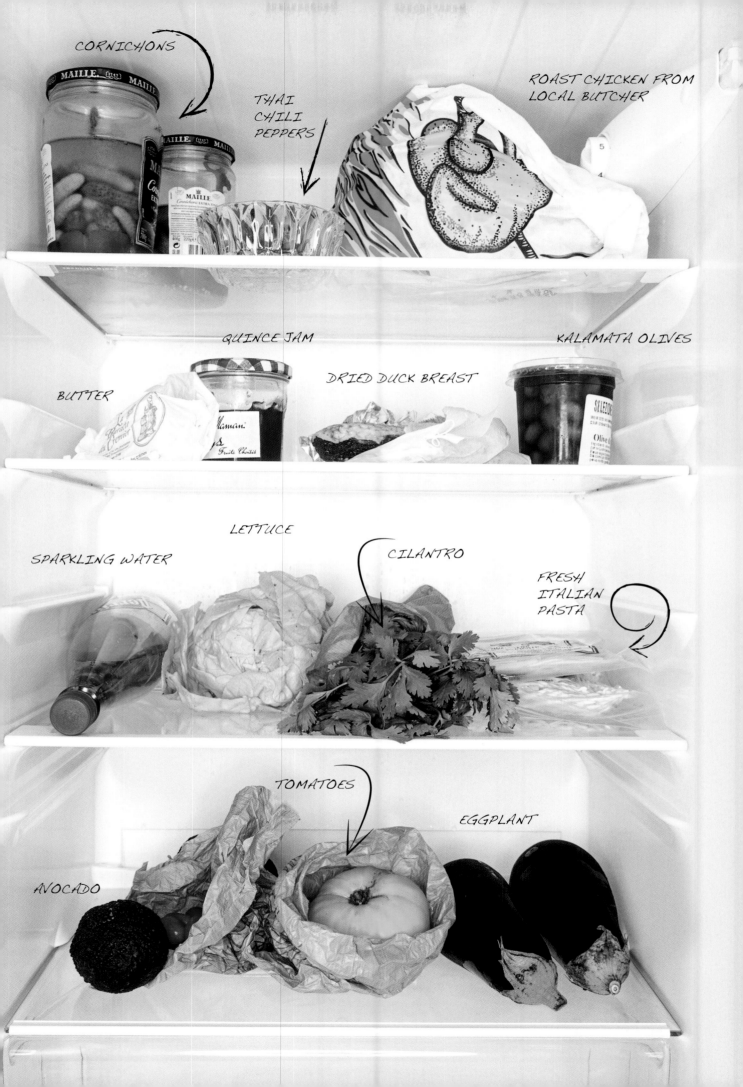

ROAST CHICKEN (*POULET RÔTI*)
WITH BLACK VINEGAR, RED PEPPER, AND CORIANDER (CILANTRO)

Serves 4

1 rotisserie chicken, preferably free-range
(about 2kg or 4½ lbs.)
300g (1½ cups) Jasmine rice
80ml (⅓ cup) black vinegar
3 small, spicy red peppers, minced
40ml (2 Tbsp. plus 2 tsp.) soy sauce,
preferably organic
40ml (2 Tbsp. plus 2 tsp.) olive oil
Freshly ground black pepper
Sea salt
1 large head lettuce, quartered
300g (11 oz.) heirloom tomatoes, chopped
1 bunch coriander (cilantro) sprigs
with tender stems

Cook rice in a rice cooker; keep it warm. In a small
bowl, combine black vinegar, red peppers,
soy sauce, and olive oil; don't emulsify the mixture.
Set aside.

Cut the chicken (warm or cold—your choice) into
pieces. Arrange lettuce, tomatoes, and coriander
(cilantro) sprigs on four plates, and place
the chicken alongside. Season to taste with sea salt
and freshly ground black pepper. Serve with
the spicy vinaigrette alongside.

SPICY RED PEPPER LINGUINI
WITH LEMON

Serves 2–4

Sea salt
350g (12 oz.) linguini
100ml (⅓ cup plus 1½ Tbsp.) olive oil
1 garlic clove, minced
3 small, spicy red peppers, minced
Handful flat-leaf parsley leaves, chopped
Juice of 1 Sicilian or Meyer lemon
Freshly grated Parmesan (optional)

Bring a large pot of salted water to a boil.
Add linguini, and cook according to package
instructions. Drain, reserving 200ml (¾ cup)
of the starchy pasta water.

Meanwhile, prepare the spicy red pepper sauce.
Heat the olive oil in a large skillet over medium-high
heat. Add garlic and peppers, and sauté for a few
minutes. Add reserved pasta water to the skillet,
followed by the pasta. Cook, tossing vigorously,
until the sauce emulsifies, coating the pasta.
Add parsley and lemon juice to the skillet, and
season with sea salt. Toss to evenly distribute.
Serve with freshly grated Parmesan, if you wish.

FATÉMA
HAL

LE MANSOURIA

•·····················•

Paris, France

Hailing from a small town on the Moroccan/Algerian border, and forced into an arranged marriage at a young age, Hal came to France and led the life of a housewife for six years before leaving her husband, battling for the custody of her three children, and fighting to make a living for herself and her family.

Before becoming a successful chef, she worked for the French government advising on women's rights, opening afterwards the first restaurant in France to elevate Moroccan cuisine to a gastronomic level, Le Mansouria, in a once very working class and newly gentrified neighborhood behind the Bastille square.

A culinary hero in both her native Morocco and her adoptive France, Fatéma Hal is well-known for seeking out and documenting ancient dishes, spending as much time finding traditional, often unknown recipes as she does cooking them in her restaurant kitchen. She has become a well-known expert on the subject on French television and the international chef circuit.

Where Fatéma comes from, oral recipes are transmitted from mother to daughter. "Cooking is culture," she says, "I have created nothing. I simply transmit the knowledge of those who came before me, women who obtained their freedom through cooking."

Sundays and Mondays are reserved for home dining, and the children and grandchildren come by on Sundays, for dishes such as tagine with potatoes and preserved lemon. "My home cooking is much different from my restaurant. Don't get me wrong, I love my couscous, but at home it's simpler, unless friends are coming." When she entertains, the *plat de resistance* might be lamb with butternut squash and honey, but if she's alone, she'll be eating pasta, grilled peppers with fresh tomatoes, or sardines, fresh and grilled or from a tin, crushed with olive oil and served with shallots and lemon.

Her home fridge is a mix of ever-present staples such as organic honeys, store bought pickles and sweet peppers, mingled with more exotic products such as absinthe leaves (she loves their tea in winter), North African figs, fresh herbs (coriander and parsley), and Moroccan saffron from Taliouine. "I always have fresh produce, and I get everything from the nearby Marché d'Aligre. They have absolutely everything."

But the food she eats most is pasta. "Why do you eat so much pasta?" a grandchild once asked her. "Why? Because it's Moroccan," she says, "I tell them the story that most people don't know, that wheat was brought to North Africa by the Romans and that women there have always prepared pasta such as *dwida* (vermicelli). I laugh when they tell me, 'We thought pasta came from Italy!'"

Whirlpool

HONEY FROM THE MIELLERIE DU GÂTINAIS

On the outskirts of Fontainebleau, this small, eco-friendly producer, located in the Gâtinais natural park, cultivates and sells a variety of honeys and royal jelly raised in a strictly traditional, and sustainable manner. The most sought after flavors are acacia, tilleul, and chestnut.

WHIRLPOOL GREEN GENERATION

INSIDE CHEFS' **FRIDGES**

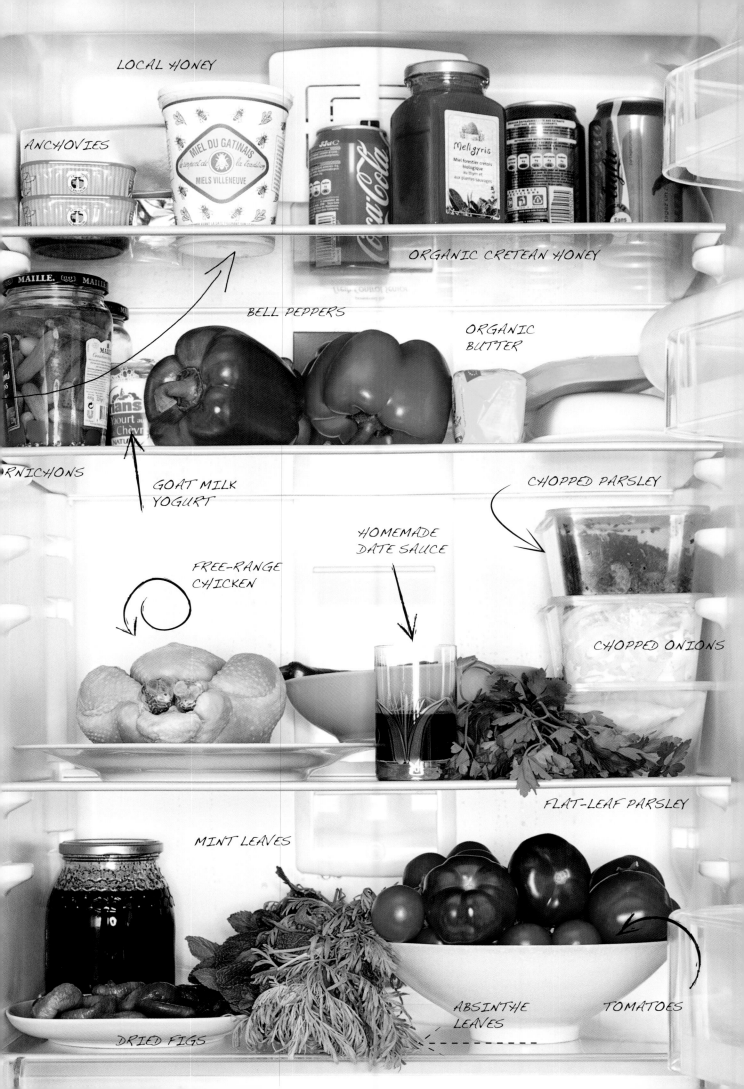

LOCAL HONEY

ANCHOVIES

ORGANIC CRETEAN HONEY

BELL PEPPERS

ORGANIC BUTTER

RNICHONS

GOAT MILK YOGURT

CHOPPED PARSLEY

HOMEMADE DATE SAUCE

FREE-RANGE CHICKEN

CHOPPED ONIONS

FLAT-LEAF PARSLEY

MINT LEAVES

DRIED FIGS

ABSINTHE LEAVES

TOMATOES

CHICKEN TAGINE
WITH FIGS AND ALMONDS

Serves 6–8

120ml (8 Tbsp.) olive oil, divided
1.5 kg (3 lbs.) chicken, preferably free-range,
broken down into pieces
3 small onions, minced
2 garlic cloves, smashed
5ml (1 tsp.) ginger, minced
5 saffron threads
2ml (½ tsp.) salt
1 bunch coriander (cilantro), chopped
750ml (3 cups plus 3 Tbsp.) water, divided
500g (1.1 lbs.) dried figs
100g (6.6 Tbsp.) sugar
5ml (1 tsp.) cinnamon
100g (7 Tbsp.) butter
100g (3½ oz.) blanched almonds
10g (.35 oz.) sesame seeds
1 dried rose bud (for serving)

Heat 60ml (4 Tbsp.) olive oil in a large cast-iron
skillet or Dutch oven over medium heat.
Add chicken pieces, onion, garlic, ginger, saffron,
salt, and coriander (cilantro). Add 500ml
(2 cups plus 2 Tbsp.) water and cook 30 minutes,
stirring occasionally.

While the chicken is cooking, prepare figs and
almonds. Place figs, 250ml (1 cup plus 1 Tbsp.) water,
sugar, cinnamon, and butter in small saucepan.
Bring to a boil, then reduce heat to low, and simmer
20 minutes or until sauce has reduced and has a
honey-like consistency. Slice figs. Heat 15ml (1 Tbsp.)
olive oil in a small skillet and toast the almonds.
Remove almonds and let cool.

Remove chicken from skillet, reserving broth.
Heat remaining olive oil in a large skillet, and brown
chicken parts, working in batches if necessary.
Place on a large serving dish, and spoon broth over.
Top chicken with sliced figs, toasted almonds,
and sesame seeds. Place rose decoratively
in the center of the dish.

CINNAMON ORANGE SALAD

Serves 4

100g (3.5 oz.) slivered almonds
4 beautiful oranges, peeled, sliced
Powdered sugar (for serving)
Cinnamon (for serving)
10ml (2 tsp.) orange flower water

Preheat oven to 180°C (350°F). Spread out
the almond slivers on a parchment-lined baking
sheet. Bake 5 minutes, turning once. Let cool.

Place oranges on a large, flat plate. Sprinkle
with sugar, cinnamon, orange flower water,
and toasted almonds.

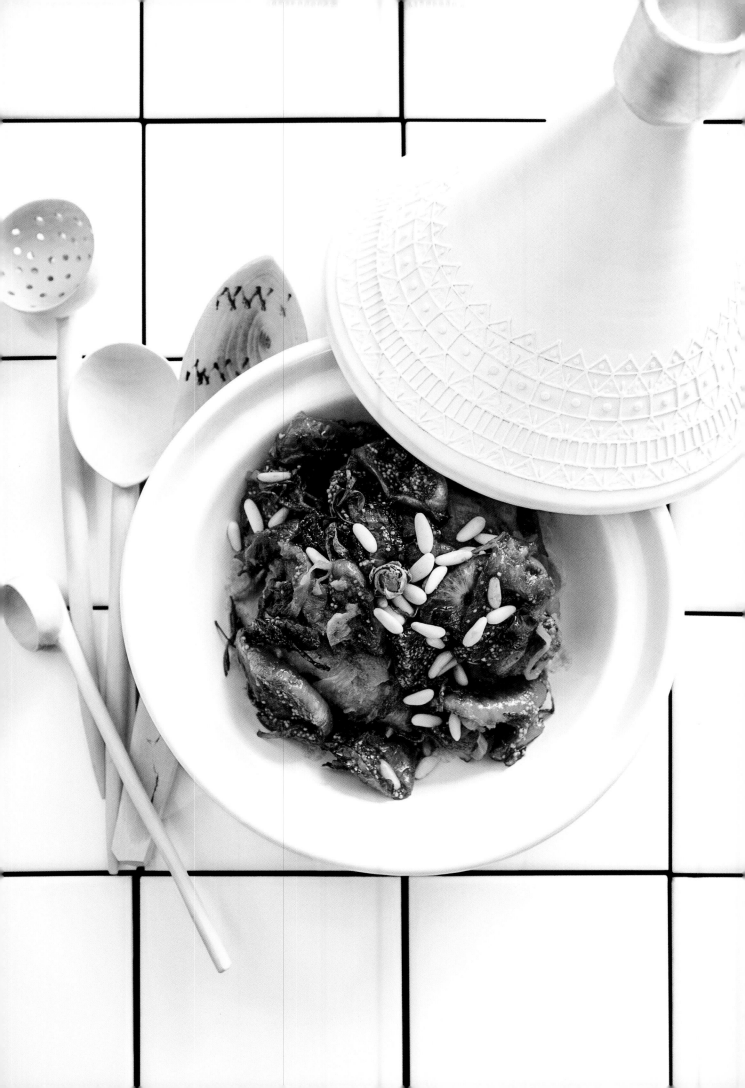

FERGUS
HENDERSON

ST. JOHN RESTAURANT

•••••••••••••••••••••••••••

London, England

It's difficult to say much about Fergus Henderson that hasn't already been said in a thousand different publications. One of Great Britain's most iconic culinary figures, savior of old school British cooking, harbinger of the return of delicious things from the past, and changer of culinary perceptions, Henderson has a special place in the gastronomic heart of the British Isles. He is also a man who has surmounted great physical and mental challenges, both in his daily job and as a sufferer of Parkinson's Disease, with grace and style, and what he has achieved is all the more exceptional for these difficulties.

An architect turned restaurateur turned self-taught chef and author, Henderson came to the public eye when opening St. JOHN, one of the most influential restaurants in recent times and one that forever transformed the perception of unpopular cuts of meat and offal in the dining public's mind. His unwavering belief in his "nose to tail" philosophy has influenced chefs from around the world.

Henderson's home, like his fridge, is a study in measured madness and his refrigerator is, predictably, chaotic. The freezer compartment has, to his knowledge, never been used, and is, literally, a solid block of ice, that seems, very probably, to have forced the freezer door off of its hinges. The rest of the fridge is a mishmash of items both store bought, taken from St. JOHN's, or just simply unknown and unidentifiable, wrapped up in their own private chemistry experiment. Malt extract and goose fat share space with *umeboshi* plum spread and Maille mustard. Chunks of Parmesan and bottles of anchovies border homemade piccalilli and Dashi miso. And always close at hand is his trademark tipple, Fernet-Branca, a tradition handed down from his father for its "restorative powers." "It's some of the best advice I ever had," he says raising a tiny glass to his lips.

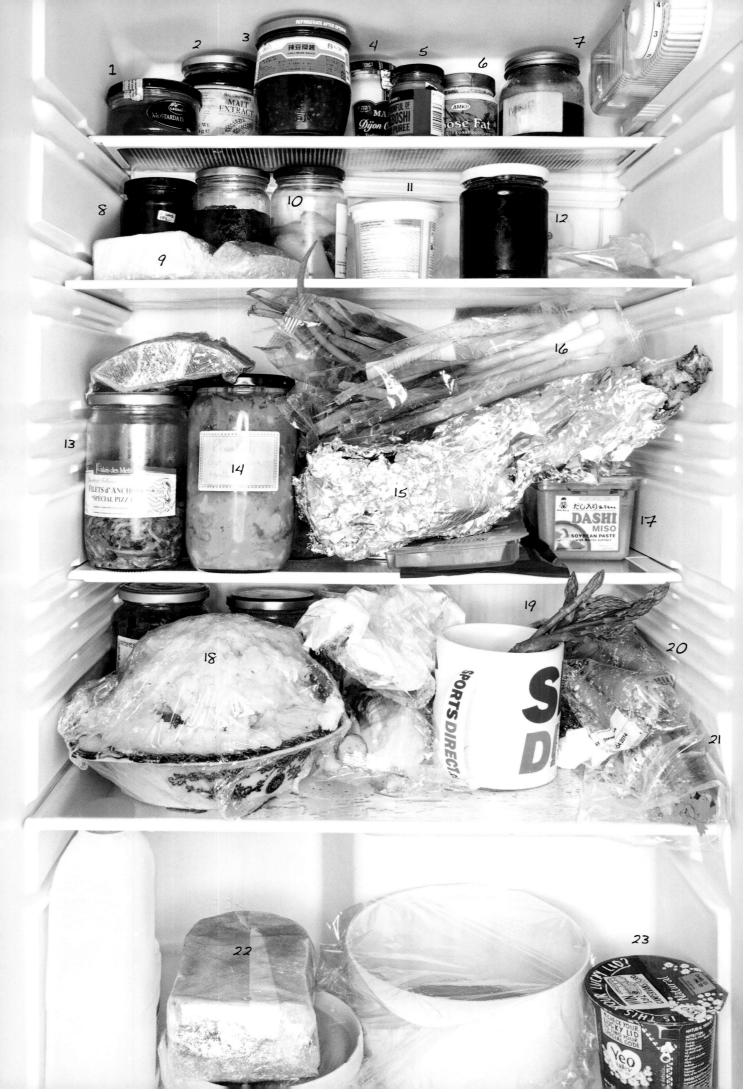

LIEBHERR
CTNES 4753

1 Italian Mostarda
2 Malt extract
3 Chili bean sauce
4 Dijon-style mustard
5 Umeboshi plum purée
6 Goose fat
7 Mint jelly
8 Chutney
9 Parmesan cheese
10 Preserved lemons
11 Crème fraîche
12 Fruit jam
13 Anchovy filets
14 Piccalilli sauce
15 Leg of lamb
16 Green onions
17 Dashi miso
18 Leftover mashed
 potatoes
19 Asparagus
20 Carrots
21 Celery
22 A sandwich
23 Yogurt

FERNET-BRANCA

This bitter, aromatic spirit was invented in 1845 in Milan as a stomach remedy and is a popular digestive throughout Italy and South America. Branca, which is but one of many fernets, has a secret herbal formula known only to the president of the company, who personally doses out the 27 different herbs and spices. Those known include aloe, rhubarb, gum myrrh, and galanga. Although the health benefits of the drink are largely disputed, its reputation as a hangover cure are legendary, and a caffè corretto con Fernet is a popular morning remedy among Milanese partygoers.

HEALTHY JAR
OF TROTTER GEAR

Makes 1 jar

6 pig trotters, hair removed
2 onions, peeled
2 carrots, peeled
2 celery stalks
2 leeks, halved lengthwise
1 head of garlic
Handful thyme leaves
Handful whole peppercorns
400ml (1⅔ cups) Sercial Madeira
1.5–2L (6–8½ cups) chicken stock

Preheat oven to 180°C (350°F).
Place trotters in a large pot, cover with water, and bring to a boil. Boil 5 minutes; drain. (This removes the initial scum given off by the trotters.) Now place the blanched trotters back in the pot, and add the remaining ingredients, using chicken stock as needed to cover the trotters. Cover; place in the oven and cook until the trotters are totally giving, about 3 hours. Strain the cooking liquor; reserve. Allow the trotters to cool just enough to handle. (Don't let them go cold— they'll become much harder to deal with.) Pick off all the meat, fat, and skin, tearing the skin into shreds. Add back to the cooking stock, seal in a jar, and refrigerate. Use the trotter gear to flavor a soup, stew, or meat pie.

WELSH RAREBIT

Serves 4

25g (2 Tbsp.) butter
7g (1 Tbsp.) flour
5ml (1 tsp.) English mustard powder
2ml (½ tsp.) cayenne pepper
200ml (¾ cup plus 1½ Tbsp.) Guinness beer
30ml (2 Tbsp.) Worcestershire sauce
450g (1 lb.) strong cheddar cheese, grated
4 pieces toast

Melt butter in a skillet, then stir in flour. Cook together until it smells biscuity, without letting it brown. Add mustard powder and cayenne pepper, then stir in Guinness and Worcestershire sauce, and gently melt in the cheese. When it's all one consistency, remove from heat, pour into a shallow container, and allow to set. Preheat broiler. Spread the sauce thickly onto toast, and place under the broiler until golden brown. Serve immediately with a glass of port.

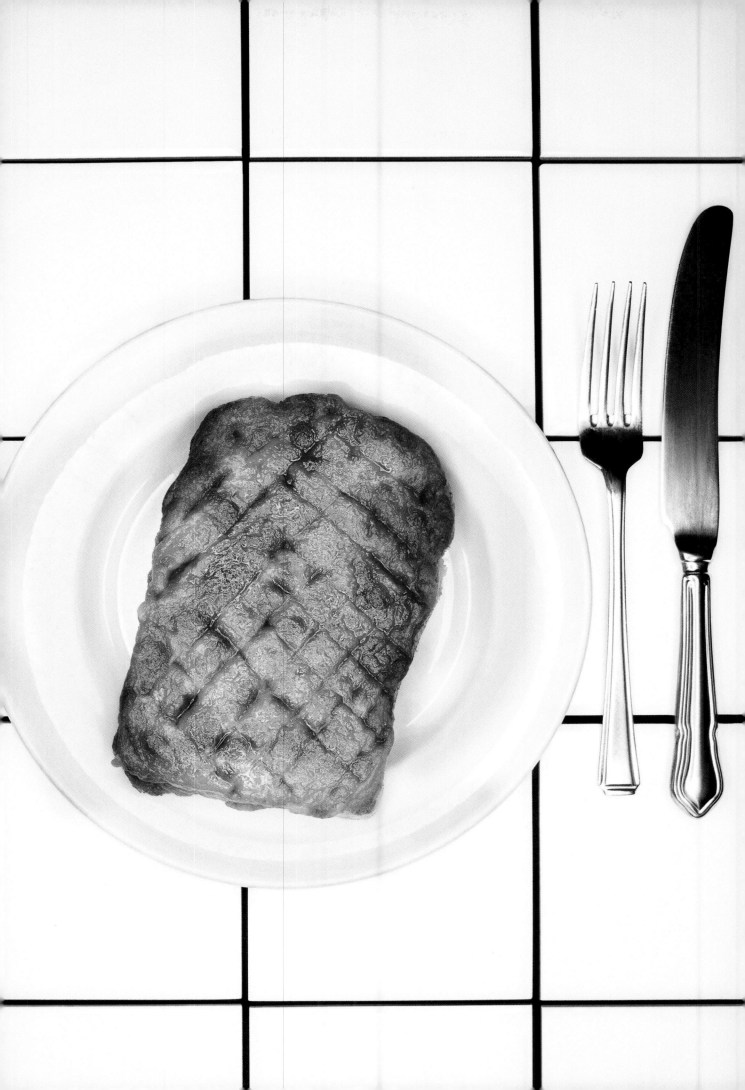

JAMES
HENRY

BONES

•·····················•

Paris, France

James Henry, the most punk rock of Paris's new wave of chefs, was the immediate darling of the fast forward culinary press, and every foodista's wet dream when he opened his pocket-sized gastro-bistro in a former Irish pub in the far-flung 11th arrondissement. Funnily enough, his first four years were spent in Paris, where his father was a functionary in the Australian Embassy, but, as Henry says, "I don't really have any nascent food memories except for maybe my mother's milk."

Henry, a former (and *toujours!*) surfer who lived on a catamaran in Sumatra scouting hidden beaches for film crews, learned to cook in part-time jobs while a photography student in his native Australia, and in a handful of foodie hotspots in Paris (Spring, Au Passage). He is known for his obsessive connection to small niche producers and his DIY philosophy wherein he taught himself artisanal bread, butter, and charcuterie-making skills. Henry respects the seasons above all and his cooking is immediate, raw, and driven by an unwavering perfectionism and determination. His off time is devoted to experimenting with spicy ethnic cuisines (Chinese, Indian, and Malaysian are favorites) and trying new restaurants of all types, many run by chef friends.

The tiny, under-the-counter fridge he shares with his, mostly chef, roommates is pure utility; shared space, a small repository of comfort food almost half full of beer, (Australian brand, Cooper's Pale Ale, a gift from a chef friend), bottles of vodka and cough syrup, salted Sicilian anchovies, industrial goat cheese, and relics from food festivals (foodie-fan-made kimchee). "I'm not here a whole lot though," he says, "I'm always over at my girlfriend's place, so maybe the fridge isn't very representative of me. I'm an itinerant Ozzie chef to the core!"

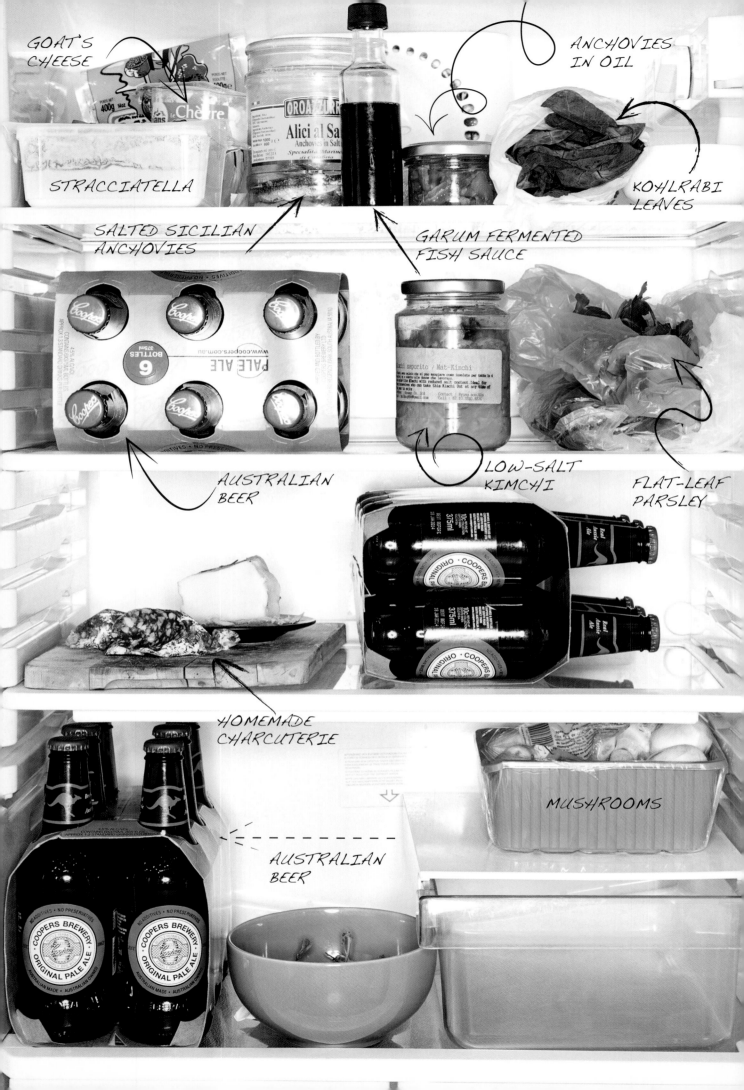

GOAT'S CHEESE

ANCHOVIES IN OIL

STRACCIATELLA

KOHLRABI LEAVES

SALTED SICILIAN ANCHOVIES

GARUM FERMENTED FISH SAUCE

AUSTRALIAN BEER

LOW-SALT KIMCHI

FLAT-LEAF PARSLEY

HOMEMADE CHARCUTERIE

MUSHROOMS

AUSTRALIAN BEER

BRAND UNKNOWN

INSIDE CHEFS' **FRIDGES**

PENNE WITH KOHLRABI LEAVES AND STRACCIATELLA

Serves 4

60ml (4 Tbsp.) olive oil, divided
2 shallots, minced
2 cloves garlic, minced
3 small dried red chilies
6 best-quality anchovy filets
400g (14 oz.) penne pasta, preferably Martelli brand
100g (3.5 oz.) kohlrabi leaves, chopped
½ lemon, juiced
100g (3.5 oz.) stracciatella cheese, roughly chopped

Heat 30 ml (2 Tbsp.) olive oil in a large pan over medium heat. Add shallots, garlic, and chilies, and sauté. When the garlic begins to color, add anchovy filets, and continue to cook until they melt. Meanwhile, cook penne until *al dente*. Drain penne, reserving 150ml of the cooking water. Add kohlrabi leaves to the pan with shallot-anchovy mixture, and sauté over medium heat until leaves start to soften. Add some of the reserved cooking water to loosen the vegetables; cook until liquid is slightly reduced. Add penne and toss vigorously. Finish with remaining olive oil, lemon juice, and stracciatella. Remove dried chilies and discard.

BROCCOLI WITH XO SAUCE

Serves 4

21g (3 Tbsp.) dried shrimp
100ml (⅓ cup plus 1½ Tbsp.) olive oil
125g (4.4 oz.) shallots, minced
75g (2.6 oz.) ginger, minced
50g (1.7 oz.) garlic, chopped
12g (1 Tbsp.) sugar
45ml (3 Tbsp,. chili paste
30ml (2 Tbsp.) oyster sauce
600g (1⅓ lb.) broccoli, cut into florets
50ml (3 Tbsp. plus 1 tsp.) grapeseed oil
15ml (1 Tbsp.) freshly squeezed lemon juice
White rice (for serving)

Preheat oven to 180°C (350°F). Line a baking sheet with parchment paper; add shrimp. Transfer to oven and roast, 6–8 minutes. Add olive oil to a large skillet set over medium heat. Add shallots, ginger, and garlic, and cook until they begin to brown. Mince roasted shrimp, and add to skillet. Sauté 5 minutes. Add sugar, and cook until mixture turns a dark caramel color, about 15 minutes. (If the sauce doesn't cook long enough, it will be too sweet.) Add chili paste and oyster sauce, and cook 5 minutes. Meanwhile, bring a large pot of salted water to a boil, and add broccoli. Cook 3 minutes. Let broccoli steam-dry. Heat grapeseed oil in a large skillet over high heat. When the pan is smoking hot, add broccoli. Once broccoli becomes crispy, add a few spoonfuls of XO sauce, and toss gently. Finish with lemon juice, and serve with steamed rice.

SERGIO
HERMAN

THE JANE

● ································· ●

Antwerp, Belgium

ATAG

One of the Benelux countries' most well-known and media-friendly chefs, Sergio Herman is also interesting as a man who chose his own gastronomic destiny, achieving the ultimate accolade of three Michelin stars at his family's restaurant Oud Sluis, then giving them up when he burned-out. "I had been at it for 25 years and was pushing myself hard, doing 19 hour days; I needed more balance in my private and professional life."

Frustrated by what he called "too much gold leaf," he opened a couple of more casual places (The Jane in an abandoned church in Antwerp, Pure C in a beachside town in Cadzand), starred in television shows, wrote books, and became one of Belgium's culinary stars as well as a more relaxed person with more time for family.

In the open plan home kitchen, the emphasis is one of simple, easy food and seasonal products from local organic famers (rainbow chard, kale, beetroot), although what's eaten oscillates between the desires of his four children and his super foods obsessed wife, who does the cooking most of the time. Always present staples include Fever Tree tonic water, mozzarella and burrata, bacon from the local butcher, mayonnaise, cheese spread for the kids, and chunks of Parmesan. Frozen fish fingers and meatballs are tucked into corners of the freezer next to frozen wheatgrass and kaffir lime leaves, for homemade "vitality" drinks.

The importance of a meal in the Herman house is to teach his children the importance of taste and health, although the occasional Chinese, Indonesian, or Japanese takeout is tolerated. "Although we're really health concerned, we've got a relaxed attitude with junk food," says Herman, "I mean, who doesn't like French fries, there's nothing like it, right?"

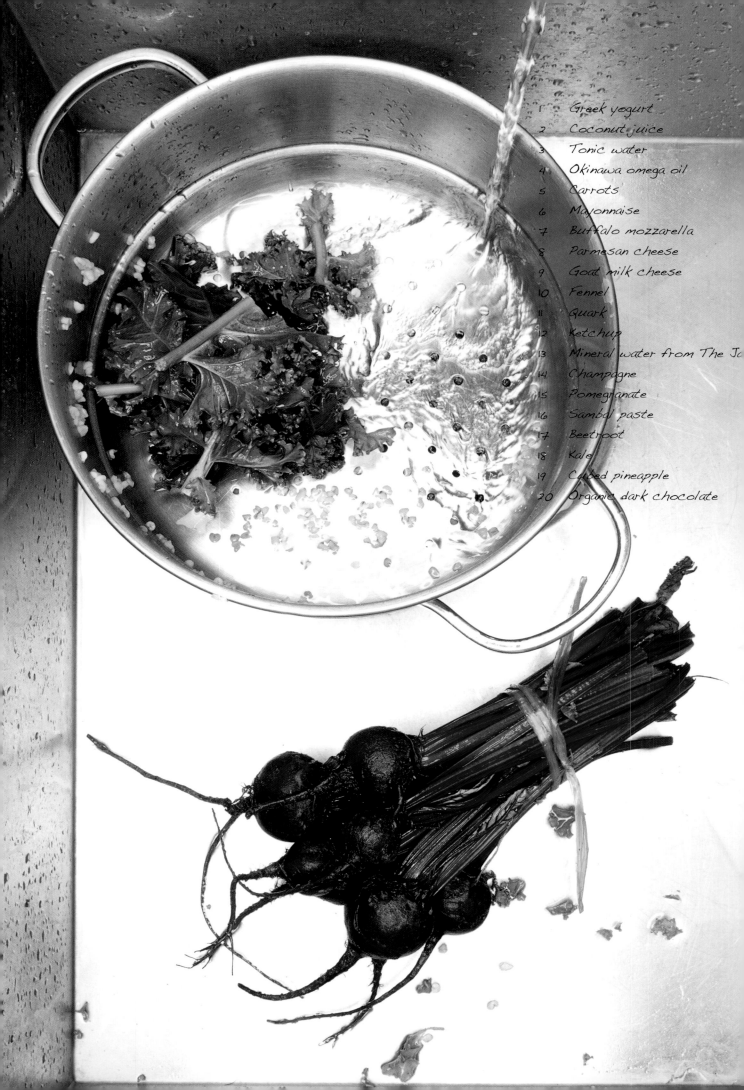

1 Greek yogurt
2 Coconut juice
3 Tonic water
4 Okinawa omega oil
5 Carrots
6 Mayonnaise
7 Buffalo mozzarella
8 Parmesan cheese
9 Goat milk cheese
10 Fennel
11 Quark
12 Ketchup
13 Mineral water from The Ja
14 Champagne
15 Pomegranate
16 Sambal paste
17 Beetroot
18 Kale
19 Cubed pineapple
20 Organic dark chocolate

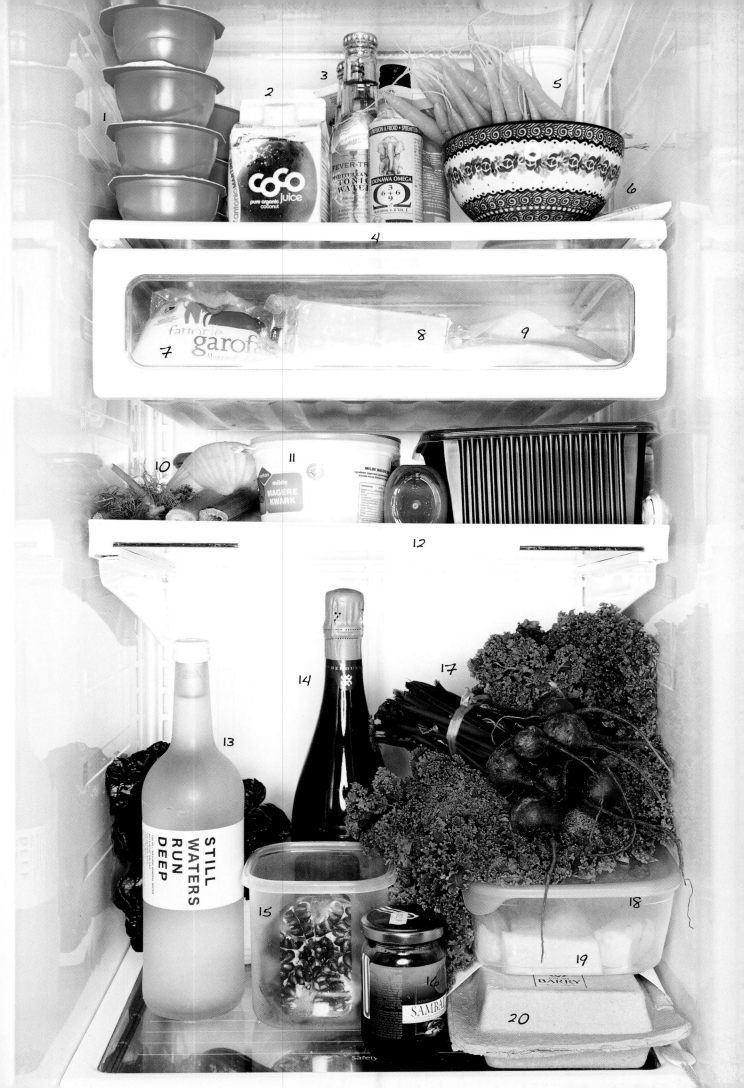

CASHEW, BLACK SESAME, QUINOA, AND KAFFIR LIME CONDIMENT

Makes 1 jar

175g (6 oz.) cashews
40g (1.4 oz.) black sesame seeds
60g (2.1 oz.) coconut flour
4 kaffir lime leaves, thinly sliced
300g (10.6 oz.) puffed quinoa
(available in many health food stores)
50ml (3 Tbsp. plus 1 tsp.) olive oil
Sea salt
3g (½ tsp.) crushed Sichuan peppercorns

Preheat oven to 180°C (350°F). On a baking sheet, lightly toast cashews until slightly golden in color, about 5 minutes. Toast black sesame seeds separately, about 3 minutes. Grind the toasted cashews in a food processor. Mix together the ground cashews, toasted black sesame seeds, coconut flour, kaffir lime leaves, and puffed quinoa. Add olive oil and mix again. Spread the crumble onto a parchment paper–lined baking sheet. Toast in the oven for 7–8 minutes, stirring once. Season with salt and Sichuan peppercorns. Serve alongside fish or vegetables.

BULGUR SALAD
WITH MARINATED VEGETABLES, YOGURT, AND BERGAMOT

Serves 4

2 spring shallots, finely chopped
1 garlic clove
15ml (1 Tbsp.) olive oil
200g (7 oz.) bulgur, medium grind
½ cinnamon stick
Freshly ground black pepper
Sea salt
500ml (2 cups) vegetable stock
Hibiscus salt
100ml (⅓ cup plus 1½ Tbsp.) elderflower vinegar
150ml (⅔ cup) apple cider vinegar
190ml (⅔ cup plus 2 Tbsp.) Arbequina olive oil, divided
4 kale leaves, finely chopped
150g (5 oz.) Greek yogurt
2g (1 tsp.) bergamot zest
8 mini (baby) carrots, thinly sliced
1 bulb fennel, thinly sliced
1 bunch chard, thinly sliced
100ml (⅓ cup plus 1½ Tbsp.) bergamot juice
100ml (⅓ cup plus 1½ Tbsp.) dashi vinegar
50g (1.7 oz.) buckwheat seeds
15g (.5 oz.) sesame seeds
20g (.7 oz.) flax seeds
1g (½ tsp.) turmeric powder
6 nasturtium flowers
50ml (¼ cup) organic bergamot oil

In a large saucepan, sauté shallots and garlic in olive oil over low heat. Add the bulgur and cinnamon stick. Season with pepper and sea salt. Pour in the vegetable stock, and cook until bulgur is tender, about 7–10 minutes. Drain any excess water, and let bulgur cool. Discard cinnamon stick. Season the bulgur with hibiscus salt, pepper, elderflower vinegar, apple cider vinegar, 80ml (⅓ cup) Arbequina olive oil, and a pinch sea salt. Toss with kale.

Season Greek yogurt with pepper, sea salt, and bergamot zest. In a separate bowl, toss carrots, fennel, and chard with salt, pepper, 80ml (⅓ cup) olive oil, bergamot juice, and dashi vinegar.

In a skillet, toast buckwheat, sesame and flax seeds in remaining 30ml (2 Tbsp.) olive oil, and season with turmeric and hibiscus salt. Combine the bulgur and yogurt in a bowl, and top with the vegetables and toasted seeds. Garnish with nasturtium flowers and drizzle with bergamot oil.

PIERRE HERMÉ

Paris, France

For Pierre Hermé, the most famous pastry chef in the world, destiny was written from early childhood. "I was born into the universe of pastry from an early age, its tastes and flavors imbued my early life and from the age of nine, I knew exactly what I wanted to do."

A fourth generation pastry chef from the Alsace region, Hermé helped out from time to time in his father's pastry lab—"for me it was the only way to spend time with him"—and came to Paris at the age of fourteen to apprentice with Gaston Lenôtre. He then worked as pastry chef at Fauchon, all the while thinking and dreaming up his own enterprise. "I wanted to be free in my choices and my creativity, and with Charles Znaty (his business partner), we wanted to create a luxury brand in the pastry business, which didn't exist before."

The *macaron*, which had existed for years in France, Italy, and Switzerland, but which had fallen by the wayside, became the artistic palette with which Hermé expressed himself, sublimating and reinventing the classic pastry and creating his own universe of tastes, sensations and gustative pleasures.

He used new flavors and textures that he started to experiment with while head chef at Fauchon, and he grasped the public's gustative imagination, and paved the way for his new vision of pastry making.

Hermé is also an accomplished cook and devout epicurean, and his home fridge showcases a varied and well-curated selection of France's best niche producers. Meat is from Yves-Marie Le Bourdonnec and Hugo Desnoyer, cheese from exceptional cheese-mongers Marie-Anne Cantin, Bernard Anthony and Quatrehomme, bread (in the freezer) from cult baker La Pointe du Grouin or Poilâne's rue du Cherche-Midi bakery and olive oil from Cédric Casanova. A few supermarket staples are always present: pickles and Heinz ketchup, butter, milk and eggs, yoghurt, herbs and hazelnut oil ("keeps best in the fridge"). One thing Hermé never buys is ready made dishes.

The meals that the chef concocts are for friends and family, and may be by turns simple or complex, something as classic as a blanquette de veau, or gravlax of beef, and made with the same care as he does his pastries, one thing remaining constant: "The taste and the quality of the ingredients are primordial, as well as the resulting goodness."

And when asked where his inspiration comes from, the response is evident for him: "It's the ingredients! Creations can also be born from discussions, images, in reading and traveling", he adds, "When one is curious and open to discovery, we often encounter a product we didn't know about and that can be a fantastic source, leading to all sorts of creation."

GAGGENAU RC472

1	Blanched almonds	12	Cream
2	Hazelnut powder	13	Eggs
3	Hazelnut butter	14	Mexican vanilla pods
4	Pistachios	15	Coffee beans
5	Organic salted butter	16	Strawberries
6	Macarons	17	Peaches
7	Gifts for friends	18	"Isphahan" jam from his friend Christine Ferber
8	Clementine "Delice" spread		
9	Fig "Delice" Mexican vanilla spread	19	Oranges
		20	Lemons
10	Raspberries	21	Limes
11	Whole milk		

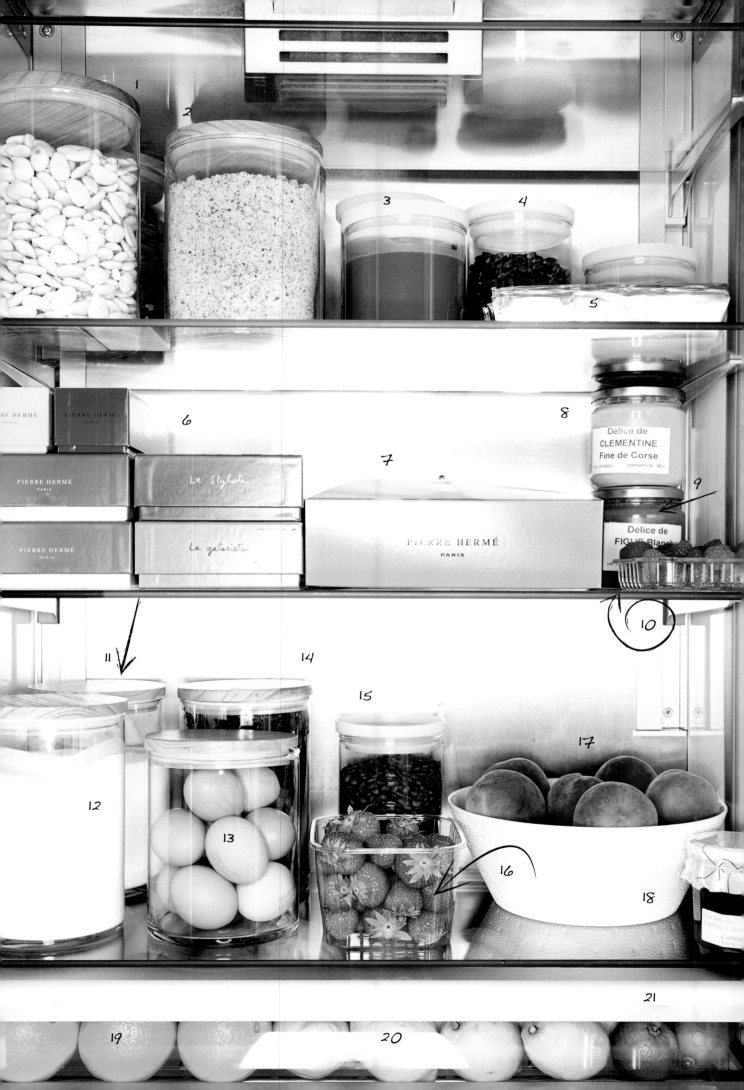

SOUTH AMERICAN
CUPUAÇU JELLY

MAPLE SYRUP

STRAWBERRY
"DELICE" SPREAD

COCONUT
EGG JAM

CHOCOLATES

MISO PASTE

BLACK SESAME
PASTE

CHAMPAGNE

ORANGE JUICE

GRAPEFRUIT
JUICE

WHITE WINE
(ALSATIAN)

VANILLA BUTTER COOKIES

(SABLÉS)

Makes 50 cookies

225g (16 Tbsp.) butter, room temperature, diced
100g (½ cup) caster (superfine) sugar
1g (about ½) vanilla bean, scraped
3g (1 tsp.) vanilla extract, without alcohol
2g (¼ tsp.) sea salt
320g (3¼ cups) pastry flour
200g (1 cup) granulated sugar

Preheat oven to 170°C (350°F). Place butter in the mixing bowl of a stand mixer fit with a flat beater. Beat until butter is creamy. Add caster (superfine) sugar, vanilla bean, vanilla extract, and sea salt, and continue mixing. Sift pastry flour into a large bowl, then add to the butter mixture, and beat just until the dough comes together. Transfer dough from the mixing bowl to a work surface, and bring it together into a ball. Divide ball into three equal portions. If the dough seems too soft, refrigerate for 10–15 minutes. Working one portion at a time, on a sheet of parchment paper, roll out dough into a cylinder 4cm (1½ inches) in diameter. Make sure that there aren't any bubbles in the dough and that it is smooth. Spread out the granulated sugar on a large piece of parchment paper. Roll each cylinder in the granulated sugar. Cut the dough into 1.5cm (½-inch) slices. Place the slices on a baking sheet lined with a silicon mat. Transfer to the oven, and bake for 22–25 minutes. Let cookies cool on a wire rack.

GELEIA DE CUPUAÇU

The cupuaçu, considered by some as the next "super fruit," is a close cousin of the cacao, and grows in the Amazonian basin. Cultivated widely by locals, the fruit has high levels of vitamin C and amino acids, and its seed is often used to make excellent quality white chocolate. Scientists believe that the fruit has been cultivated since pre-Colombian times.

PEACH AND ROSE TART
WITH CUMIN

Serves 6

Pastry Crust

190g (13 Tbsp.) butter, softened

5g (1 tsp.) sea salt, preferably from Guérande

3.5g (1 tsp.) caster (superfine) sugar

10g (.4 oz.) egg yolk

50ml (3 Tbsp. plus 1 tsp.) whole milk, room temperature

250g (2½ cups) pastry flour, sifted

Pastry Cream

½ vanilla bean

250ml (1 cup) whole milk

65g (⅓ cup) caster (superfine) sugar

60g (2 oz.) egg yolks

8g (1 Tbsp.) flour

17g (.6 oz.) flan powder

25g (2 Tbsp.) butter, room temperature

Almond-Rose Cream and Assembly

62.5g (4½ Tbsp.) unsalted butter, room temperature

62.5g (½ cup) powdered sugar

62.5g (2.2 oz.) almond powder

37.5g (1.3 oz.) eggs

6g (.2 oz.) flan powder

75g (2.6 oz.) pastry cream

2g (.07 oz.) rose essence, preferably Sevarôme

12g (.4 oz.) rose syrup

1.2kg (2.6 lbs.) ripe peaches

100g (⅓ cup plus 1½ Tbsp.) caster sugar

5g (.2 oz.) cumin powder

Pastry Crust:

The dough can be made either with a stand mixer or by hand.

With a stand mixer:

Cut the butter into small cubes, and place in the bowl of a stand mixer fit with a flat beater. Add salt and caster (superfine) sugar. Add egg yolk and milk, and beat until evenly incorporated. Add flour and mix just until dough comes together into a ball. Tightly cover the dough in plastic wrap, and refrigerate for at least 2 hours.

To make the dough by hand:

Cut the butter into small cubes and place in a large bowl. Using a wooden spoon, beat the butter until smooth. In a separate bowl, stir the sugar and salt into the milk. Stirring regularly, slowly pour the milk mixture into the butter mixture. Add the egg yolk and mix well. Slowly incorporate the flour, little by little, into the butter. Place the dough on a lightly floured surface. With the palm of your hand, squash the dough, pushing it away with a forward movement. Gather the dough into a ball again, then repeat the same movement. Form a ball, cover tightly with plastic wrap, and refrigerate for at least 2 hours.

Preheat oven on a convection setting to 180°C (350°F). Roll out the pastry dough into a 24cm (9 in.) pastry circle. The crust should be 3cm (1 in.) thick. Prick the crust all over with a fork, and refrigerate for 30 minutes. Cover the crust with parchment paper and dried beans or pie weights. Bake for 20 minutes, then remove the beans and parchment paper, and bake for 10 minutes. Let cool.

Pastry Cream:

Halve vanilla bean, and scrape seeds into a deep pan. Pour in milk, and bring to a boil. Reduce heat, and gently simmer for 30 minutes. Strain the milk. In a large bowl, whisk together sugar and egg yolks, then add flour and flan powder. Pour in a third of the milk, whisking constantly, then add in the rest. Prepare an ice bath (a large bowl filled with ice cubes). Pour the mixture into a deep pan, and bring to a boil for 2 minutes, stirring constantly. Transfer the pan of cream to the ice bath. Once the cream has cooled to 60°C (140°F), add in the butter little by little, and stir well. Cover with plastic wrap, pressing it directly onto the surface of the cream, and chill until cold, at least two hours.

Almond-Rose Cream and Assembly:

Preheat oven to 170°C (325°F). Soften the butter with a spatula. Adding ingredients one at a time and in order, stir in powdered sugar, almond powder, eggs, flan powder, 75g (2.6 oz.) pastry cream, rose essence, and rose syrup. Transfer the cream to a pastry bag fit with a tip (preferably #10). Pipe the cream onto the bottom of the cooled pastry crust in a spiral formation. Without removing the skin, cut each peach into 6 slices. Arrange the peaches very close together, skin-side down, on the almond-rose cream. Prepare the cumin sugar by mixing the cumin and sugar together. Sprinkle half the cumin sugar over the tart. Bake the tart for 40 minutes. Upon removing the tart from the oven, sprinkle the peaches and sides of the crust with the remaining cumin sugar. Serve warm.

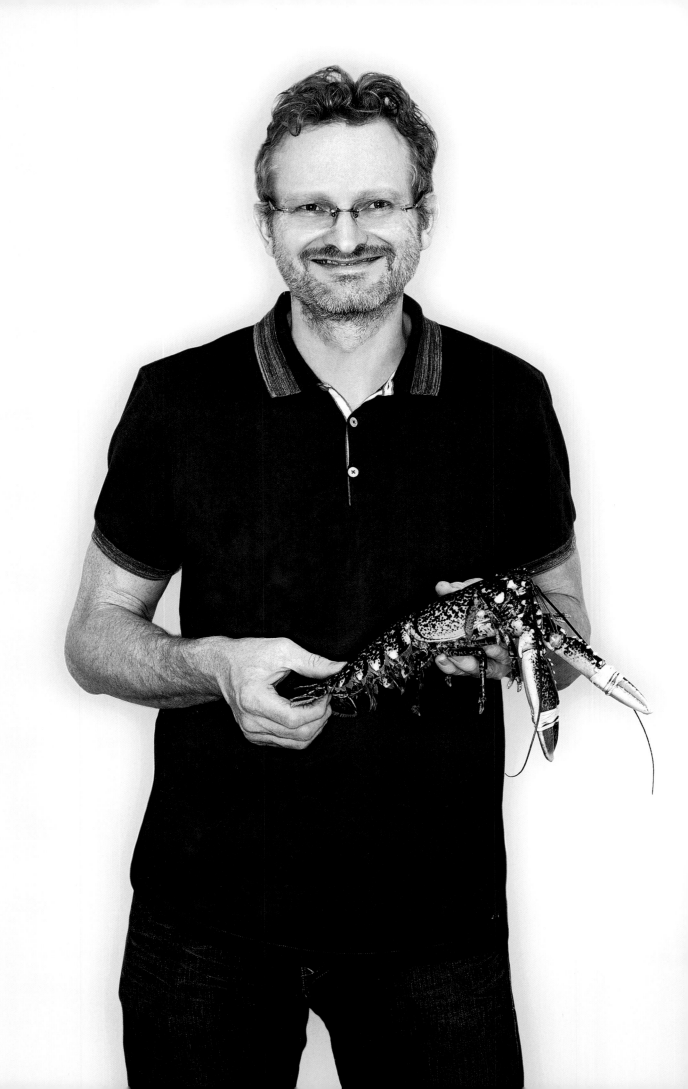

MIKAEL
JONSSON

HEDONE

•·······························•

London, England

"I'm at a point where I'm trying to find a style in the cooking. I don't know if that's going to happen, but I'm going to find out. It's very rare that anyone does find out." Some might call Swedish born Mikael Jonsson the ultimate anti-chef. Jonsson, as a child loved food and dreamed of a culinary career, but severe food allergies changed his direction in life, and he became a lawyer, entrepreneur, and blogger, reporting on his experiences in cutting edge restaurants around the world. When a radical change of diet allowed him to surmount his health problems, he decided, at age 44 to pursue his dream of becoming a chef, and he opened, with no formal training and great personal and financial difficulty, Hedone, which quickly gained a coveted Michelin star and a place on various fine dining best of lists.

He is an outsider, a stranger, an iconoclast and curmudgeon. He is scientifically curious and cerebral, dedicated to his own maverick way of doing things and at the same time creating delicious food that can be respected by neophytes and the initiated.

"I have a vision in my head of what I want to do and we're slowly getting towards that. I don't know how long it will take, but we are getting there. I do not want to create intellectual or challenging food. When people talk about food being challenging they mean that it doesn't taste good. That kind of food, even if it challenges your brain or your taste buds, is very rarely something you want to eat again. That's not great food to me. There are very few who would understand any particular chef because it will always be a work in progress."

Mikael's cooking is deceptively simple looking, often employing haute techniques, stubbornly relying on the rarest products, which he wills into culinary creations some might call elitist or high brow, but always prepared with passion, in his own way, on his own terms.

His own tastes remain simple. "A large piece of duck foie gras is just a perfect meal, firm and rich, with a custardy consistency, and I love to eat meat and fat. You have to remember that humans came into existence that very moment they first cooked flesh with fire."

BRAND UNKNOWN

1 Fresh foie gras

2 Coconut jam

3 Spanish white tuna in olive oil

4 Raw butter

5 Sea scallops

6 Lobster (female)

7 Milk

8 Red wine

9 Artichokes

Everybody's favorite blue-blooded crustacean, the lobster, an arthropod found living in all oceans, is one of the world's great luxury foods. Originally eaten only by the poor and even used as fertilizer, it wasn't until the 19th century that the dining public developed a taste for the creatures' delicate claw and tail meat, at the same time that marine technology developed specialized boats to harvest on a larger scale. Opinions vary, but top chefs know that the the best lobster (with claws) is the European lobster, also known as the blue lobster.

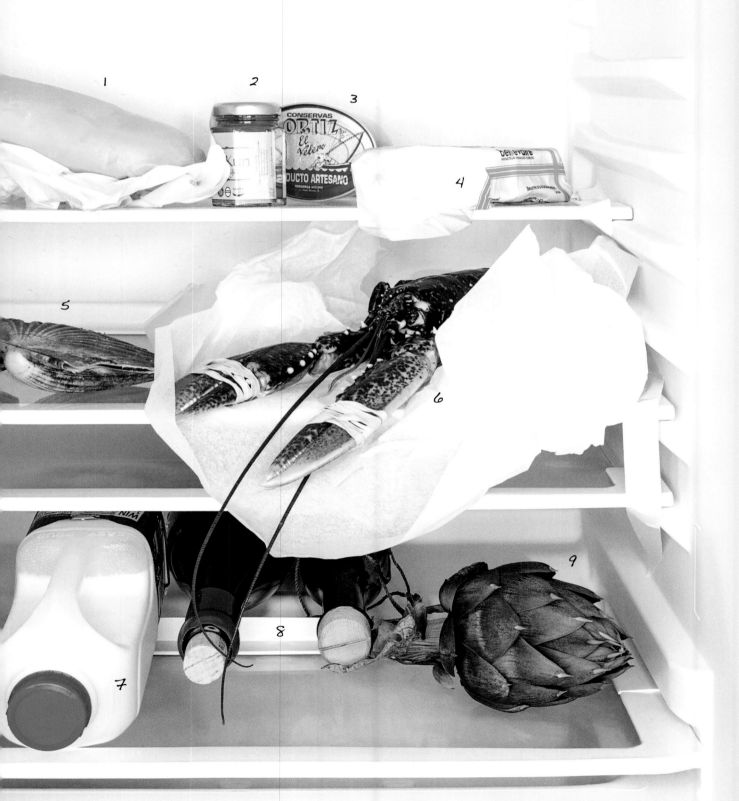

CROQUE MONSIEUR

Serves 2

120g L'Etivaz (Swiss cow's-milk cheese), grated, divided
200ml (¾ plus 1½ Tbsp.) crème fraîche
2 eggs, lightly beaten
4 slices _Pain de Mie_ (white bread)
120ml (½ cup) milk
2 thick slices cooked ham

Preheat oven to 180°C (350°F). In a skillet set over low heat, melt half the L'Etivaz cheese in the crème fraîche. Whisk in eggs to thicken mixture. Soak bread slices in milk. Spread a layer of the L'Etivaz mixture on one slice. Top with a slice of ham, then top ham with more L'Etivaz mixture. Sprinkle some of the reserved grated cheese on top, then cover with the second slice of bread. Spread the top slice with the cheese mixture, and sprinkle more grated cheese on top of it. Transfer to a baking sheet and bake until warmed through and golden-brown on top, 10 minutes.

LOBSTER
WITH MAYONNAISE

Serves 2

2 female lobsters
200g (14 Tbsp.) melted butter, plus more
15g (2 Tbsp.) nori seaweed, ground into a powder
2 duck eggs
30ml (2 Tbsp.) water
Large handful arugula leaves
Sea salt

Preheat oven to 140°C (275°F). Cut the lobster lengthwise. Crack the claws, then remove the coral (roe), and set aside. Brush the lobster with enough melted butter to cover surfaces, and sprinkle with the nori powder. Place a baking sheet, and transfer to the oven. Roast for about 12 minutes. Meanwhile, bring a large pot of water to a boil, and simmer duck eggs until hard-boiled, about 9 minutes. When cool enough to handle, peel eggs. Separate whites from yolks. (Reserve egg yolks for another use.) Using an immersion blender, purée the cooked egg whites, 200g (14 Tbsp.) butter, and water to make a mayonnaise.
While mayonnaise is still warm, add reserved lobster coral (roe). Serve lobster with the coral mayonnaise and arugula. Season with a pinch of sea salt.

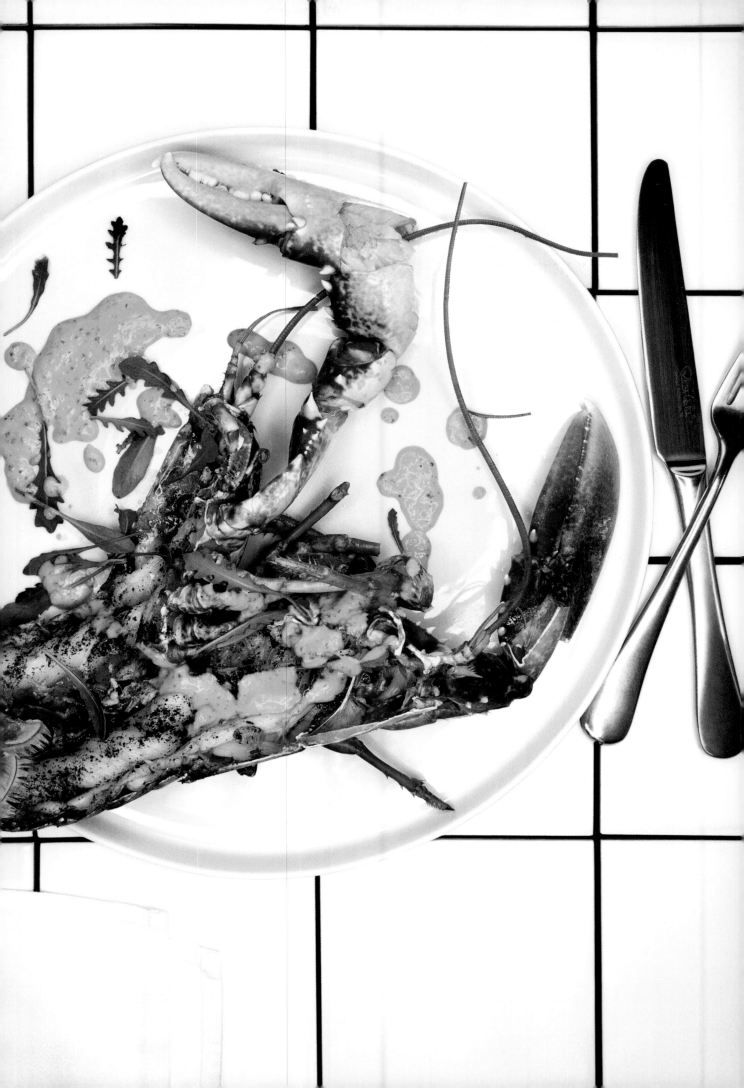

RASMUS
KOFOED

GERANIUM

•···································•

Copenhagen, Denmark

One of the most intensely talented chefs of his generation, Rasmus Kofoed has the distinction of having been the only chef to having competed in the prestigious Bocuse d'Or cooking competition three times, and to having won a medal at each.

Kofoed first started cooking professionally at Copenhagen's Hotel d'Angleterre, and in other top kitchens in the Danish capital as well as Belgium. He then struck out on his own and opened Geranium, an iconoclastic restaurant overlooking Copenhagen's largest public garden, which, in the space of a couple years, garnered two Michelin stars, and worldwide praise.

"Making food in the restaurant is so much different than making it at home," he says, "because most of the time it's for Sunday lunch, after a workweek that killed me." Lunch could be anything found in the refrigerator and/or things foraged from nearby with his little daughter. "I'll mix it up, get crazy, I can have fun with anything, because I know it's over too soon and then it's back to the restaurant." The family eats almost no meat at home and falafel is a huge favorite that Kofoed makes himself and eats at least three times a week.

And the fridge, despite the highflying, cutting edge culinary career, seems almost normal, with bottles of Heinz 57, Dijon mustard, Norwegian sauerkraut (literally "sour cabbage") applesauce (for the child), and supermarket bought olives, cucumbers, carrots, eggs, and lettuce. Then you see the shrink-wrapped flies. "My wife isn't too happy about these being in the freezer, but I need them for my fish," Kofoed says with a smile, indicating a neighboring tank where he is experimenting breeding different kinds of aquatic species: "I used to have about twenty of them, but I've calmed down a bit."

GAGGENAU VARIO RB 289

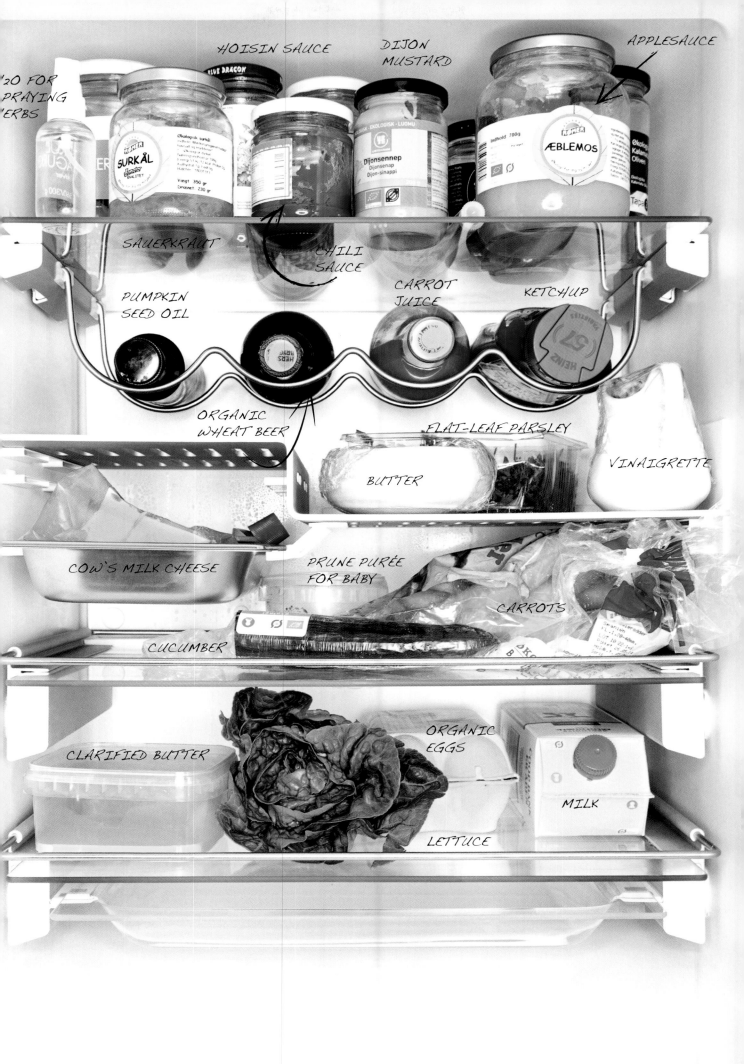

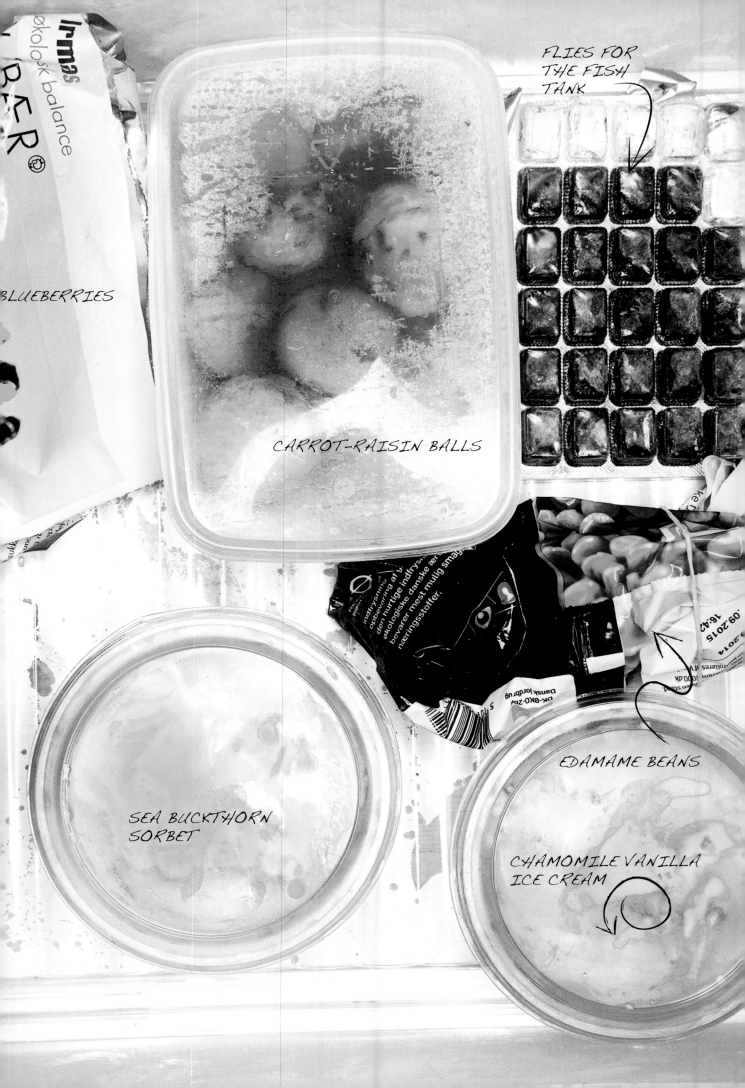

FLIES FOR THE FISH TANK

BLUEBERRIES

CARROT-RAISIN BALLS

EDAMAME BEANS

SEA BUCKTHORN SORBET

CHAMOMILE VANILLA ICE CREAM

I LOVE FALAFEL...
WITH HORSERADISH YOGURT

Serves 4

Falafel
250g (9 oz.) dried chickpeas,
soaked in water for 12 hours
30ml (2 Tbsp.) olive oil
1 garlic clove, roughly chopped
20g (1½ Tbsp.) tahini
Zest of 2 lemons
Handful parsley, chopped
12g (2 tsp.) salt
2g (1 tsp.) cumin
5g (1 tsp.) baking powder
8g (1 Tbsp.) flour
1L (1 quart) grapeseed oil, for frying

Assembly
8 large tomatoes, halved, grated
15ml (1 Tbsp.) olive oil
1 garlic clove, minced
Salt
Sugar
200g (7 oz.) plain yogurt
1 handful fresh dill, minced
5g (1 tsp.) freshly grated horseradish
4 romaine hearts
Small handful fresh parsley
Large handful of wild herbs of your choosing (for
serving)

Falafel:
Drain chickpeas. Place in the bowl of a food
processor. Add olive oil, garlic, tahini, lemon zest,
parsley, salt, cumin, baking powder, and flour.
Process until smooth. Using two spoons or a falafel
spoon, shape the mixture into oblong patties
about 4cm (1½ in.) long. Heat the grapeseed oil
in a large pot over medium-high heat. Once the oil
reaches 175°C (350°F), fry the falafel until crispy
and golden brown. Transfer falafel to paper towels
to absorb excess oil.

Assembly:
Toss together tomatoes, olive oil, garlic, a pinch of
salt, and a pinch of sugar in a large bowl.
In a separate bowl, stir together the yogurt, dill,
horseradish, and a pinch of salt. Serve the falafel
wrapped in the romaine hearts with the horseradish
yogurt, grated tomatoes, parsley, and wild herbs
alongside.

SEA BUCKTHORN SORBET

Serves 4

400g (14 oz.) frozen sea buckthorn
600ml (2½ cups) water
250g (1¼ cups) sugar
100g (3.5 oz.) glucose

Stir together all ingredients in a large saucepan,
and heat to 80°C (175°F). Purée with an immersion
blender. Press the mixture through a sieve,
discarding solids. Refrigerate the mixture until
cold. Freeze in an ice cream maker according to
manufacturer's instructions.

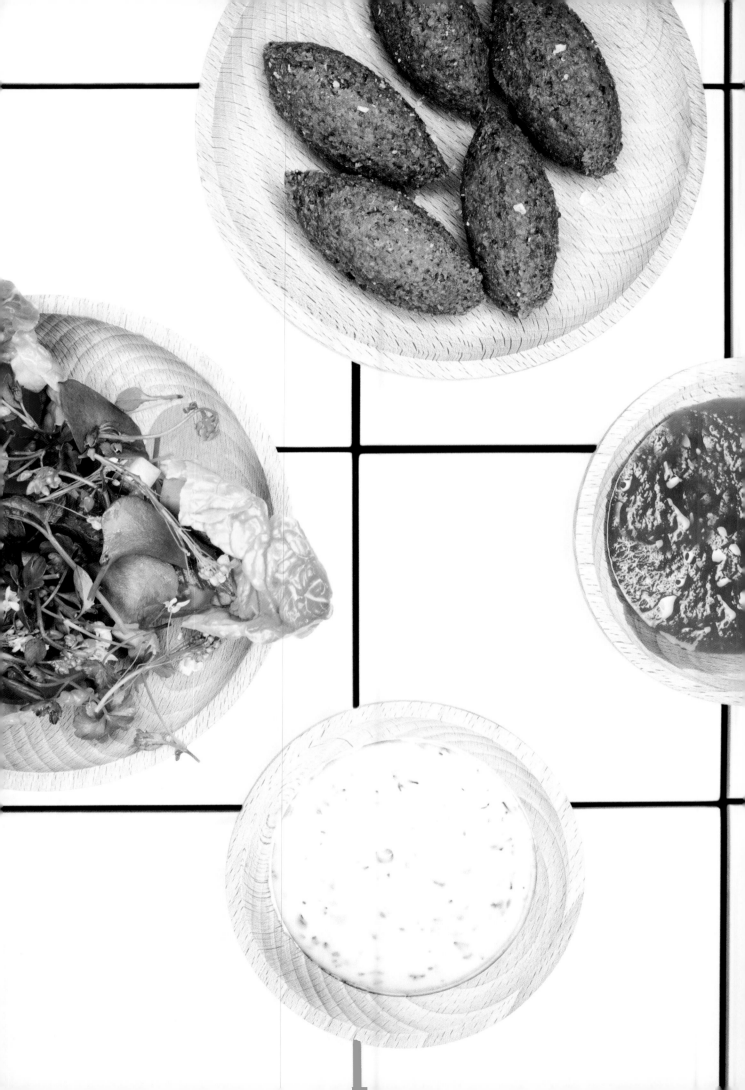

GRÉGORY
MARCHAND

FRENCHIE

• •

Paris, France

One of his generation's brightest culinary stars, Grégory Marchand started life as an orphan and began cooking when he was sixteen. He did his requisite time at cooking school then vagabonded around the world for the next decade, through London, New York, and elsewhere, learning his trade without restraint, anywhere but his homeland. He eventually returned, with a young family, opened up a tiny bistro on a forgotten and unpopular side street in Paris and sent shock waves through the food world.

Marchand is an astute culinary trend maker whose impossible to book, pared down bistro Frenchie—named after his kitchen moniker from stints in New York's Grammercy Tavern and at Jamie Oliver's Fifteen—redefined casual fine dining in the French capitol. The tiny bistro's seasonal, limited-choice menus caught on like wildfire, setting a new template for what democratic gastronomy could be. Marchand quickly followed with other concepts; a wine bar and a modern deli, that quickly rose to prominence on gastro tourist bucket lists, and his cooking is highly respected by some of the greatest chefs in the world and a highly discerning international dining public.

At home in Paris's newly hip garment district, not too far from his businesses, Marchand's small open kitchen houses a decent sized fridge that is sometimes more experiment locker than larder for his young family. New recipes for his deli, Frenchie to Go (reinvented sauces, charcuterie experiments) share space with La Vache qui Rit cheese ("I can't get enough of it, it's like crack to me"), and condiments of all kinds (his beloved HP Sauce, Heinz tomato ketchup, *bio bien sûr*, Maille mustard) stack the fridge shelves. Kiddie convenience food abounds, and there are always the necessary ingredients for Marchand's favorite meal of all, The English Breakfast, a most fitting repast for a French chef, whose entire education took place outside of the shackles of his home country.

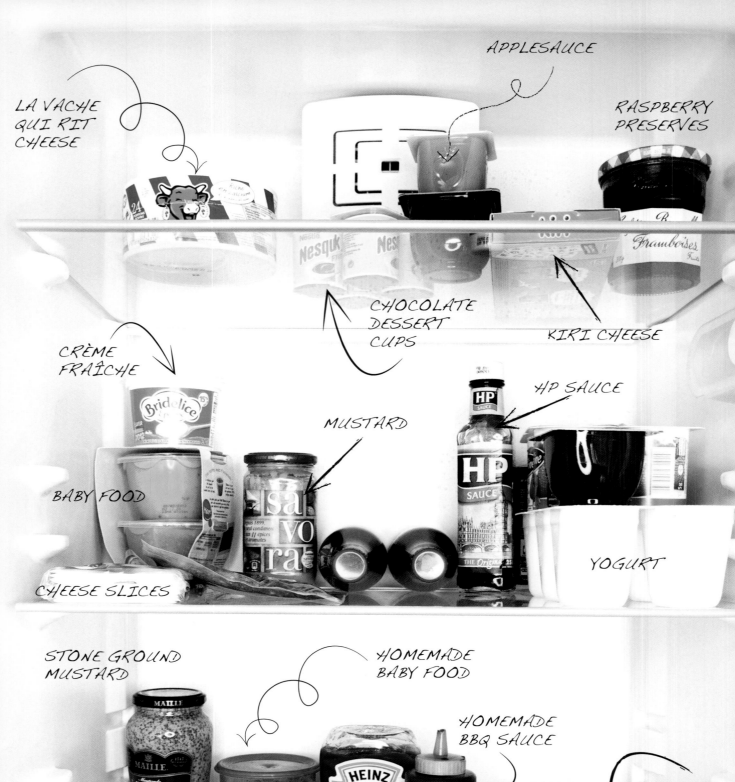
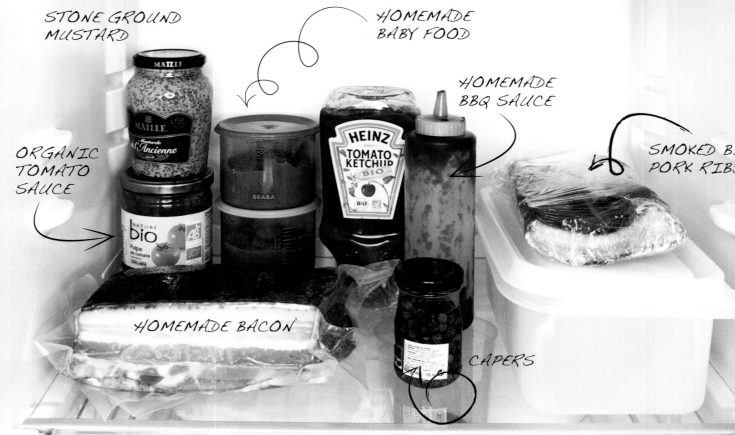

LA VACHE
QUI RIT
CHEESE

APPLESAUCE

RASPBERRY
PRESERVES

CHOCOLATE
DESSERT
CUPS

KIRI CHEESE

CRÈME
FRAÎCHE

MUSTARD

HP SAUCE

BABY FOOD

YOGURT

CHEESE SLICES

STONE GROUND
MUSTARD

HOMEMADE
BABY FOOD

HOMEMADE
BBQ SAUCE

ORGANIC
TOMATO
SAUCE

SMOKED B.
PORK RIB.

HOMEMADE BACON

CAPERS

WHIRLPOOL WTE3813

La Vache qui Rit

One of the world's most beloved processed food products, the joyous cow's face and wedge presentation have an inimitable brand presence and evoke nostalgia in supermarket shoppers across the world, many of whom eat the spreadable cheese right out of its foil wrapper. Originally founded in 1921 in the mountainous Jura region of France, the spread is now produced worldwide in a number of different product variations. Its original taste, a blend of cream, milk, and mixed aged cheeses such as Comté has remained unchanged over the years, and the fact that it is pasteurized guarantees a long shelf life.

SPAGHETTI
ALLA PUTTANESCA

Serves 4

100ml (⅓ cup plus 1½ Tbsp.) olive oil
2 garlic cloves, peeled, minced
2–4 bird's eye chilies (depending on your taste)
400g (14 oz.) whole peeled canned tomatoes
4 cured anchovy filets, chopped
16g (2 Tbsp.) capers
20 Kalamata olives, pitted, quartered
400g (14 oz.) spaghetti
Salt
Handful flat-leaf parsley leaves

Heat olive oil in a large skillet over medium heat. Add garlic and chilies, and sauté 3 minutes. Crush tomatoes by hand, and add to the skillet. Reduce heat to low and continue to cook, stirring occasionally, 20 minutes. Add anchovies, capers, and olives, and cook a few more minutes. Meanwhile, bring a pot of salted water to a boil, and cook the spaghetti until _al dente_. Drain the pasta, then add to the sauce with a few parsley leaves. Season with salt and pepper.

HOMEMADE SMOKED MAPLE BACON
AND EGG SANDWICH

Serves 4

Smoked Maple Bacon

100g (3.5 oz.) pink curing salt

60ml (¼ cup) maple syrup

50g (¼ cup, packed) dark brown sugar

2.5 kg (5.5 lbs.) skinless pork belly

Egg Sandwich

12–16 slices smoked bacon (80g or 3 oz. per person)

4 slices country bread

28g (2 Tbsp.) salted butter

8 fresh eggs

Sea salt

Freshly ground black pepper

HP Sauce (for serving)

Smoked Maple Bacon:

Prepare the dry brine by mixing together curing salt, maple syrup, and brown sugar. Rub all sides of the pork belly with the dry brine. Place the brined pork belly in a large re-sealable plastic bag, squeeze out excess air, and seal. Refrigerate for 7 days, turning the pork belly over every 24 hours so that the brine penetrates in a uniform manner. After the seventh day, remove the pork belly from the bag, rinse, and dry on an oven rack overnight in the refrigerator. Smoke the pork belly in a smoker set to 90°C (200°F). Once the inside of the pork belly registers 80°C (175°F) on a meat thermometer, remove from smoker. Once bacon has cooled, cover tightly in plastic wrap, and refrigerate up to 3 weeks. Yields 2.5kg (5.5 lbs).

Egg Sandwich:

Cook bacon over medium-low heat in a skillet, 8–10 minutes, flipping once. Once bacon is crispy, remove, and reserve on a plate. Crack the eggs into the bacon grease, and season with sea salt and ground pepper. Meanwhile, toast the bread, and spread generously with butter. Serve the bread with the bacon on top, eggs on the side, and plenty of HP Sauce.

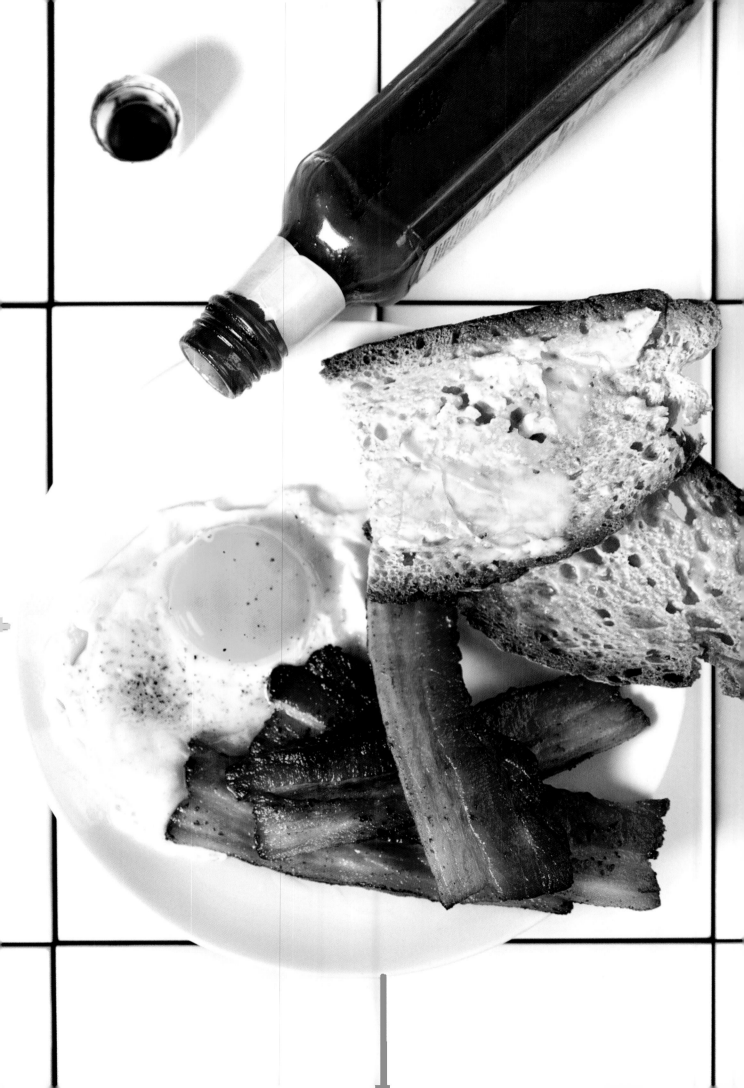

THIERRY
MARX

SUR MESURE PAR THIERRY MARX,
MANDARIN ORIENTAL

● ⋯⋯⋯⋯⋯⋯⋯⋯ ●

Paris, France

Thierry Marx is at the head of France's culinary vanguard, and is as inspired by technique as he is Asian philosophy. "Confucius inspired Chinese cuisine. They understood that they could invent something original once in their lives, but that the importance is on improving something a thousand times. It's not about how to do things, but why we do things."

And far from any modern day idea of fusion, his cooking developed from a rough and tumble neighborhood in the east of Paris where he grew up. The melting pot of Arabs, Chinese, and Jewish people was his first experience of different culinary traditions. Marx loves all sorts of cooking, none of which he says should be idolized or placed above others, and the key to a successful meal at home is simplicity and rapidity.

"When friends and family come over, we cook one dish and the whole idea is that we're together. I love having them cook with me, whether they know how to or not. I hate table conversations, which I find boring." Favorite dishes, always a single shared recipe, include couscous and beef Wellington.

In his enormous double-sized, special order fridge, which would not be out of place in a professional kitchen, Asian condiments of all sorts (mirin vinegar, umeboshi salted plums) share space with supermarket canned goods (the omnipresent pickle jar), food from the market ("I love Parisian mushrooms") and the odd jar of Old El Paso salsa (blame the daughter).

For a highly cerebral chef, a bit of low brow doesn't bother Marx at all: "In my day job, it's always complicated, thinking up new dishes, ideas; it's everything I don't want to do at home."

KITCHEN AID KRBV 9710 WITH WINE CABINET

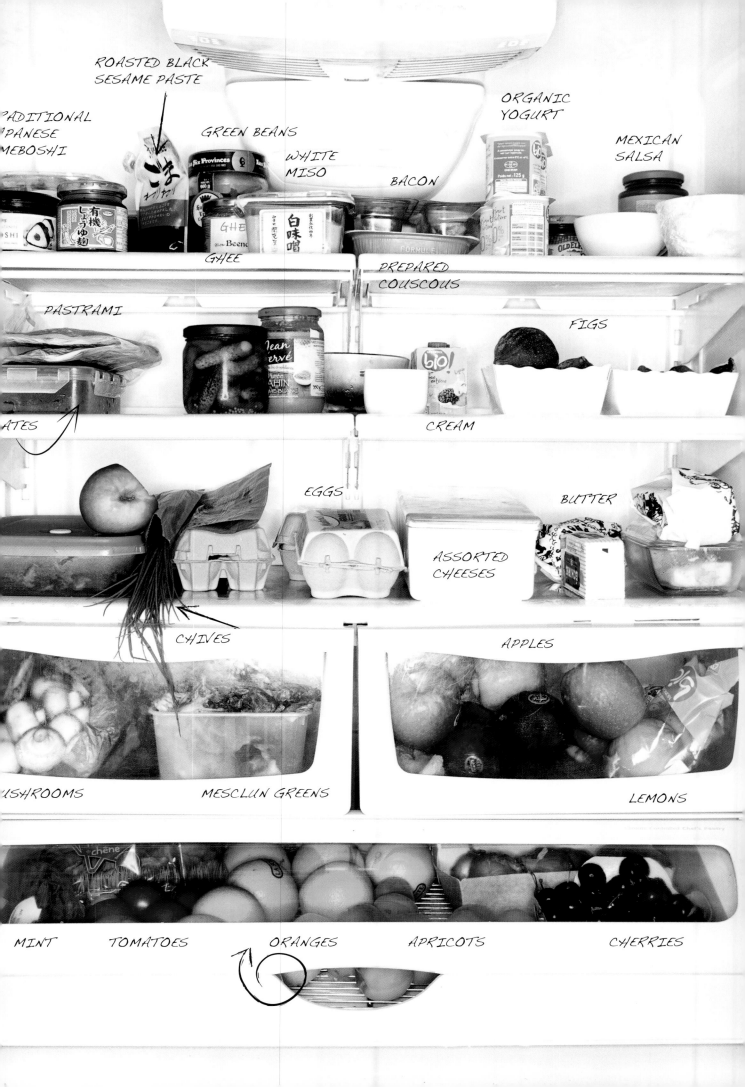

Soba Noodles

Soba, which means buckwheat in Japanese, can also refer to a number of different types of thin noodles, a very popular staple of Nippon cuisine. Noodles, in general eaten cold in summer and hot in winter, are often accompanied with a dipping sauce made from dashi, a fish sauce made with kelp and preserved fish shavings, soy sauce, and mirin, a type of rice wine and popular condiment.

ROAST CHICKEN THIGHS
WITH RED WINE
AND SOY-HONEY SAUCE

<u>Serves 4</u>

5g (1 tsp.) minced garlic
5g (1 tsp.) minced fresh ginger
50g (2 Tbsp. plus 1 tsp.) honey
150ml (⅔ cup) red wine
5ml (1 tsp.) Kikkoman soy sauce
4 chicken thighs, deboned
15ml (1 Tbsp.) olive oil

In a skillet, combine garlic, ginger, honey, red wine, and soy sauce. Bring the marinade to a boil, then let cool completely. Place chicken thighs in a shallow baking dish, pour marinade over chicken thighs, cover, and refrigerate for 4 hours. Roll up the thighs into *paupiettes*, and wrap each one tightly with plastic wrap. Reserve the marinade. Place rolled chicken thighs in a steamer basket above simmering water, cover, and steam the chicken at 80°C (175°F) for 20 minutes. Once chicken is cool enough to handle, remove the plastic wrap, and cut each thigh into medallions. Heat olive oil over medium heat in a skillet. Add the medallions, and brown until lightly caramelized. Remove chicken from skillet, and add marinade to skillet. Deglaze the skillet with the marinade, scraping up any browned bits with a wooden spoon, and cook the marinade over medium heat until it reduces into a sauce. Serve the medallions with the sauce alongside.

SOBA NOODLES
WITH SHRIMP TEMPURA

<u>Serves 4</u>

400g (14 oz.) soba noodles
150ml (⅔ cup) mirin
150ml (⅔ cup) sake
150ml (⅔ cup) soy sauce
13g (1 Tbsp.) sugar
5g (1 tsp.) salt
900ml (3¾ cups) dashi broth
12 jumbo shrimp, deveined
1 egg
150g (1¼ cups) flour
500ml (2 cups) canola oil, for frying
3g (1 Tbsp.) chives, minced
2 sheets nori, cut into strips

Bring a large pot of water to a boil. Add soba noodles, and stir. As soon as the water becomes frothy, add 50ml (3 Tbsp.) cold water, to keep the noodles from sticking. Repeat this process each time the water becomes frothy until the noodles are tender: The soba should be softer than *al dente* pasta. Drain the noodles, and rinse with cold water to remove starch. Set noodles aside.

Pour mirin into a large pot and bring to a boil. Add 800ml (3⅓ cups) water, sake, soy sauce, sugar, and salt. Bring to a boil once more, and simmer 10 minutes. Remove from heat, and add dashi broth. Set broth aside.

Cut 5 small notches on the belly of each shrimp. Clip the tails, and press excess moisture out of each prawn. Pat dry. In a large pot, bring 500ml (2 cups) water to a rolling boil. Beat in the egg. Quickly add flour, and beat by hand with a whisk until just combined but still lumpy. Heat canola oil to 170°C (338°F). Holding the shrimp by the tail, coat them in the batter, then drop them into the oil. Fry the shrimp two at a time until light golden brown. Transfer to a paper towel to drain.

Reheat the broth. Quickly toss the noodles in boiling water just to reheat them, then drain. Separate the noodles into 4 bowls, placing 3 shrimp in each bowl. Cover with the hot soup, and garnish with chives and strips of nori.

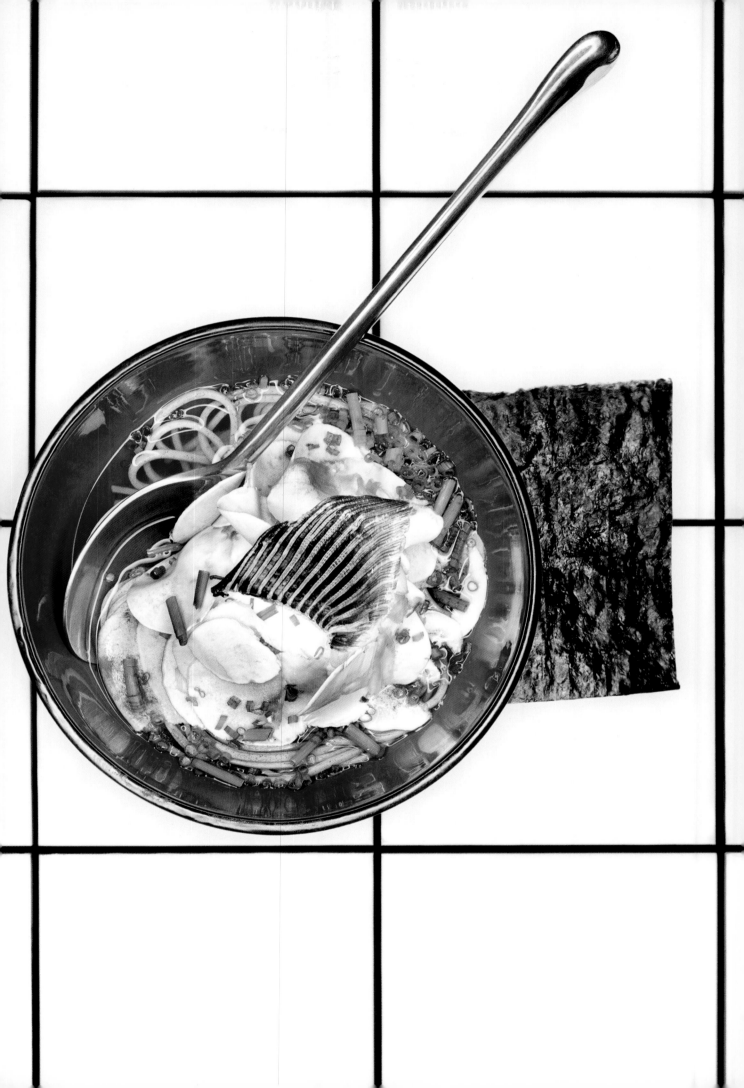

DAVID
MUÑOZ

DIVERXO

•............................•

Madrid, Spain

Madrid's only three-star Michelin restaurant is the work of an iconoclastic, Mohawk-crested, and pierced young chef whose influences run the full gamut of global cuisine. David Muñoz, an unlikely looking member of the gastronomic elite is indeed top of the food chain with his in-your-face techno-emotional trompe l'oeuil cooking, a product of his non-stop creative mind and influences as diverse as the Iberian Peninsula and Chinese and Japanese traditions.

David, who cooked at home from a young age, had his culinary imagination set on fire when his parents first took him to chef Abraham García's restaurant Viridiana—Madrid's first creative, modern restaurant. He knew then that this was what he wanted to do. His parents loved taking him out and Muñoz developed a taste for the better things in life. "My first love was foie gras at age six. I wanted to eat it everyday for the rest of my life. My birthday present for years afterwards was always foie gras."

What followed next were a couple years of cooking school and a whirlwind tour of London's in vogue gastro-Asians: Hakkasan, Nahm, Nobu, and a return to his hometown to create a completely different restaurant experience. A Cirque de Soleil of gastronomy in his words, with global food inspired by everything: different cultures, different countries.

Muñoz, who almost never eats at home ("I haven't had a day off in a year!"), craves South Asian food like crab and papaya salad and Thai curries as much as traditional Basque favorites such as hake cheek with garlic and chili or roast baby lamb. He lives on cheese, any kind of cheese, and popcorn drives him crazy. "I eat it with everything!"

He has no idea how he comes up with his recipes, they just happen. Outside of the kitchen he is obsessed with traveling and gaining knowledge, being inspired to make something unique, and his ideas often come on a post work run through sleeping Madrid at 1 a.m. "There is no signature dish with me," he says, "It's important that everything changes all the time."

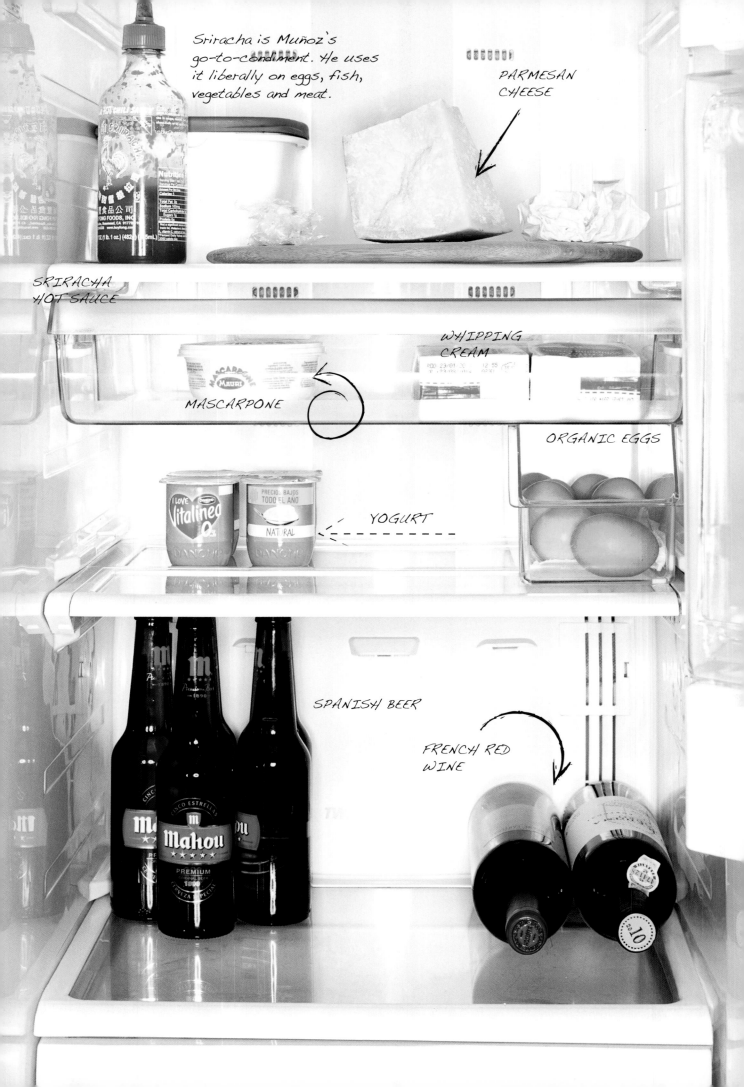

Sriracha is Muñoz's go-to-condiment. He uses it liberally on eggs, fish, vegetables and meat.

PARMESAN CHEESE

SRIRACHA HOT SAUCE

WHIPPING CREAM

MASCARPONE

ORGANIC EGGS

YOGURT

SPANISH BEER

FRENCH RED WINE

Sriracha Sauce

Named for Si Racha, the town where it was purportedly invented, Sriracha is the world's best selling and probably most well loved hot sauce. A blend of chilies, garlic, sugar, salt, and vinegar, and served in its inimitable red squeeze bottle, the hot sauce has found its way from street food stalls to supermarket shelves and high end chefs' kitchens. This popular ("rooster sauce") is manufactured by the Huy Fong Company, though many hardcore devotees prefer versions imported from Thailand.

SEMI-SALTED HAKE
WITH RED CURRY
(CURRY ROJO DE ALBAHACA
Y PIMENTÓN DE LA VERA)

Serves 4

Red Curry

40 small, dried Spanish Guindilla red chili peppers

28g (1 oz.) coriander seeds

24g (1 oz.) ground white pepper

24g (1 oz.) cumin seeds

40g (1.5 oz.) whole cloves

120g (4 oz.) lemongrass, coarsely chopped

200g (7 oz.) shallots, peeled, coarsely chopped

120g (4 oz.) garlic cloves, peeled

20g (1 oz.) kaffir lime leaves

100g (3½ oz.) coconut oil

1L (4¼ cups) chicken stock

500ml (2 cups plus 2 Tbsp.) coconut milk

20g (1 oz.) smoked paprika powder

50g (2 oz.) coconut palm sugar

Grilled Breadcrumbs

160g (1¼ cups) flour

200g (1 cup) sugar

240g (17 Tbsp.) brown butter

480g (1 lb.) eggs

7g (¼ oz.) Madras curry powder

Hake and Assembly

800g (1¼ lbs.) fresh hake

1L (4¼ cups) water

100g (⅓ cup) salt

12 mini Thai basil leaves

12 fresh walnuts, shelled, broken into small pieces

50g (2 oz.) coconut milk powder

20g (.7 oz.) tomato powder

Bergamot jelly, to serve

Red Curry:

Rehydrate chilies in warm water for 15 minutes. Drain water, reserving the chilies. Using a spice mill, grind coriander seeds, white pepper, cumin seeds, and cloves into a powder. In a food processor, make a paste by blending the spice powder with lemongrass, shallots, garlic, and kaffir lime leaves. Heat coconut oil in a skillet over medium heat. Add the curry paste, and cook for 5 minutes, stirring frequently. Heat chicken stock and coconut milk in a large saucepan, without bringing to a boil. Whisk in the curry paste, smoked paprika, and palm sugar. Simmer for 1 hour, then strain, discarding the solids.

Grilled Breadcrumbs:

Mix all the ingredients with a mixer. Place it into a double load siphon. Pour over a glass baking dish and cook for a minute in the microwave. Remove from the glass and break up. Give it a quick warm up on the charcoal oven.

Hake and Assembly:

Cut the hake into 4 portions. Mix together water and salt. Brine the fish in this mixture for 15 minutes. Vacuum seal and cook in water at 55 °C for 18 minutes. Just before serving, warm the fish over a charcoal grill.

Spoon the red curry on to plates. Top with the hake, Thai basil leaves, and fresh walnuts. Sprinkle with coconut milk powder and tomato powder. To finish, add the breadcrumbs and Bergamot jelly.

DAVID **MUÑOZ**

Madrid, Spain

SAMSUNG RS21

INSIDE CHEFS' **FRIDGES**

—

POPCORN
WITH SPICY TOMATILLO DE ÁRBOL (TAMARILLO) KETCHUP, PARMESAN CREAM, AND LIME

Serves 4

Tomatillo de Árbol (Tamarillo) Ketchup

2L (8½ cups) red wine

12 small tomatillos de árbol (tamarillos)

30g (1 oz.) garlic oil

100g (½ cup) sugar

30ml (2 Tbsp.) Sriracha sauce

60ml (4 Tbsp.) Lea & Perrins Worcestershire sauce

200ml (⅔ cup plus 1½ Tbsp.) rice vinegar

25g (scant 1 oz.) Sichuan peppercorns, crushed

6g (1 tsp.) salt

Popcorn and Assembly

200g (7 oz.) freshly grated Parmesan, divided

100g (3½ oz.) cream

Salt

530ml (2¼ cups) vegetable oil

200g (7 oz.) corn nuts

200g (14 Tbsp.) butter

250g (9 oz.) popcorn kernels

Freshly ground black pepper

Zest of 2 limes

Tomatillo de Árbol (Tamarillo) Ketchup:

In a deep saucepan, reduce the wine over medium-low heat to 100ml (just under a ½ cup). Add the tomatillos de árbol (tamarillos) to the reduced wine and remove from heat. Once cool, transfer the wine and tomatillos de árbol to a resealable plastic bag. Press excess air out of the bag, and seal tightly. Let marinate in the refrigerator for 48 hours. In a food processor, combine wine-tomatillo mixture with the remaining ketchup ingredients, and purée until smooth.

Popcorn and Assembly:

Pulverize 150g (5 oz.) Parmesan in a food processor. Combine with cream in a saucepan, and stir constantly over low heat, until temperature reaches 90°C (194°F) and the mixture is completely emulsified, about 16 minutes. Season to taste with salt. Set Parmesan cream aside.

Heat vegetable oil in a large, deep saucepan. Once oil is hot, deep fry the corn nuts until they are lightly browned. Remove from the oil, and season immediately with salt. Once the corn nuts have cooled, pulverize to a fine powder in a food processor. Set corn-nut powder aside.

Melt butter in a large, deep saucepan over medium-high heat. Pour in popcorn kernels, and cover with a lid. Shake the pan gently so that the kernels pop without burning. Once kernels have popped, sprinkle immediately with salt, black pepper, and remaining 50g (2 oz.) grated Parmesan.

Spread out popcorn on a large sheet of parchment paper or platter. Drizzle with tomatillo d'árbol ketchup and Parmesan cream, and top with corn-nut powder and lime zest.

Popcorn

Cultivated for millennia in Central and South American, popcorn was originally from Mexico and is one of the oldest varieties of corn (maize) in the world. The popcorn pops when heated beyond a certain temperature, as the moisture contained in the hard kernel expands. The resulting fluffy structure is caused by the gelatinized starch, which it replicates almost like a series of bubbles.

MAGNUS
NILSSON

FÄVIKEN

•·····················•

Järpen, Sweden

Magnus Nilsson's restaurant, Fäviken, is perhaps the most sought after, and isolated restaurant in the world, a Holy Grail of destination dining. Located in the far northwest of Sweden on the largest, privately owned estate in the country, Nilsson's cooking is, by necessity, rigorously local, and defined by the short growing seasons inherent in this part of the world.

Nilsson, who grew up in a food-loving family, where everyone cooked, decided to become a chef in high school and trained professionally in Paris kitchens such as L'Arpège, where he was fired because he didn't speak enough French, and then at three-star L'Astrance. Afterwards, he returned to Sweden and studied oenology, got a sommelier job at Fäviken (which was then more famous for making moose fondue for tourists than fine dining), and through a series of events, became head chef.

"Every meal serves some purpose, and people eat for different reasons. Sometimes you just have to eat, sometimes it's a social event, but no matter what, there's no point in doing it in a way that is not pleasurable. Deliciousness is important regardless of whether it's a home cooked meal or in a restaurant."

In lieu of a family fridge, Magnus prefers his root cellar, a very traditional part of Western culture, he says, but one that most people don't have anymore. "All the farmers here have them, and it's the most efficient way of storing things, as the temperature remains constant throughout the year." In the "fridge," predictably, much is fermented and pickled: turnips, crowberries in water, mushroom in *attika* vinegar, alongside hand-churned butter and locally produced ham, and as supermarkets are scarce in the region, he prefers hunting, fishing, and foraging in the estate's woods, always obsessed with finding perfect products.

"When friends come over, we like to cook together, mostly simple things like meat stew, green vegetables or roast turkey." When not in the kitchen, Nilsson is inspired by other creative pursuits and paints nature and landscapes, takes photographs, and travels as much as possible. "Curiosity is so important," he says. "Discovery is just a part of life."

ROOT CELLAR

The great-granddaddy of the modern fridge, root cellars have been in use for years to keep vegetables from spoiling throughout the winter. Root cellars use the earth's own properties of humidity and temperature control to prevent the growth of mold and microorganisms, and the release of ethylene gas (the ripening agent that also makes fruits and vegetables decompose). Australian aboriginals created the first root cellars over forty thousand years ago, and this ancient technology uses the same principles today wherever they are found the world over.

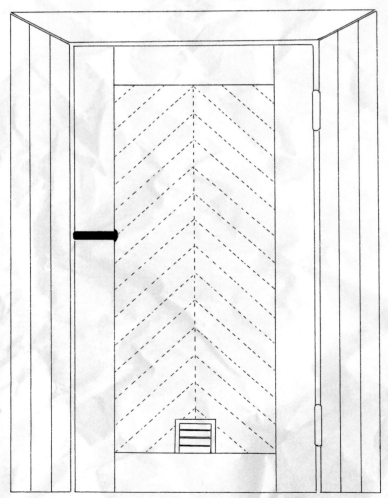

CUSTOM DESIGNED SWEDISH ROOT CELLAR

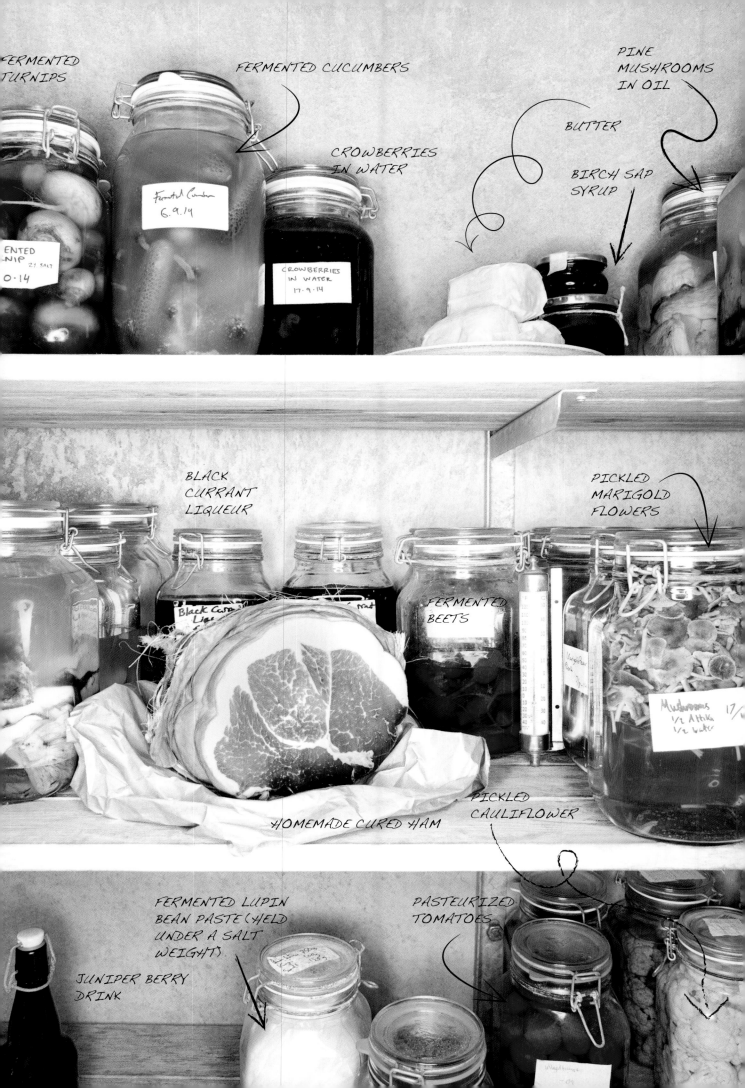

BRINED CUCUMBER PICKLES

Makes 1 large jar

1kg (2.2 lbs.) small cucumbers
1L (1 quart) water
40g (2 Tbsp.) salt

Fill a large pot or glass jar with the cucumbers. Stir together the salt and water, and pour over the cucumbers. Seal the pot or jar with a tight lid, and leave at room temperature, away from light. If it ferments and bubbles a lot, open the lid to release the pressure, then reseal the pot or jar. Cucumbers are ready to eat after 2-3 weeks fermentation. Store the cucumbers away from light in a root cellar or a refrigerator. If stored properly, the cucumbers will keep for a very long time.

HOMEMADE SWEDISH FLATBREAD
WITH HAM

Makes 8 flatbreads

25g (3 Tbsp.) active, fresh yeast.
12g (2 tsp.) salt
20ml (1 Tbsp. plus 1 tsp.) golden syrup
600ml (2.5 cups) milk
7g (1¼ tsp.) baker's ammonia (ammonium carbonate)
210g (7.4 oz.) barley flour
210g (7.4 oz.) wheat flour, plus more

In a large pot or bowl, mix yeast, salt, and golden syrup together, then pour in milk. Add baker's ammonia, and stir. In a separate large bowl, sift both types of flour. Slowly pour milk mixture on top of flour mixture. Mix with a large spoon until a loose, sticky dough forms. Proof near a hot oven for about 45 minutes.

Place the dough on a work surface, and pull out bite-sized pieces of dough, about 120 grams (4 ounces) each. Form each piece by hand into a bun shape, about 10–12 cm (4–5 inches) in diameter, dusting with additional wheat flour when needed. Let the buns rise under canvas or a towel until doubled in size.

On a floured work surface, thinly roll out the buns. Brush off any excess flour. Bake in a wood-fired bread oven until the color turns light golden brown, approximately 45–60 seconds. Buns should be eaten immediately or frozen on the same day. For a typical sandwich, serve the flatbread buttered and topped with _spickeskinka_ (delicious sliced ham). If you have the opportunity, learn from an old Swedish grandmother who has lifelong experience baking flatbread.

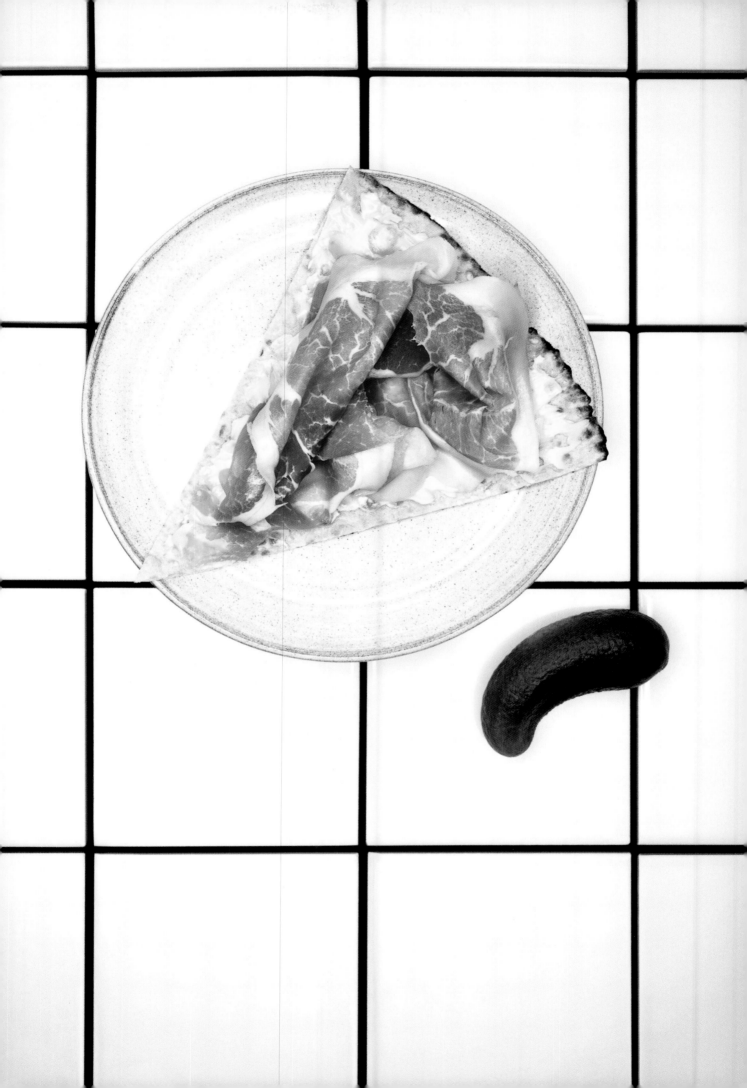

MATT
ORLANDO

AMASS

• •

Copenhagen, Denmark

GORENJE ION GENERATION

Gourmets from around the world went crazy when news broke that former Noma head chef and San Diego native Matt Orlando quit his position at the world famous New Nordic table and struck out on his own with a restaurant located in the Copenhagen docklands. Amass, as it is named, is a graffiti strewn, highly conceptual dining room in a former industrial space, and, since its opening, one of the hottest destination dining spots in the world.

"It's all about the product," Orlando says when asked about his cooking philosophy. "I tell my farmers, you tell me what you have, not what I want, and I'll work with that. People still call my cooking Nordic, but I'm just looking for the delicious things that obsess me, and interesting textures, using seasonal produce."

Orlando, who trained at Le Bernardin, The Fat Duck, and Per Se, to name a few illustrious restaurants, is as known for his pristine technique as for the eclectic dishes he serves, and his home icebox is a reflection of this. Ranging from supermarket bought items to super-scarce seasonal produce pilfered from Amass's larder, Orlando says, "My fridge is funny, it shows you how much work spills into your personal life."

His top shelf is dedicated to honey, which he defines as the ultimate *terroir*. Scattered sporadically throughout the rest of the fridge are lots of vegetables: sun chokes, avocados, cucumber, Japanese sake, and organic cider (French *L'Atelier de la Pépie*, Spanish *Clos de les Soleres*) and red seaweed ("I always have it, you can season anything with it"). More mainstream products include Caesar salad dressing, maple syrup ("someone gave this to me because they think all Americans eat it"), and his wife's omnipresent bottle of apple juice. Hidden away in a corner is a partially finished takeout container from local Chinese restaurant Magasassa, an after work, tired-chef treat, "best washed down with a beer from Mikkelar's brewery. It's almost like he's a professionally trained chef, just that he isn't food-oriented."

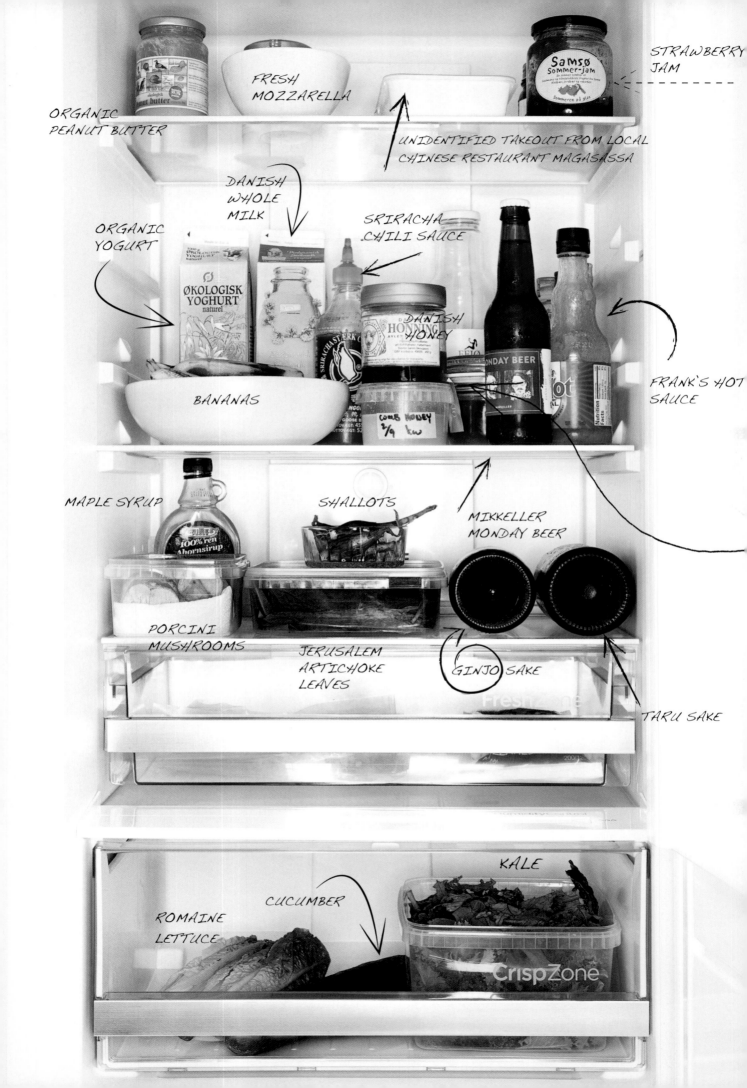

Honey
One of nature's most unique products,
honey is also one of the most ancient
foods consumed by humans. Cultivated over
thousands of years by cultures as diverse
as the Chinese, Egyptians, Indians, Mayans,
and Romans, the natural nectar has remained
relatively unchanged over the centuries.
It is prized as much for its dense sweet
taste as it is revered by certain people
for its mystical properties or as folk
remedies for various ailments.

Austrian honey from
vineyard. (" Honey is
the ultimate terroir,
definitely")

ROASTED KALE
WITH PLUMS, RED SEAWEED, AND BROWN BUTTER

Serves 2

20g (.7 oz.) red seaweed
2 plums, pitted, cut into 16 slices
10ml (2 tsp.) apple cider vinegar
60g (4 Tbsp.) butter
70ml (¼ cup) grapeseed oil
1 bunch kale, ribs and stems removed,
leaves torn into large pieces
20ml (1 Tbsp. plus 1 tsp.) lemon juice
Salt
Freshly ground black pepper

Soak red seaweed in cold water until soft.
Drain water, and set aside seaweed at room
temperature. Toss sliced plums with apple cider
vinegar. Melt butter in a medium saucepan over
medium heat, stirring often, until butter foams,
then starts to turn brown and smell nutty.
Remove from heat, cover, and reserve.
Heat grapeseed oil in a large skillet. When oil starts
to smoke, add kale, and sear aggressively
until the edges of the kale start to burn.
Remove kale from pan, and place in a large bowl.
Toss with brown butter, red seaweed, and lemon
juice. Season to taste with salt and pepper.
Garnish with plums.

GRILLED SPRING ONIONS
AND SALTED MACKEREL

Serves 4

4 large mackerel filets
5g (1 tsp.) salt, plus more
4 large spring onions
20ml (1 Tbsp. plus 1 tsp.) grapeseed oil
8ml (½ Tbsp.) lemon juice
8g (2 Tbsp.) horseradish leaves, roughly chopped
8g (1½ Tbsp.) fresh horseradish root, grated, divided
4 large Swiss chard leaves
Nasturtium flowers
Beach mustard flowers

Season mackerel with 5g (1 tsp.) salt, and refrigerate
overnight. The next day, remove bones, skin,
and bloodline from mackerel. Prepare a grill.
Once the grill is hot, char spring onions until tender.
Finely dice the mackerel, and toss with grapeseed
oil, lemon juice, horseradish leaves, and half of
grated horseradish root. Season to taste with salt.
Place chard leaves on grill just until they begin
to wilt. Lay chard leaves flat, and top with grilled
spring onions and marinated mackerel. Roll chard
leaf around spring onions and mackerel to make
a packet, and garnish with remaining horseradish,
nasturtium flowers, and beach mustard flowers.

YOTAM OTTOLENGHI

VARIOUS ESTABLISHMENTS THROUGHOUT LONDON

•·····································•

London, England

Yotam Ottolenghi, one of the most well-known and loved cookbook writers in the world, has found his own perfect recipe and distilled the essence of Middle Eastern and Mediterranean comfort food for the general dining public, enticing their taste buds with whole new takes on traditional ethnic dishes. A widely recognized home cooking maven, Ottolenghi started out as a journalist in Tel Aviv, before moving to London, training at the Cordon Bleu, and finally honing his pastry skills at the swanky Capital restaurant. One thing led to another and opportunities sprang up; a successful chain of delis, followed by a newspaper column, and a slew of immensely successful and highly personal cookbooks. "I guess I started at the right time, when people were looking to get just a little bit out of their comfort zone," he says. "They realized that there are all these other cuisines out there. The British and American markets started to discover Middle Eastern cuisine, and it was a time when people got more and more into vegetables."

Ottolenghi's well-stocked fridge has everything from friendly gifts (homemade mango chutney) to products from work, and a mishmash of supermarket and farmer's market bought items. Arabic pastry noodles ("called kataifi, I love cooking them savory with eggplant and cheese") and labneh (Arabic strained yogurt cheese) share space with eggplant paste and preserved lemons, while hiding in the freezer is chicken stock from last Christmas. "I've got everything in my fridge, I'm not a purist."

Although Ottolenghi shops everywhere from Whole Foods to the local green grocers, pilfering products from time to time from his test kitchen, he always relies on food from the Mediterranean, North Africa, and Asia: "I'm so inspired by food from sunny places—it's as if you can feel the sunlight in the food."

1	Whole grain mustard	26	Labneh balls	
2	Strong English mustard	27	Ricotta	
3	Horseradish with beetroot	28	Stuffed vine leaves	
4	Smoked chili paste	29	Chicken stock	
5	Capers	30	Vinaigrette	
6	Cornichons	31	Eggplant paste	
7	Horseradish sauce	32	Organic miso paste	
8	Gelfilte fish	33	Salami	
9	Shrimp paste	34	Smoked salmon	
10	Harissa	35	Avocado	
11	Slow cooked lentils	36	Ground beef	
12	Lobster bisque	37	Organic eggs	
13	Slow cooked okra	38	Herring	
14	Tamarind paste	39	Celery	
15	Lime pickle	40	Fennel	
16	Mango chutney	41	Pomegranate	
17	Pickled lemons	42	Shallots	
18	Vine leaves	43	Lettuce	
19	Clementine marmalade	44	Tomatoes	
20	Blackcurrant jam	45	Lemons	
21	Gooseberry elderflower jam	46	Chili pepper	
22	Cranberry relish	47	Lime	
23	Mozzarella with truffles	48	Carrots	
24	Organic Greek yogurt	49	Fresh herbs	
25	"Beyaz Peynir" sheep milk cheese			

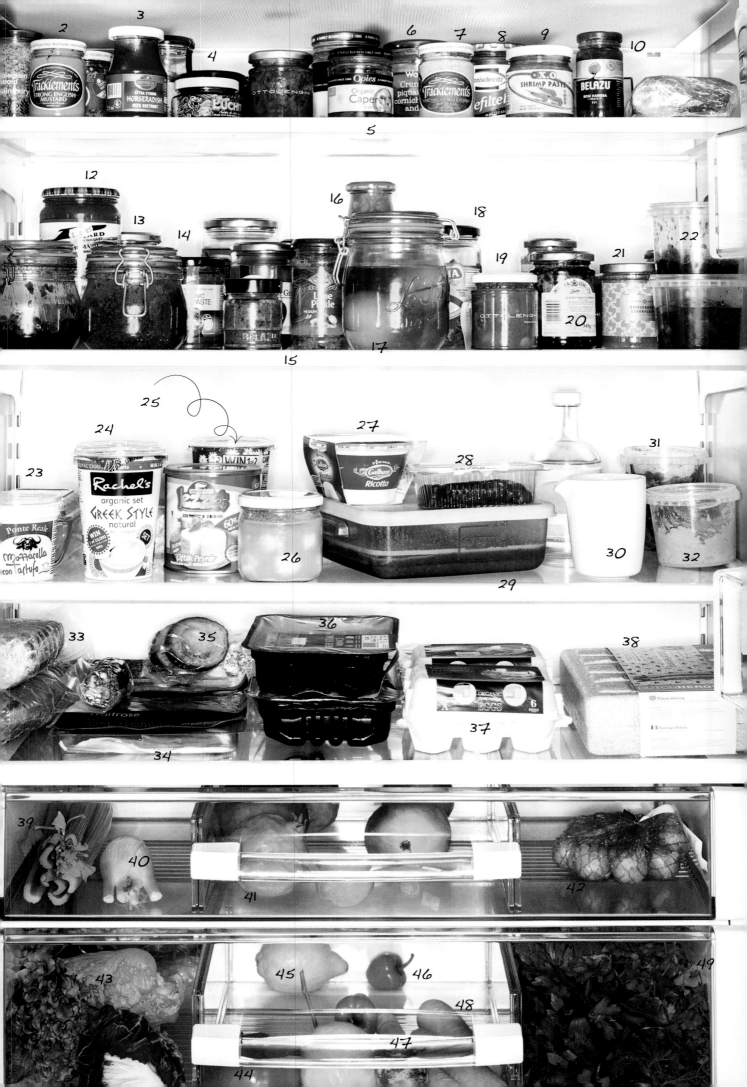

SUB ZERO, ICBBI-36UFD

" My slight obsession with lemons and all things green makes this a definite desert island salad. It's pretty quick to put together and delivers with plenty of nutty (farro), sharp (lemon) and fresh (all those herbs) aromas and lots of contrasting textures. It's a proper spring feast."

FARRO AND
BROAD BEAN SALAD

Serves 6

70g (2.5 oz.) farro

350g (12 oz.) broad beans, fresh or frozen

1 head baby gem lettuce, cut lengthwise into 1.5cm (½-in.) wedges

2 Tbsp. preserved lemon rind, finely chopped

5g (.2 oz.) mint leaves, roughly shredded

10g (.4 oz.) parsley leaves, roughly chopped

10g (.4 oz.) basil leaves, roughly shredded

5g (1 tsp.) dried mint

15ml (1 Tbsp.) lemon juice

45ml (3 Tbsp.) olive oil

2g (½ tsp.) salt

Freshly ground black pepper

70g (2.5 oz.) goat cheese

2g (¾ tsp.) Urfa chili powder

Bring a medium pot of water to the boil. Add farro, and simmer over medium heat until cooked but still retaining a bite, about 18 minutes. Drain, rinse under cold water, and set aside to dry.

Bring a large pot of water to a boil. Add broad beans and simmer for 2 minutes. Drain and rinse under cold water. Pop the beans out of their skins; discard the skins.

In a large mixing bowl, combine beans, farro, lettuce, preserved lemon, fresh mint, parsley, basil, dried mint, lemon juice, and olive oil. Stir gently, and season with salt and a generous crack of black pepper. Transfer the salad to serving bowls, and crumble goat cheese on top. Sprinkle with Urfa chili powder.

ALMOND AND ROSE SEMOLINA CAKE

Serves 8

Cake

250g (8.8 oz.) ground almonds

170g (6 oz.) semolina

12g (2 Tbsp.) ground fennel seeds, toasted

6g (1¼ tsp.) baking powder

1g (¼ tsp.) salt

300g (21 Tbsp.) unsalted butter, room temperature

330g (1½ cups) caster (superfine) sugar

4 medium eggs, lightly beaten

Grated zest of 1 lemon

15ml (1 Tbsp.) lemon juice

30ml (2 Tbsp.) rose water

2ml (½ tsp.) vanilla extract

Syrup

100ml (⅓ cup plus 1½ Tbsp.) lemon juice

85ml (⅓ cup) rose water

100g (⅓ cup plus 1½ Tbsp.) caster (superfine) sugar

Cream

200g (7 oz.) Greek yogurt

200g (7 oz.) crème fraîche

10g (1 Tbsp.) icing (powdered) sugar

15ml (1 Tbsp.) rose water

3g (2 tsp.) dried rose petals (for serving)

Cake:

Preheat oven to 160°C (320°F). Grease a 22cm (9-in.) spring-form cake pan, and line the base and sides with parchment paper. Stir together ground almonds, semolina, fennel seeds, baking powder, and salt; set dry ingredients aside. Combine butter and sugar in the bowl of a stand mixer, and use an electric beater to mix until fully combined. Be careful not to overwork the mixture—you don't want to incorporate a lot of air. Slowly add eggs, scraping the sides of the bowl occasionally. Once the egg is fully incorporated, add the dry ingredients, and gently fold in by hand. Add lemon zest, juice, rose water, and vanilla. Fold gently, transfer the batter to the lined pan, level with a palette knife, and bake for about an hour. You can tell if the cake is ready when a skewer inserted comes out dry (but oily).

Syrup:

While the cake is baking, make the syrup. Combine lemon juice, rose water, and sugar in a small saucepan, and place over medium heat. Bring to the boil, making sure the sugar fully dissolves, and remove from the heat. As soon as the cake comes out of the oven, brush it with the hot syrup. Allow cake to come to room temperature.

Cream and Assembly:

Whisk together Greek yogurt, crème fraîche, icing (powdered) sugar, and rose water until soft peaks form. Slice the cake into wedges and divide among plates. Spoon a generous dollop of the cream over each slice, and sprinkle with rose petals.

JEAN-FRANÇOIS PIÈGE

LE GRAND RESTAURANT DE JEAN-FRANÇOIS PIÈGE

● ∙∙∙∙∙∙∙∙∙∙∙∙∙∙∙∙∙∙∙∙∙∙∙∙∙∙∙ ●

Paris, France

SAMSUNG SIDE-BY-SIDE SRS683GDHLS

Jean-François Piège is a towering figure in French gastronomy: former chef of the three-star Alain Ducasse at the Plaza Athénée, then at the two-star restaurant Les Ambassadeurs at the Hotel de Crillon, and finally at his eponymous gastronomic restaurant Jean-François Piège, another shrine of high gastronomy, crowned with two Michelin stars. He has since taken wing with Clover, which he opened with his wife Élodie in December 2014. In September 2015, he inaugurates his new gourmet restaurant Jean-François Piège / Le Grand Restaurant on the Right Bank. Veritable flagship of the chef, this restaurant will become his laboratory of ideas and high cuisine, a stone's throw from the rue du Faubourg Saint-Honoré, in Paris's 8th arrondissement.

Piège has forged his own path and many consider him, with his encyclopedic knowledge of products and his highly perfected technique, a bridge connecting the past and the future of French gastronomy. Passionate collector of antique and contemporary cookbooks, he has amassed a collection of more than 10,000 works over the years. Enriched by these historical and traditional bases, today he offers up ferociously personal cooking filled with modernity and sensibility.

His tasteful eclectic abode in the heart of historic Paris houses a non-pretentious, but extraordinarily well-equipped La Cornue kitchen with KitchenAid mixers, Mauviel pans and casserole dishes, and all the usual chef's knives and utensils of course. As one might expect from a prestigious chef, his kitchen is as immaculate as a starred table, with the generosity that goes with it.

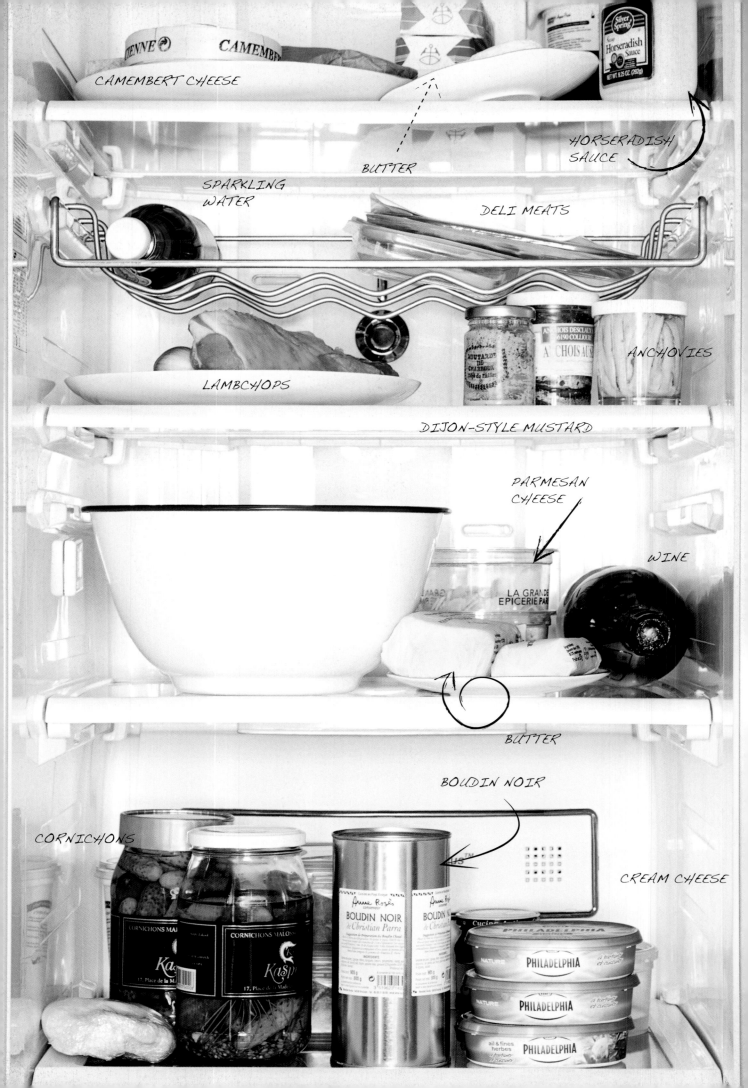

CAMEMBERT CHEESE

BUTTER

HORSERADISH SAUCE

SPARKLING WATER

DELI MEATS

LAMBCHOPS

ANCHOVIES

DIJON-STYLE MUSTARD

PARMESAN CHEESE

WINE

BUTTER

BOUDIN NOIR

CORNICHONS

CREAM CHEESE

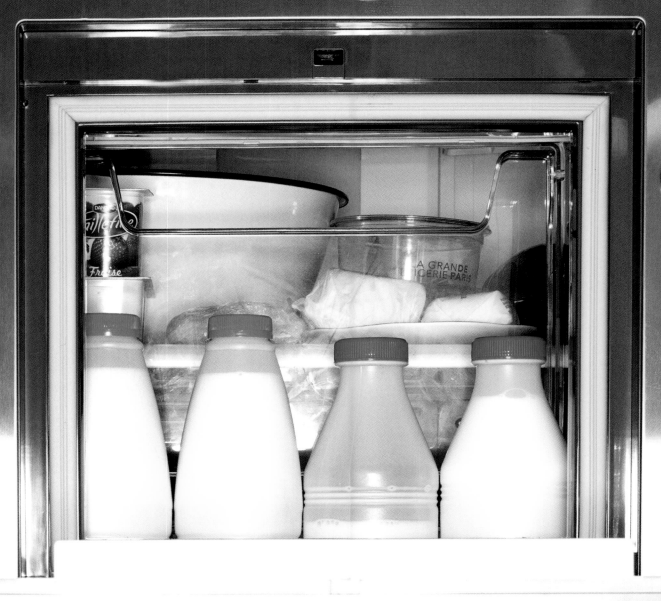

Horseradish

Used since ancient times, as a medicinal herb for ailments as varied as back pain and bronchitis, as an aphrodisiac and even a hangover remedy, horseradish is the dark horse of condiment culture. The kissing cousin of broccoli, cabbage, and wasabi, horseradish was enormously popular in 16th century England as an accompaniment for beef and seafood, but it wasn't until the early 1850s that it achieved large-scale commercialization in the United States. The plant itself has no smell or taste until cut, at which point the chemical that gives mustard oil its taste is released. After being cultivated, it must immediately be preserved in vinegar or lemon juice to avoid spoilage. Horseradish sauce refers to horseradish that has mayonnaise or salad cream added.

ONE-POT LAMB
WITH SPAGHETTI

Serves 4

2 tomatoes
8 lamb chops
Salt
Piment d'Espelette powder
60ml (4 Tbsp.) olive oil, divided
3 shallots, diced
1 yellow onion, diced
2 garlic cloves, minced
240g (8.5 oz.) spaghetti
120ml (½ cup) dry white wine
1 chicken bouillon cube
Fresh thyme leaves (for serving)
1 bunch flat-leaf parsley, minced

Bring a large pot of water to a boil. Add tomatoes and cook 30 seconds. Remove from water, peel immediately, and dice. Sprinkle lamb with salt and *Piment d'Espelette* to taste. Heat 45ml (3 Tbsp.) olive oil in a large cast-iron skillet over medium heat. Sear lamb chops on each side until browned. Add shallots, onion, and garlic, and sauté 5 minutes. Add the diced tomatoes, and cook 5 minutes. Add remaining olive oil, and stir in spaghetti. Add white wine, and simmer until liquid is reduced by half, deglazing skillet. Add just enough water to cover the spaghetti and lamb chops, and add bouillon cube. Sprinkle with more *Piment d'Espelette* powder and salt. Bring to a boil, then reduce heat to a simmer, and cook 15 minutes. Add a little more water if necessary, and check the seasoning. Top with fresh thyme leaves and parsley.

POTATO CHIP
OMELET

Serves 2

125g (4 oz.) bag potato chips
4 eggs
2 handfuls coriander (cilantro), chopped
1 garlic clove, chopped
1 pinch *Piment d'Espelette* powder 15ml (1 Tbsp.)
olive oil

Pierce a hole in the potato chip bag, and smash the chips inside the bag. Transfer crushed chips to a medium bowl, and set aside. Crack eggs into a medium bowl, and whisk vigorously. Pour eggs over the chips and gently combine with a fork. Add coriander (cilantro), garlic, and *Piment d'Espelette* powder. Heat olive oil in a nonstick skillet over medium heat. Pour in the egg mixture, and cook over low heat for 3 minutes. Smooth the sides and top of the omelet with the back of a spoon. Slide the omelet onto a plate, and flip it delicately back over into the skillet, being careful not to break it. Cook for 1 minute. Smooth sides and top of the omelet again, and serve.

CHRISTIAN F.
PUGLISI

RELÆ

•·································•

Copenhagen, Denmark

One of Copenhagen's most interesting chefs, Christian Puglisi, a half-Sicilian, half-Norwegian, came to Denmark as a child and has worked in some of the world's greatest kitchens, including establishments as diverse as Taillevent, El Bulli, and Noma. As illustrious as his cooking education was he realized that he would only be truly happy in his own restaurant, one stripped down to what he considers the essentials. Relæ was the result: a food first place, simple yet creative and without the chichi inherent in other fine dining establishments.

Puglisi's modest home refrigerator is in synch with the laid-back chef's low-key attitude: high quality products pilfered from his Michelin-starred table share space with homemade pastas made by friends. Italian style blood sausage made with a fine mince and local chilies sits side by side with his favorite artisanal fish sauce, found on vacation in the South of Italy and made from aged anchovy heads. He claims it is miles better than any other, especially for Thai cooking. He is also a self-professed vinegar freak and loves white wine, apple and cherry versions, but hold the balsamic, which, in his words, is too sweet and tricky to combine with other things.

And although his first home cooked meals (for his future girlfriend) were inspired by his day job as a "fancy" sous chef at Noma (visions of tenderloin tartar covered in wood sorrel and dipped in a tarragon emulsion come to his mind), his cooking for friends and family run to easier fare now, and his home style is light years away from what he does in his professional kitchen. "On a Sunday morning, I've basically been destroyed by a week of work, and all I want is some easy Italian food or a roast chicken. I work with what I have in the fridge and throw in a few herbs from my courtyard garden, and it's done."

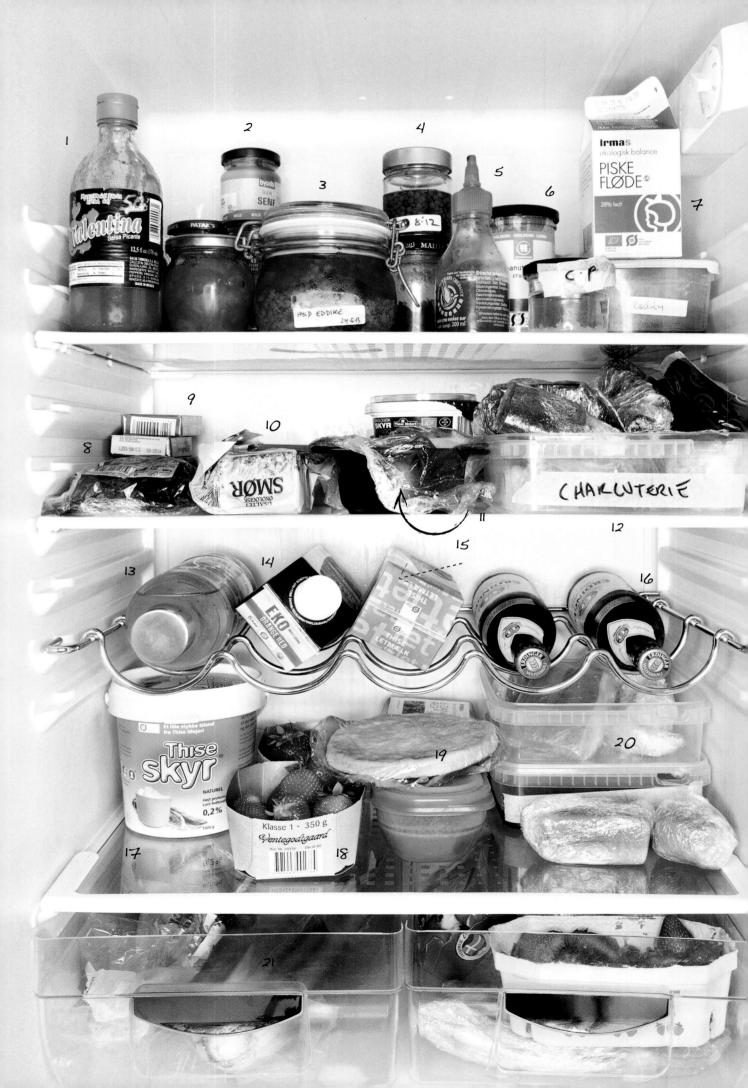

1 Hot sauce
2 Dijon-style mustard
3 Elderflower vinegar
4 Elderberry capers
5 Sriracha hot sauce
6 Peanut butter
7 Whipping cream
8 Miso paste
9 Liver paste
10 Butter
11 'Nduja sausage
12 Assorted cured meats
13 Homemade soda water
14 Orange juice
15 Milk
16 German beer
17 Icelandic-style yogurt
18 Strawberries
19 Girlfriend's birthday cake project
20 Assorted cheeses
21 Celery

GORENJE K337

SPAGHETTI
WITH BREADCRUMBS AND ANCHOVIES

Serves 4

2 small tins anchovies (about 90–100g
or 3–3½ oz. fish), preferably Lolin brand
15ml (1 Tbsp.) sunflower oil
1 garlic clove, minced
100g (⅔ cup) dry breadcrumbs
400–500g (14–18 oz.) high-quality spaghetti
Handful parsley leaves
15ml (1 Tbsp.) olive oil
50g (2 oz.) freshly grated Parmesan

Strain oil from anchovy tins and discard.
(Rarely is the oil that's used for canning of any
quality.) Bring a large pot of salted water to a boil.
Heat the sunflower oil in a large skillet over medium
heat. Add garlic, and sauté until soft, then add
breadcrumbs. Sauté breadcrumbs until golden,
adding a bit more oil if necessary. Cut the anchovy
filets in half, but no smaller: With a quality anchovy,
you want to taste and feel the texture.

Cook the spaghetti until _al dente_; strain.
Reserve half the breadcrumbs. Stir pasta into
the pan with the remaining toasted breadcrumbs.
Add anchovies, parsley, and olive oil. You don't
want to cook any of these—just give them a bit of
heat—so toss the pasta for less than a minute.
Top with Parmesan and remaining breadcrumbs.

BERRIES
WITH BUTTERMILK SAUCE (_KOLDSKÅL_)

Serves 4

100ml (⅓ cup plus 1½ Tbsp.) egg yolks
60g (½ cup plus 1½ Tbsp.) powdered sugar
2 lemons, zested and juiced
1L (4¼ cups) buttermilk
500g (1.1 lbs) strawberries or raspberries

Whisk egg yolks and sugar until very fluffy and airy,
then quickly whisk in the lemon zest.
Incorporate the buttermilk, then the lemon juice.
Refrigerate for a few hours prior to serving.
If the mixture starts to separate, just whisk it back
together. Pour over freshly sliced strawberries
or raspberries and serve. _Koldskål_ is often poured on
fresh berries and is best eaten when
the sun is shining!

JOAN
ROCA

EL CELLER DE CAN ROCA

Girona, Spain

One of the greatest chefs in the world, Joan Roca, along with sommelier brother Josep and pastry chef Jordi, comprise what is probably the most exceptional family gastronomic unit in existence today. Their restaurant, located in what was once a working class neighborhood of Girona, is located next to the family restaurant, where his mother still serves up simple, honest fare to locals and gourmet travelers who can't get into her son's three-star Michelin flagship. They are widely recognized as being on the forefront of modern cuisine, as much as for respecting their traditions and for moving Catalonian cooking into another dimension.

Joan Roca, who lives in very close proximity to the restaurant, cooks every day for his wife and two children, in between the lunch and dinner services. Meals are almost always vegetable based, with local fish (marlin, sea bass, and monkfish being favorites) or for protein, veal or duck.

"We're lucky to have a professional kitchen so close as well," he jests. "We get food from there or from the market in Girona where I go with my daughter every Saturday to see what's happening around us, and to see what is new. It's a reflection of the seasons, of the products around us."

The family eats lots of vegetables (often cooked in a wok with fresh pasta and fermented soy sauce) with fish or chicken, and spiced with Mexican or Asian chili peppers. "We love spice," he says. Rice dishes such as paella or risotto, and cream of vegetable soup are also regular favorites, but the recipe they love the most is pigeon with rice (cooked with its liver) and truffles if they are in season. The chef's comfort food of choice is his grandmother's *escudella*, a soup made traditionally with meatballs, seasonal vegetables, and pasta or rice, or crispy, scissor cut lamb sandwiched between traditional *pan con tomate* and eaten with the hands.

In the fridge are local specialties: king prawns from Palamós ("an extraordinary product"), Galician cow's milk cheese, black olive tapenade ("great to make vinaigrettes with"), next to plastic sealed boxes of chopped onions and tomato sauce ("to make a quick pasta sauce from"). Fast and delicious snacks could be Ibérico ham and local *boudin blanc*, eaten cold, or frozen bread from the freezer, quickly reheated for sandwiches and bouillon for sauce making on the fly.

And tying everything together from the private to work space is family: "With my brothers and our shared interests in science, botany, the visual arts, literature, and travel, we have a union and a shared creative process that enables us to create rich and interesting things. From our own traditions we can extrapolate and make something extraordinary."

MIELE WHIRLPOOL WTE3813

MONTSERRAT **FONTANÉ,** CAN ROCA

Behind the avant-garde cooking the Roca brothers have been creating for nearly three decades lies their mother, Montserrat Fontané, who runs Can Roca, a humble restaurant a few hundred meters away from their ground-breaking fine dining establishment. All three of the brothers learned the value of hard work in her kitchen, and return daily to have their lunch, standing up, in the kitchen with their mother.

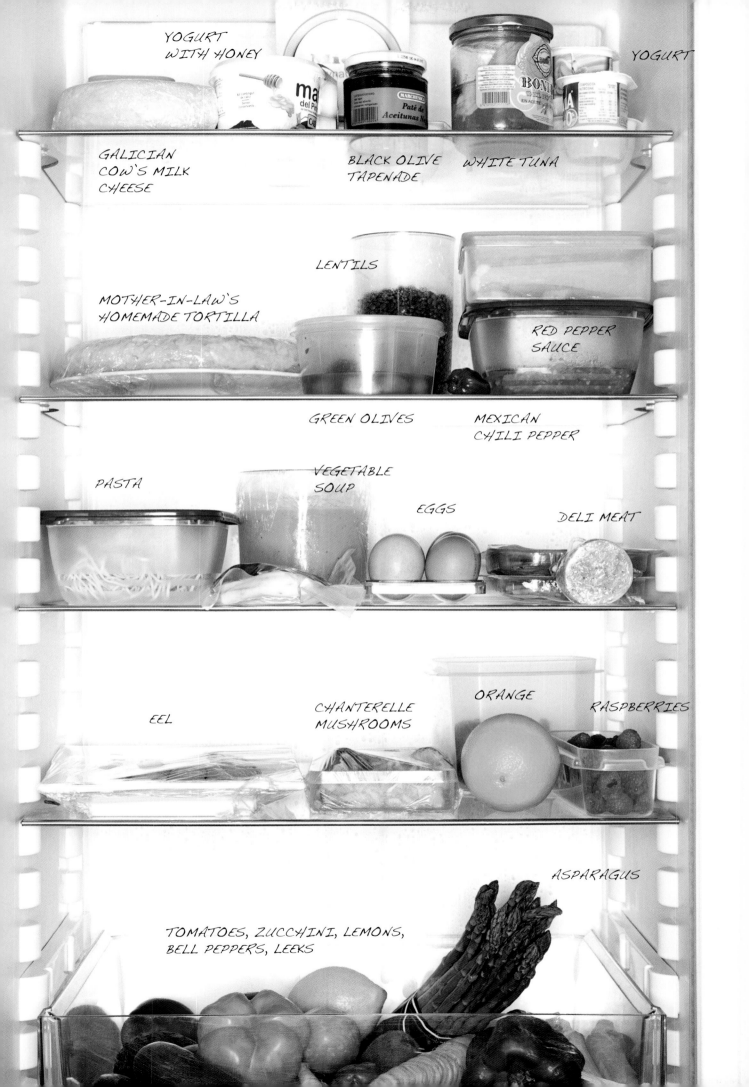

●·································●

Girona, Spain

CREAMED ZUCCHINI
WITH PESTO

Serves 4

Handful basil leaves
50 ml (2 Tbsp.) olive oil
100ml (⅓ cup plus 1½ Tbsp.) water
2ml (½ tsp.) salt, plus more to taste
600g (1⅓ lbs.) zucchini, chopped
200ml (⅔ cup plus 3 Tbsp.) heavy cream
100g (3.5 oz.) mascarpone cheese
Freshly ground black pepper
40g (1.5 oz.) pine nuts, toasted

Set aside a few of the smallest basil leaves for garnish. In a blender purée remaining basil with olive oil. Set basil oil aside.

Combine water and salt in a pressure cooker. Add zucchini. Bring to a boil (once the cooker ejects steam pressure), and cook two minutes. Remove the pressure cooker from heat, and drain the water. Transfer zucchini to a blender, and purée until smooth. Chill creamed zucchini in an inverted double boiler with cold water (so as not to lose color or taste). In a medium bowl, combine heavy cream and a pinch of salt. Add mascarpone, and beat until the texture resembles whipped cream. Season with salt and pepper to taste.

Divide zucchini among four shallow soup bowls. In the center of the creamed zucchini, add a scoop of the mascarpone cream. Finish with basil oil, pine nuts, and reserved basil leaves.

RICE WITH FRIED MUSHROOMS AND SMOKED EEL

Serves 4–6

2L (8.5 cups) water
400g (14 oz.) porcini mushrooms, cleaned, sliced
400g (14 oz.) chanterelle mushrooms, cleaned, sliced
1 onion, diced
Olive oil
1 tomato, diced
2 cloves garlic, minced
1 green pepper, thinly sliced
¼ red pepper, thinly sliced
400g (14 oz.) short-grain rice
250g (9 oz.) smoked eel, chopped
Salt
Handful arugula leaves (for serving)
Garlic flower petals (for serving)

In a large pot, bring water to a boil. Add porcini and chanterelle mushrooms, and cook 2 minutes. Strain mushrooms, reserving cooking water. In a cast-iron skillet, sauté onion with a drizzle of olive oil. Add tomato, and cook until the liquid evaporates. Add mushrooms, and cook for a couple minutes. Add garlic, green pepper, and red pepper, and continue to cook until the vegetables are caramelized, and the mushrooms have released their juices. Add rice, and stir to combine. Slowly add the reserved mushroom-water, and cook over high heat for 8 minutes. Reduce heat to a simmer, and continue to cook until rice is tender, a few more minutes. Add chopped eel, just to warm it (be careful not to overcook). Season with salt. Serve with fresh arugula leaves and garlic flower petals.

INSIDE CHEFS' **FRIDGES**

294

DOUCE
STEINER

RESTAURANT HIRSCHEN

•·······································•

Sulzburg, Germany

"I live in the most beautiful part of Germany, and this restaurant is my home, always has been," says Douce Steiner, Germany's highest-rated female chef. Steiner got her start in the family restaurant that her father, a former culinary great himself, opened 35 years ago with her French mother. When still a child she already knew she wanted to be a professional cook. The Steiner's hotel and restaurant, located in the Black Forest, and started by her parents from scratch, was also her first professional experience, followed by stints with such notable three-star chefs as George Blanc and Harald Wohlfahrt.

After attending hotel school in Heidelberg, Steiner returned with her new husband and expecting a child, taking over the reigns of the family business, and rising to culinary prominence. Her mother works the breakfast shift and acts as sommelier, and her father, although no longer in the kitchen keeps his eyes on the business and goes on food shopping expeditions, and even her teenage daughter is an aspiring chef. "But she has to finish her studies first," says the chef/mom.

Steiner, who describes her cooking as anchored in "classic French, modern and light with lots of aromas," is picky about her produce, and her search for the most pristine ingredients takes her around Germany, Italy, and especially France, where she shops twice a week.

The Steiner's live behind the restaurant, and, more often than not, her shopping is done in its pantries. "It's ridiculous to go out shopping when the pantries downstairs are full of so many good things." More mundane shopping assures the basics are always present: water and wine, butter, cheese, ham, and pickles. The freezer is reserved for bread or leftovers.

Favorite products might include blood sausage and salami from Sulzburg, Vacherin Mont-d'Or and vieux Gruyère from Switzerland, and, her go to snack, Chantecler apples. There is never anything industrial and junk food is banned from the fridge. "We eat everything, as long as it is fresh. It doesn't mean we eat lobster and foie gras all the time, just as long as it's good." A typical meal could be a pizza, a chicken in bouillon, or grilled meats with crudité salad.

"I have so many memories from growing up, but the only thing that's stayed in my mind is that I've always wanted to cook, and that I've grown up in a gastronomic family. I've always eaten well, and food is all we talk about and all we care about."

BAUKNECHT KGIN NO FROST

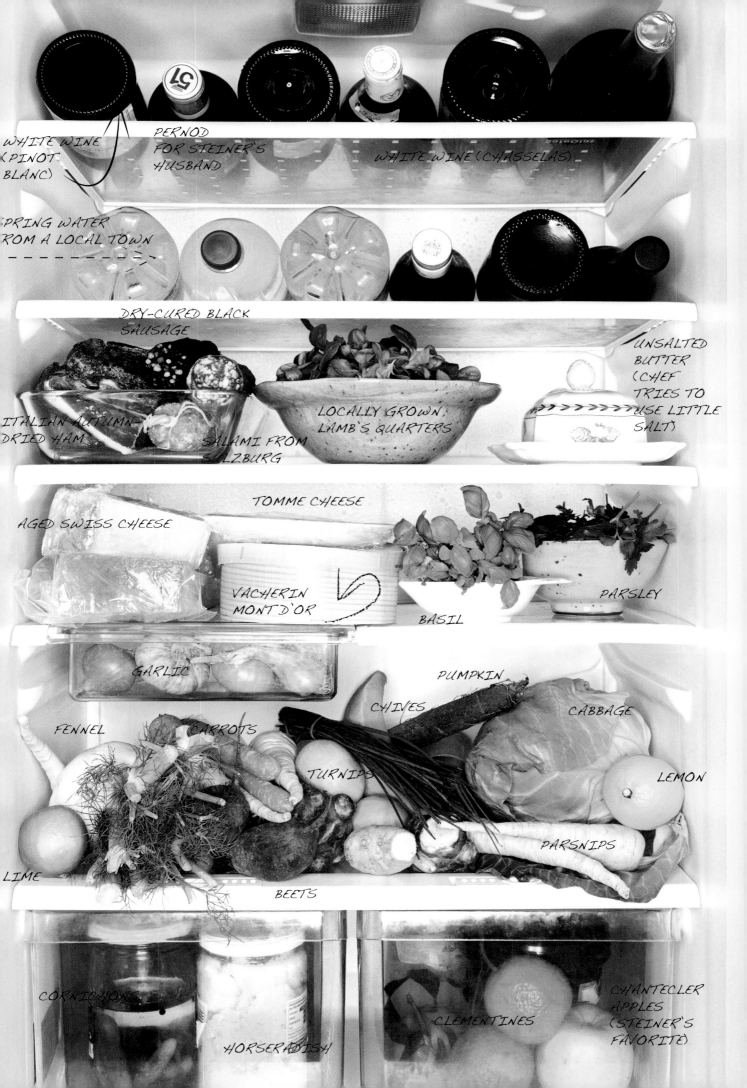

LAMB'S LETTUCE SALAD
WITH BACON, POTATOES, AND MONT D'OR

Serves 4

500–600g (1–1⅓ lbs.) Vacherin Mont d'Or
cow's milk cheese

200g (½ lb.) lamb's lettuce or mâche

16 small fingerling potatoes, peeled, halved

Salt

60ml (4 Tbsp.) grapeseed oil, divided

8 slices bacon

15ml (1 Tbsp.) white wine vinegar

5ml (1 tsp.) Dijon mustard

15ml (1 Tbsp.) chicken stock

Freshly ground black pepper

Remove cheese from refrigerator, and let come to room temperature for 2 hours. Preheat oven to 200°C (400°F). Carefully wash and dry lettuce. Toss potatoes with 30ml (2 Tbsp.) grapeseed oil on a baking sheet; season with salt. Roast potatoes until tender.

Meanwhile, fry bacon slices in a skillet over medium heat, stirring occasionally, until fat is rendered and bacon is crisp. Remove from pan and place on paper towels. Whisk together remaining grapeseed oil, vinegar, mustard, and chicken stock in a medium bowl. Season to taste with salt and pepper. Toss salad in vinaigrette. Serve with bacon, potatoes, and Vacherin Mont d'Or.

SALAD

The word salad comes from the Latin 'salata,' meaning "salted things," after the briny dressing the Greeks and Romans used to eat mixed greens with—yes, even back then, they used oil and vinegar dressings. It later appears in Old French and then English in the 14th century, and really came into vogue in the United States in the 19th century, where, arguably for the first time, it was seen as a meal in itself, and not just a side dish.

WINTER CRUDITÉS

Serves 4

White Cabbage
15ml (1 Tbsp.) apple cider vinegar
30ml (2 Tbsp.) grapeseed oil
2ml (½ tsp.) caraway seeds
200g (7 oz.) white cabbage, thinly sliced,
preferably with a mandoline

Fennel
5ml (1 tsp.) orange zest
60ml (4 Tbsp.) orange juice
15ml (1 Tbsp.) lemon juice
Pinch salt
200g (7 oz.) baby fennel bulbs, thinly sliced,
preferably with a mandoline

Kohlrabi
15ml (1 Tbsp.) apple cider vinegar
30ml (2 Tbsp.) rapeseed or vegetable oil
Pinch salt
Pinch freshly ground black pepper
5 chives, minced
200g (7 oz.) kohlrabi, peeled, julienned

Cucumber
½ cucumber, peeled, julienned
5ml (1 tsp.) salt
15ml (1 Tbsp.) white wine vinegar
30ml (2 Tbsp.) grapeseed oil
1 sprig fresh dill (about 1 Tbsp.), stems trimmed,
minced
Pinch of freshly ground black pepper

Parsley Root
15ml (1 Tbsp,) apple cider vinegar
30ml (2 Tbsp.) grapeseed oil
Pinch salt
Pinch freshly ground black pepper
Small handful flat-leaf parsley leaves
200g (7 oz.) parsley root, peeled, julienned

Golden Beets
200g (7 oz.) golden beets, peeled, julienned
Pinch (⅛ tsp.) powdered saffron
15ml (1 Tbsp.) white wine vinegar
30ml (2 Tbsp.) rapeseed or vegetable oil
Pinch salt
Pinch freshly ground black pepper
Pinch *Piment d'Espelette* powder

Carrots
1 lime, juiced and zested
45 ml (3 Tbsp.) olive oil
Pinch salt
Pinch freshly ground black pepper
Pinch sugar
200g (7 oz.) medium carrots, peeled, julienned

Pumpkin
1 lime, juiced and zested
1 cm (⅓ inch) ginger, peeled, finely grated
15ml (1 Tbsp.) pumpkin oil
30ml (2 Tbsp.) olive oil
Pinch salt
Pinch freshly ground black pepper
Pinch *Piment d'Espelette* powder
200g (7 oz.) pumpkin, peeled, grated
Small handfull toasted pumpkin seeds

DOUCE **STEINER**

●································●

Sulzburg, Germany

White Cabbage:

Whisk together vinegar, grapeseed oil,
and caraway seeds in a large bowl.
Toss cabbage with vinaigrette.

Fennel:

Whisk together zest, orange juice, lemon juice,
and salt in a large bowl. Toss fennel with vinaigrette.

Kohlrabi:

Whisk together vinegar, rapeseed oil,
salt, pepper, and chives in a large bowl.
Toss kohlrabi with vinaigrette.

Cucumber:

Toss cucumber with salt. Let sit about 10 minutes
to allow excess liquid to release from cucumber.
Rinse and dry cucumber. Whisk together the
vinegar, oil, dill, and pepper in a large bowl.
Toss cucumber with the vinaigrette.

Parsley Root:

Whisk together vinegar, oil, salt, pepper, and parsley
in a large bowl. Toss parsley root with vinaigrette.

Golden Beets:

Whisk together the powdered saffron, vinegar, oil,
salt, pepper, and Piment d'Espelette in a large bowl.
Toss beets with vinaigrette.

Carrots:

Whisk together the lime juice, lime zest, oil,
salt, pepper, and sugar in a large bowl.
Toss carrots with vinaigrette.

Pumpkin:

Whisk together lime juice, lime zest, ginger, pumpkin
oil, olive oil, salt, pepper, and Piment d'Espelette
in a large bowl. Toss pumpkin with vinaigrette,
and top with toasted pumpkin seeds.

Assembly:

Arrange crudités on a platter or divide among
serving bowls.

DAVID
TOUTAIN

RESTAURANT DAVID TOUTAIN

•·····································•

Paris, France

David Toutain burst onto the Parisian scene as head chef at Agapé Substance, where he wowed the food world with his inventive, hyper seasonal cooking, inspired as much by avant-garde Spanish cuisine as by the simplicity and product fetish obsessed New Nordic wave (think fresh hen's egg with verbena and garlic cream, monkfish with Tonka bean and a nutty crumble). A food writer's wet dream, the restaurant's reputation spread like wildfire throughout the foodie blogosphere before he left after a year and a half to reflect on what to do next, traveling throughout the United States, Europe, China, and Japan.

An accidental chef, Toutain originally wanted to be a farmer like his parents. "That's where it all came from: my education, my love of products, and the farming culture. The original culinary spark starts when you're a child." (That and the fact that he trained with some of the world's best chefs: Bernard Loiseau, Alain Passard, Marc Veyrat, Andoni Aduriz). On their Normandy farm they ate magnificent products; there were always raw vegetables on the table, at every meal, from breakfast through dinner. "I only realized how lucky I was twenty years later, when I became a chef."

Chez les Toutain, it's all about easy cooking, seasonality, and sharing. "I love the Asian way of sharing plates." Food comes from the nearby Avenue de President Wilson market—"I go to see my friend Joel Thiebault for his vegetables"—and from Tang Frères in the 13th arrondissment for everything Asian (his food photographer wife is Vietnamese).

Despite its small size, the Toutain family fridge remains full thanks to daily food shopping. "We get whatever's in season. The seasons are ephemeral, products come and go with its rhythm: I love baby leeks, rhubarb, strawberries, blackcurrants." They get big pieces of beef and pork from the grandparent's farm in Normandy, which goes into the freezer wrapped in newspaper for consuming later. There's always something to drink as well: water, juice, and especially for David, homemade family cider. "When I come home from a hard day's cooking, I always have a glass. It really quenches your thirst, chilled with those little bubbles floating up."

Another important thing for David is to pass on his heritage to his son, to educate him on how things really are. "For his first year he never even ate salt. His snacks are fruit and vegetables. One of the most important things is to give our children good stuff and teach them how to taste."

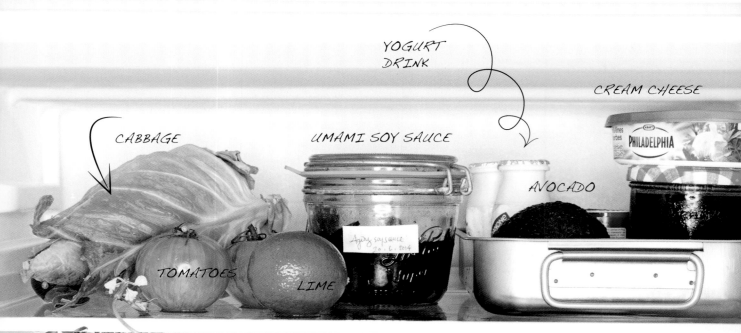

YOGURT DRINK

CREAM CHEESE

CABBAGE

UMAMI SOY SAUCE

AVOCADO

PHILADELPHIA

TOMATOES

LIME

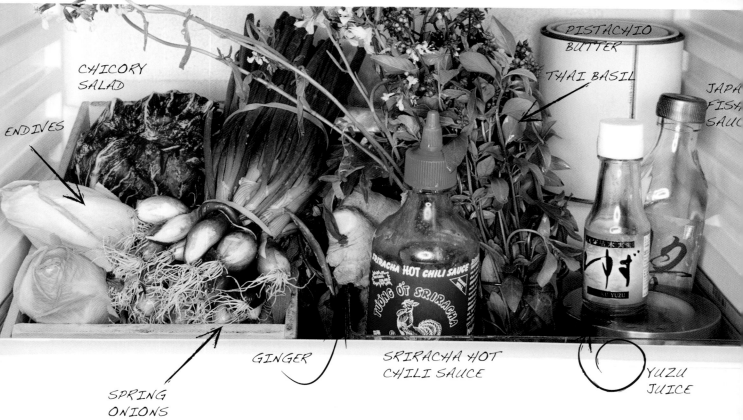

CHICORY SALAD

ENDIVES

PISTACHIO BUTTER

THAI BASIL

JAPA
FISH
SAUC

SRIRACHA HOT CHILI SAUCE

TƯƠNG ỚT SRIRACHA

GINGER

SRIRACHA HOT CHILI SAUCE

YUZU JUICE

SPRING ONIONS

Yuzu

Originally from China, this Japanese citrus fruit that looks something like a small, pockmarked grapefruit is one of the creative modern chef's favorite flavors. With a moderately acidic content and a potent perfume all its own, the yuzu is rarely consumed as a fruit itself, yet its unique taste and high level of vitamin C make it popular as a juice, and its zest a favorite for seasoning. It is also a key ingredient in various products, like yuzu kosho, Japan's most popular hot sauce, made with the peel of the fruit and fermented green chili peppers. Its antioxidant properties and fruity floral notes also make it a popular ingredient in skin care treatments and in hot bath remedies for colds and flus.

IKEA LAGAN

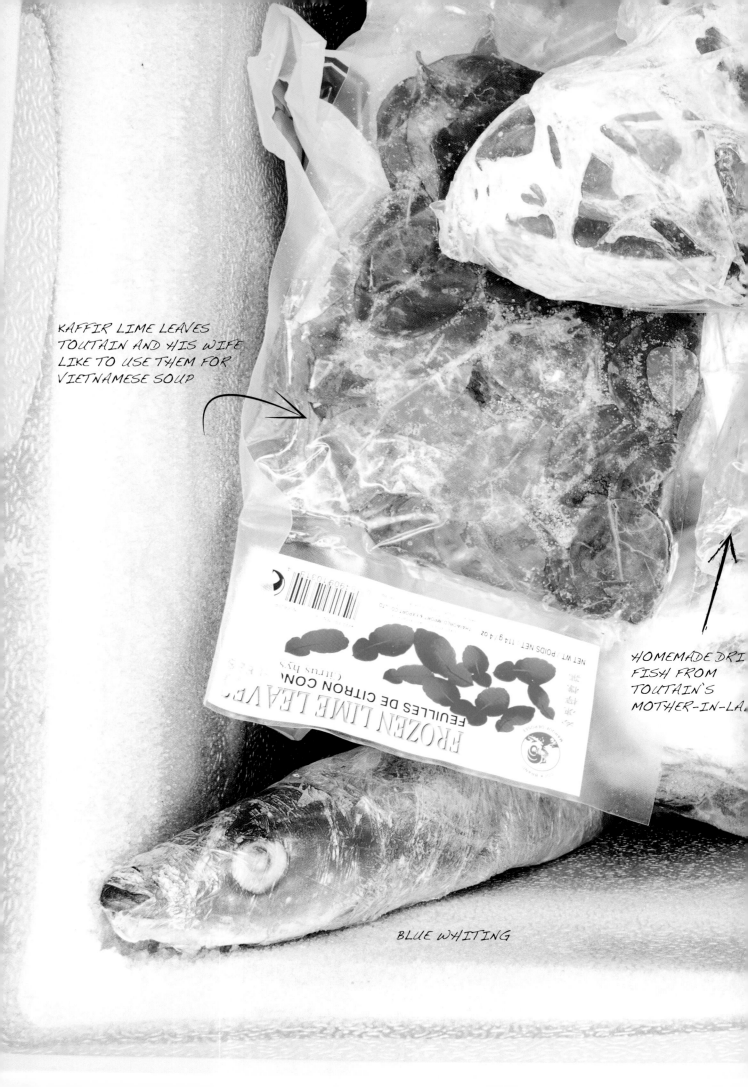

KAFFIR LIME LEAVES
TOUTAIN AND HIS WIFE
LIKE TO USE THEM FOR
VIETNAMESE SOUP

HOMEMADE DRI
FISH FROM
TOUTAIN'S
MOTHER-IN-LA.

BLUE WHITING

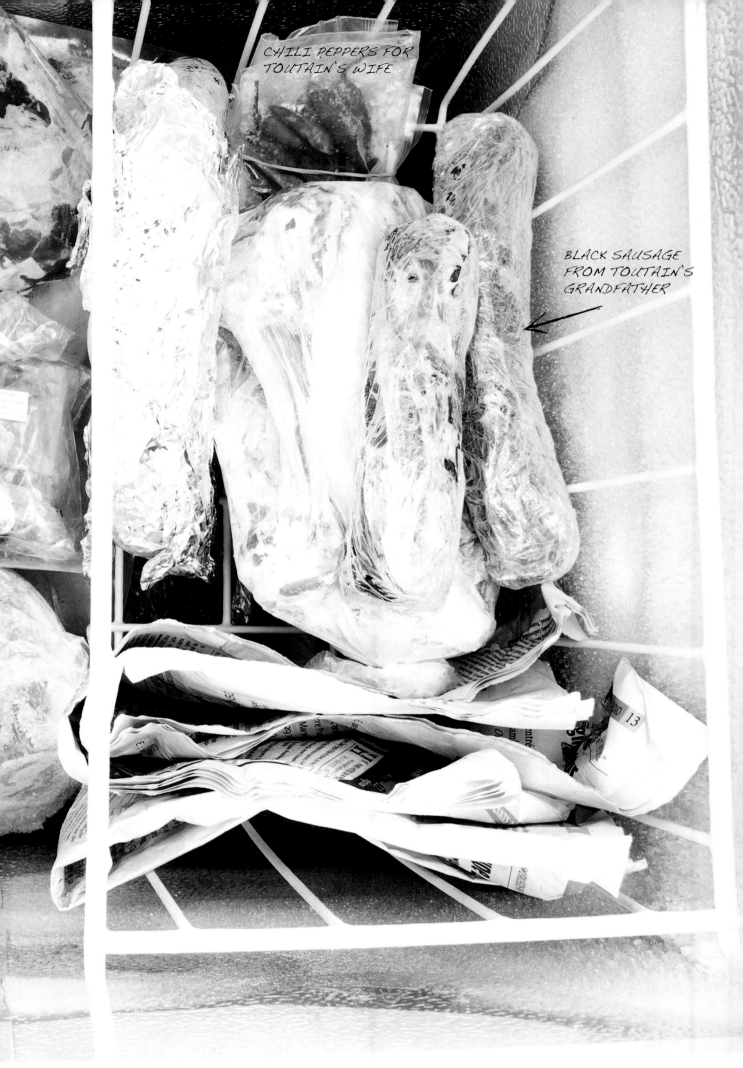

BULGUR RISOTTO
WITH TOMATO GAZPACHO AND RATATOUILLE

Serves 4

Ratatouille
60ml (4 Tbsp.) olive oil
60g (⅓ cup) sweet onions, finely chopped
80g (½ cup) zucchini, finely chopped
1 red bell pepper, peeled, finely chopped
1 yellow bell pepper, peeled, finely chopped
80g (½ cup) eggplant, finely chopped
Sea salt
Marjoram (for serving)

Tomato Gazpacho
210g (7.5 oz.) tomatoes
9g (1 Tbsp.) red peppers
20g (2 Tbsp.) spring onions
20g (2 Tbsp.) fennel
10g (1 Tbsp.) cucumber
2ml (½ tsp.) sherry vinegar
2ml (½ tsp.) sea salt, plus more

Bulgur Risotto
10ml (2 tsp.) olive oil
6 young garlic (green garlic) cloves,
peeled, halved
1 thyme sprig
400ml (1⅔ cups) water
1 chicken bouillon cube
2 bay leaves
160g (1 cup) bulgur

Ratatouille:
Heat the olive oil in a large skillet over medium-high heat. Sauté each vegetable separately for just a few minutes; the vegetables should retain their crunch. Set aside. Let cool, then season with salt and marjoram to taste.

Tomato Gazpacho:
Using a food processor, finely chop all vegetables. Add vinegar and salt, and purée. Press through a fine-mesh sieve, discarding solids. Chill gazpacho. Season to taste with sea salt.

Bulgur Risotto:
Heat the olive oil in a small skillet over low heat. Add garlic and thyme, and cook until the garlic becomes confitted, meaning golden brown and very soft (about 20 minutes). Transfer to a small bowl and let cool. Smash with the back of a fork until garlic becomes a smooth paste.

In a medium saucepan, bring water, chicken bouillon cube, and bay leaves to a simmer. Meanwhile, in a separate, large, dry skillet, toast the bulgur over medium heat, stirring occasionally, until lightly browned. Cook bulgur as you would risotto, adding the simmering broth little by little until it is completely absorbed, and stirring often. Fold in smashed garlic.

Assembly:
Spoon the bulgur and gazpacho into bowls or deep plates. Top with ratatouille.

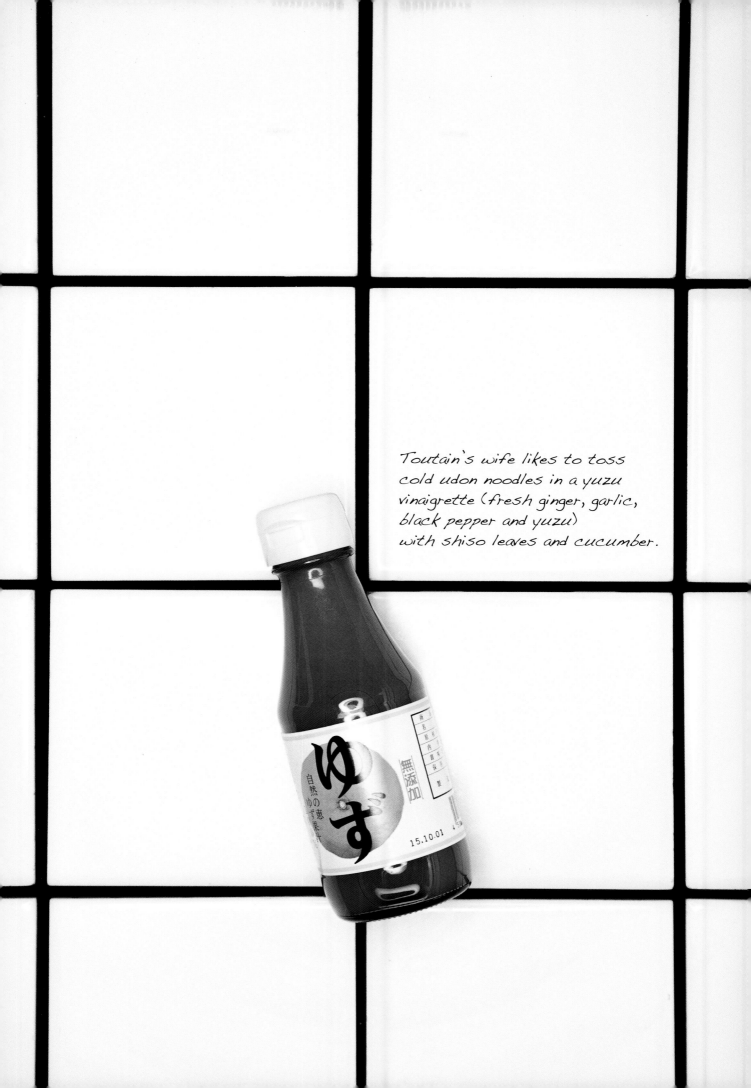

Toutain's wife likes to toss
cold udon noodles in a yuzu
vinaigrette (fresh ginger, garlic,
black pepper and yuzu)
with shiso leaves and cucumber.

BLUE WHITING
WITH RHUBARB AND GREEN PEAS

Serves 4

100ml (⅓ cup plus 1½ Tbsp.) water
20g (1 Tbsp. plus 2 tsp.) sugar
2 stalks rhubarb, peeled (peel reserved),
finely chopped
50g (3½ Tbsp.) salted butter
4 spring onions or scallions, white bulbs
and green stalks separated, minced
500g (1.1 lbs.) green peas
2 blue whiting filets (400–600g or
14–21 oz. total), pin bones removed
14 green almonds, shelled
4 basil leaves
4 lemongrass leaves
20g (¾ oz.) arugula
Sea salt

In a large saucepan, combine water, sugar, and rhubarb peel, and bring to a boil. Place finely chopped rhubarb in a medium bowl. Set a fine-mesh strainer over bowl, and pour rhubarb-peel liquid over strainer into bowl with finely chopped rhubarb. Discard solids in strainer. Chill rhubarb brunoise 24 hours in the refrigerator.

Preheat oven to 140°C (285°F). Melt butter in a large, oven-safe skillet over low heat. Add the spring onion bulbs, and sauté 2 minutes. Add green peas, cover, and cook 2 minutes. Add fish filets, and transfer pan to the oven to cook for 6 minutes.

Just before serving, top fish mixture with rhubarb brunoise, green almonds, basil, lemongrass, and arugula. Season with sea salt.

Nuoc Mau

Nuoc Mau (pronounced "nook mao") is a burnt caramel sauce, second only to fish sauce as a popular condiment in Vietnamese households. The sauce can be bitter, but adds a delicious dimension and color to a host of classic Vietnamese meat and seafood dishes, and is a secret and essential ingredient to many stews. The fact that it is made (with varying degrees of difficulty!) with just refined sugar and water, and lasts up to a year in the fridge, makes it an understandable favorite.

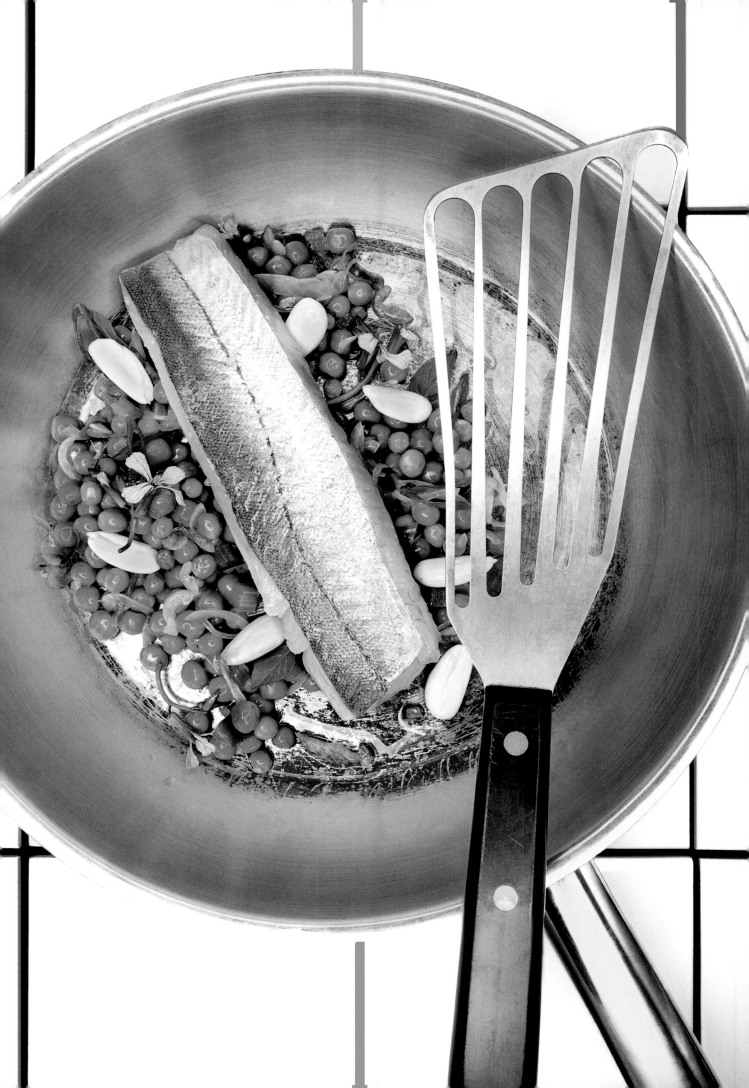

MARCO PIERRE
WHITE

VARIOUS ESTABLISHMENTS
THROUGHOUT THE UNITED KINGDOM

•..................................•

London, England

One of the world's most iconoclastic and iconic chefs, Marco Pierre White has carved his own history into the culinary bedrock of the British Isles on his own terms, and chosen his personal destiny with no holds barred.

The original so-called bad boy chef, the youngest of his time to win three Michelin stars, burned out and famously gave them back, eventually building up a portfolio of more honest eateries across the United Kingdom, a highly successful media career, with cooking relegated to the home and for personal pleasure only.

Although White spends a great deal of time in London, his Wiltshire countryside retreat affords him access to his favorite pastimes of hunting and fishing; he rarely, if ever, eats at his art filled, pristine Georgian home, and his magnificent, restored vintage fridge is more likely to be filled with his housekeeper's supermarket bought food than his own. The vintage Frigeco icebox was found abandoned on a French riverbed and was restored and modernized at great expense. "My fridge is an object of great beauty, but nowadays they are more form than function."

White's favorite dishes are mostly British classics, and, ever the hunter-gatherer away from his metropolitan digs, more than likely the product of his expert shooting skills. He loves woodcock or partridge cooked "à l'Anglaise" with bread sauce ("like a *purée de pain* made with breadcrumbs and clarified butter, the head taken off and cooked with its intestines"). If it's the season, it gets finished off with black truffles. Other well-loved snacks may be a breakfast time portion of sardines on Poilâne bread with a good butter, haddock with soft boiled egg and new potatoes or salmon gravlax from H. Forman & Son; "they're such a luxury these great smokers."

At his London residence, White cooks every day for his girlfriend and her daughter, focusing on deliciously simple dishes such as banana pancakes with maple syrup for breakfast or *pot-au-feu* for dinner. White allows himself frequent snacks throughout the day, always well-sourced, regional products: manchego cheese with pear or figs, Vacherin or Tomme de Savoie ("I love cheese, I could eat them all"), pickled pears from the Spanish shop down the road or salted beef with maybe a touch of *moutarde de crémant*. York ham holds a special place in his heart: "It's just as good as Parma ham, maybe better, they age it for three months, then boil it, superb!"

Surely, the chef who was once as feared as he was respected is the master of his own kitchen? "My girlfriend went mad with the herbs the other day," bringing a bunch of every herb possible, "I asked her why but she just shrugged and said, "I didn't know which one you wanted, so I got them all." He smiles and seems to be shrugging inwardly as well.

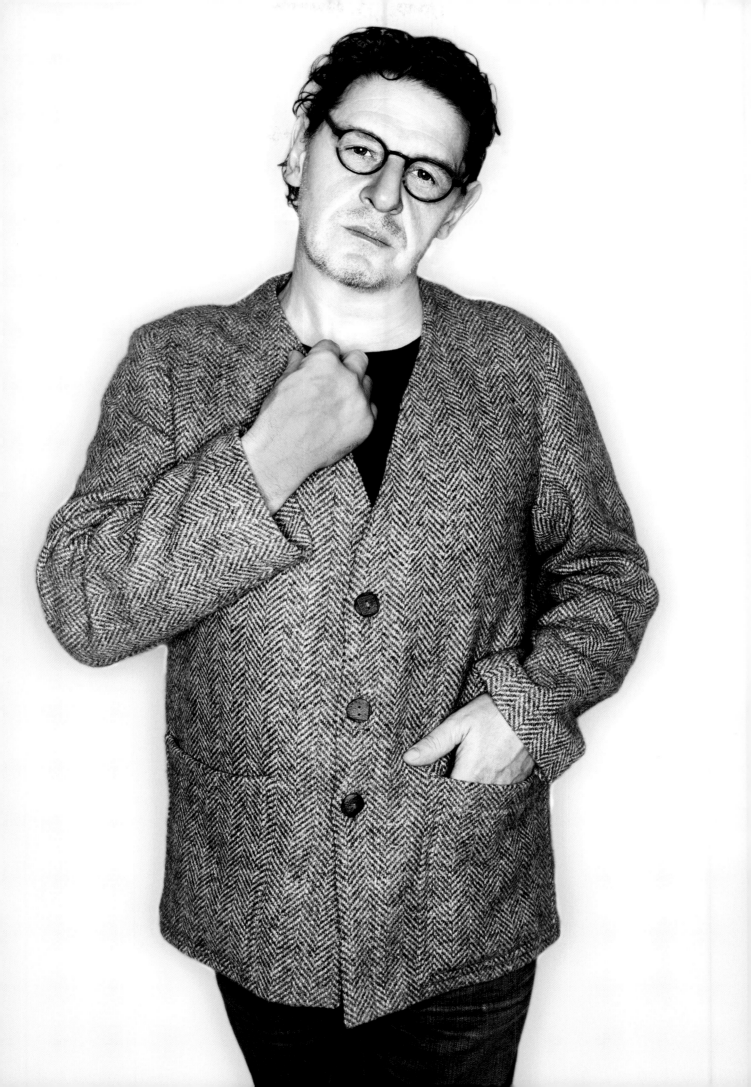

RETROFITTED FRIGECO

Iconoclastic chef, businessman, and gentleman outdoorsman, Marco Pierre White's home away from the city is his man cave in the Wiltshire wilderness, a place for his favorite natural pursuits of hunting and fishing. His art filled abode includes a perfectly restored 1930s hardwood Frigeco, which, although being his pride and joy, is more likely to be filled with his housekeeper's store bought items, (as the chef eats and lives mostly in London), but on occasion is privy to fresh game caught in the nearby fields and woods.

ROAST PHEASANT
WITH BREAD SAUCE

Serves 4

Pheasant
8 slices streaky (American) bacon
2 1.1kg (2½ lb.) pheasants
4 sprigs thyme
12 juniper berries
Salt
Freshly ground white pepper
Goose fat, for roasting
4 slices back bacon

Game Chips (Homemade Potato Chips)
2 large Maris Piper potatoes, peeled, very thinly
sliced on a mandolin
Vegetable oil, for frying

Bread Sauce
400ml (1⅔ cups) milk
1 onion, sliced
1 whole clove
4 slices white bread, crusts removed, diced

Gravy
1 celery stalk, chopped
1 onion, peeled, chopped
1 carrot, peeled, chopped
2 garlic cloves, peeled, halved
100ml (⅓ cup plus 1½ Tbsp.) white wine
2 sprigs thyme
200ml (¾ cup 1½ Tbsp.) veal stock

Preheat oven to 200°C (400°F). Arrange 4 pieces
streaky bacon across each pheasant. Stuff the cavity
of each bird with 2 sprigs of thyme and 6 juniper
berries, and season the birds inside and out with salt
and pepper. Tie and truss the pheasants.
Heat goose fat in a roasting pan, and rub the melted
goose fat on all sides of the pheasant. Transfer to the
oven and roast for about 25–30 minutes, depending
on the size of the birds. Let rest for 5–10 minutes,
then remove the strings, and keep warm.
Grill or pan fry the back bacon.

Game Chips:
Rinse sliced potatoes under cold running water for
20 minutes to remove excess starch. Drain very well,
and dry on paper towels. In a large pot, bring 5cm
(2 in.) vegetable oil to 160°C (320°F), and deep fry
potatoes until golden brown. Drain on paper towels,
and season with salt.

Bread Sauce:
In a medium pot, bring milk to a boil with onion and
whole clove. Reduce heat and simmer for 2 minutes.
Strain out the onion and clove. Transfer half of milk to
a medium bowl, and add bread, mashing together.
Season with salt. Add as much of the remaining milk
as necessary until you get a thin mashed potato
consistency. Cover with plastic wrap, and keep warm.

Gravy and Assembly:
Place celery, onion, carrot, and garlic in the roasting
pan that the pheasant was cooked in, and roast in
the oven until golden brown. Transfer pan to stovetop,
and place over two burners. Add white wine, thyme,
and a little salt and pepper, and boil until liquid is
virtually evaporated. Add veal stock, bring to a boil,
reduce heat, and simmer for 3 minutes. Pass through a
fine-mesh sieve, discarding solids.
Remove the legs from the pheasant, trim the foot,
and cut between the thigh and the drumstick.
Remove the breast from the bird, and slice into
thirds. Place the sliced breast on top of a thigh and
drumstick. Serve with bread sauce, game chips,
bacon, and gravy. Serve with roasted Brussels
sprouts, braised cabbage, or roasted parsnips.

ETON MESS

Serves 6

400g (14 oz.) strawberries
400g (14 oz.) raspberries
20g (.7 oz.) powdered sugar, plus more to taste
Kirsch liqueur
200g (7 oz.) heavy cream
6 meringues
6 scoops vanilla ice cream
6 mint sprigs (for serving)

Set aside 6 strawberries and slice into wedges.
Purée remaining strawberries with raspberries until
the fruit becomes a pulp. Season with powdered
sugar and Kirsch liqueur to taste.
Beat 20g powdered sugar into the heavy cream,
until the cream forms very soft peaks. Using an
immersion blender, break up meringues until
they are in small chunks. Divide vanilla ice cream
among 6 chilled sundae glasses, placing 1 scoop
into each. Cover the ice cream with a small amount
of berry pulp, and top with strawberry wedges.
Gently fold the crushed meringues into the
remaining semi-whipped cream to form a ripple
effect; spoon mixture into glasses. Garnish each
glass with a mint sprig.

INDEX

INDEX

INDEX

• •

ADDRESSES

Daniel Achilles
Reinstoff
Schlegelstrasse 26c,
10115, Berlin, Germany
+49 30 3088 1214

Andoni Luis Aduriz
Mugaritz
Aldura Aldea, 20,
20100, Errenteria, Gipuzkoa, Spain
+34 943 52 24 55

Inaki Aizpitarte
Le Chateaubriand
129 avenue Parmentier,
75011, Paris, France
+33 1 43 57 45 95

Bo Bech
Geist
Kongens Nytorv 8, 1050,
Copenhagen, Denmark
+45 3313 3713

Akrame Benallal
Restaurant Akrame
19 rue Lauriston, 75016, Paris, France
+33 1 40 67 11 16

Massimo Bottura
Osteria Francescana
Via Stella 22, Modena, Italy
+39 059 223912

Sébastien Bras
Le Suquet
Route de l'Aubrac, 12210, Laguiole,
France
+33 5 65 51 18 20

Yves Camdeborde
Le Comptoir
Hotel Relais Saint Germain
9 Carrefour de l'Odéon, 75006, Paris,
France
+33 1 44 27 07 97

Sven Chartier
Saturne
17 rue Notre-Dame des Victoires,
75002, Paris, France
+33 1 42 60 31 90

Mauro Colagreco
Mirazur
30 avenue Aristide Briand,
06500, Menton, France
+33 4 92 41 86 86

Hélène Darroze
Restaurant Hélène Darroze
4 rue d'Assas, 75006, Paris, France
+33 1 42 22 00 11

Hélène Darroze at The Connaught
Carlos Place, Mayfair, London,
W1K 2AL, United Kingdom
+44 207 499 7070

Sang Hoon Degeimbre
L'Air du Temps
Rue de la Croix Monet 2, 5310,
Eghezée, Belgium
+32 81 81 30 48

Kobe Desramaults
In De Wulf
Wulvestraat 1, 8951, Heuvelland
(Dranouter), Belgium
+32 57 44 55 67

Niklas Ekstedt
Restaurant Ekstedt
Humlegårdsgatan 17, 114 46,
Stockholm, Sweden
+46 8 611 12 10

Sven Elverfeld
Aqua
The Ritz-Carlton Wolfsburg
Parkstrasse 1, 38440, Wolfsburg,
Germany
+49 5361 606056

Klaus Erfort
GästeHaus Klaus Erfort
Mainzer Strasse 95, 66121,
Saarbrucken, Germany
+49 681 9582682

Annie Féolde
Enoteca Pinchiorri
Via Ghibellina, 87, 50122, Florence,
Italy
+39 055 242757

Alexandre Gauthier
La Grenouillère
rue des la Grenouillère,
62170, La Madelaine-sous-Montreuil,
France
+33 3 21 06 07 22

Adeline Grattard
Yam'Tcha
121 rue Saint Honoré,
75001, Paris, France
+33 1 40 26 08 07

Bertrand Grébaut
Septime
80 rue de Charonne,
75011, Paris, France
+33 1 43 67 38 29

Fatéma Hal
Le Mansouria
11 rue Faidherbe,
75011, Paris, France
+33 1 43 71 00 16

Fergus Henderson
St. JOHN
26 St. John Street, London, EC1M 4AY,
United Kingdom
+44 207 251 0848

James Henry
Bones
43 rue Godefroy Cavaignac, 75011,
Paris, France
+33 9 80 75 32 08

Sergio Herman
The Jane
Paradeplein 1, 2018, Antwerp,
Belgium
+32 3 808 44 65

Pierre Hermé
Various boutiques throughout
the world

Mikael Jonsson
Hedone
301–303 Chiswick High Road,
London, W4 4HH, United Kingdom
+44 208 747 0377

ADDRESSES

●·································●

Rasmus Kofoed
Geranium
Per Henrik Lings Allé 4,8.,
2100 Copenhagen, Denmark
+45 69 96 00 20

Tatiana Levha
Le Servan
32 rue Saint-Maur, 75001, Paris
France
+33 155 28 51 82

Gregory Marchand
Frenchie
5 rue du Nil, 75002, Paris, France
+33 1 40 39 96 19

Thierry Marx
Sur Mesure par Thierry Marx
Mandarin Oriental, Paris
251 rue Saint Honoré, 75001, Paris,
France
+33 1 70 98 73 00

David Muñoz
DiverXO
C/ de Padre Damián, 23,
28036, Madrid, Spain
+34 915 70 07 66

Magnus Nilsson
Fäviken
Fäviken 216, 830 05, Järpen, Sweden
+47 647 401 77

Matt Orlando
Amass
Refshalevej 153,
1432, Copenhagen, Denmark
+ 45 435 84330

Yotam Ottolenghi
Various establishments throughout
London, United Kingdom

Jean-François Piège
*Le Grand Restaurant
Jean-François Piège*
7 rue d'Aguesseau, 75008, Paris,
France

Clover
5 rue Perronet, 75007, Paris, France
+33 1 75 50 00 05

Christian Puglisi
Relae
Jaegersborggade 41, 2200,
Copenhagen, Denmark
+45 3696 6609

Joan Roca
El Celler de Can Roca
Can Sunyer 48, 17007, Girona, Spain
+34 972 222 157

Douce Steiner
Restaurant Hirschen
Hauptstrasse 69, 79295, Sulzburg,
Germany
+49 7634 8208

David Toutain
Restaurant David Toutain
29 rue Surcouf, 75007, Paris, France
+33 1 45 50 11 10

Marco Pierre White
Various establishments throughout
the United Kingdom

THANKS

• ·································· •

We are very grateful to each and every chef who invited us into his or her home and fridge. You shared with us both your food and your personal lives away from the professional kitchen.

Thanks to:

Daniel Achilles and his wife as well Regine from Reinstoff; Andoni Luis Aduriz, Susana Nieto, Oswaldo Oliva, Sara Al-Ali, and Fernanda and Monica from Lotus PR; Inaki Aizpitarte; José Avillez, his wife and family for their generosity, also to Monica Bessone who helped with advice and logistics in Lisbon; Bo Bech for showing us around Copenhagen; Akrame Benallal and his wife Farah, as well as Stephanie Messian and Elena from Akrame Conseil; Massimo Bottura and Lara Gilmore and Alessandro, and thanks as well to Sarah Canet and Ailsa Wheeler at Spoon PR and Alice Stanners; Sébastien Bras and his family; Yves Camdeborde and his family; Sven Chartier and his wife Marianne; Mauro Colagreco and his wife Julia Ramos Colagreco, as well as Gonzalo Benavides; Hélène Darroze for meeting with us in Paris, and thanks as well to Jannes Soerensen and Christelle Curinier for all their help; Sang Hoon Degeimbre and his family, as well at Olivier Deschetier and Danila at L'Air du Temps; Kobe Desramaults and Eff, as well at Debbie Pappyn from Class Touriste; Niklas Ekstedt; Sven Elverfeld, his family, and Sandra Schuschkleb from restaurant Aqua, The Ritz-Carlton, Wolfsburg, Germany; Klaus Erfort, Torsten Burgmaier, Jerome Pourchere, and especially Michael Raber for his invaluable introduction; Annie Féolde and Cristina Matteuzi, as well as David Fink for his extremely useful help; Alexandre Gauthier, his family, and to Lizzie; Adeline Grattard and Chiwah; Bertrand Grébaut and Tatiana Levha; Fatéma Hal; Fergus and Margot Henderson, as well as Kitty Cooper; James Henry and his roommates; Sergio Herman, his family, and the people from Spoon PR; Pierre Hermé and Marine Attrazic; Mikael Jonsson for inviting us into your brand new home when all you had was your fridge. Thanks again to the people from Spoon PR; Rasmus Kofoed and Kristian Brask Thomsen from Bon Vivant; Grégory Marchand and his wife Marie; Thierry Marx, Mathilde de L'Ecotais and

Anais Buzias from the Mandarin Oriental; David Muñoz and Patricia, Lola and Pati at Mateo and Co; Magnus Nilsson, his family, and the entire team at Fäviken Magasinet; Matt Orlando, his wife, as well as Evelyn Kim; Yotam Ottolenghi and his partner, as well as Lucy and Felicity and Juliet at Lutyens & Rubinstein; Jean-François Piège and his wife Elodie; Christian Puglisi and his wife; Joan Roca, his family, and especially his mother Montserrat Fontané; Douce Steiner and her extended family; David Toutain and his wife Thai; Marco Pierre White for putting us up in his lovely abode, bringing us along on a game hunt, and a special thanks as well to his and our friend Kevin Cash, another extraordinary man, who's followed our project since it was a twinkle in our eye.

Most of all, we would like to thank Benedikt Taschen for his vision and for making this happen in the first place, as well as Florian Kobler and the whole team at Taschen for their patience, commitment, and determination to make an exceptional book.

And thank you, Nathan Myhrvold for setting the tone for our book better than we could have hoped. Thanks as well to Stephanie Swane and Maggie Wheeler from the Cooking Lab.

Those who helped make our travels smooth and who lent a hand when needed: Olivier Pacteau, Cecile Perrin, Julia Goldstein, Lisa Hryniewicz.

Laurence Maillet for her superb design, Aurore D'Estaing for her detailed illustrations; Julia Kramer and Aaron Bogart for their thoroughness and meticulousness.

We thank as well Philippe Demouy and Karolina Symington.

And last and certainly not least, both Adrian and Carrie would like to thank their friends and family for their encouragement and motivation and without whom none of this would have been possible. Adrian would like to especially dedicate this book to Chloe.

COLOPHON

•·································•

Unlesss otherwise noted, all text is ©
Carrie Solomon and Adrian Moore
Foreward appears courtesy of **Nathan Myhrvold/
The Cooking Lab** © The Cooking Lab, LLC
All recipes are © **the respective chefs**
All photographs © **Carrie Solomon**
Portrait page 10 by **Tempé Storm Cole**
All illustrations © **Aurore d'Estaing**

Design: **Laurence Maillet, Paris**
Editorial coordination: **Florian Kobler, Berlin**
Collaboration: **Inga Hallsson, Berlin**
Production: **Ute Wachendorf, Cologne**

Printed in Slovakia

ISBN 978–3–8365–5353–7

EACH AND EVERY TASCHEN BOOK PLANTS A SEED!
TASCHEN is a carbon neutral publisher. Each year, we offset
our annual carbon emissions with carbon credits at the
Instituto Terra, a reforestation program in Minas Gerais, Brazil,
founded by Lélia and Sebastião Salgado. To find out more
about this ecological partnership, please check:
www.taschen.com/zerocarbon
Inspiration: unlimited. Carbon footprint: zero.

To stay informed about TASCHEN and our upcoming
titles, please subscribe to our free magazine at
www.taschen.com/magazine, follow us on Twitter,
Instagram, and Facebook, or e-mail your questions to
contact@taschen.com

Aizpitarte

White
Bech
Degeimbre
Hermé
Kofoed
Ottolenghi
Bottura

Puglisi

Benallal
Roca

Erfort
Gauthier

ore

Marx
Darroze
Achilles